TRAVELIN' MAN

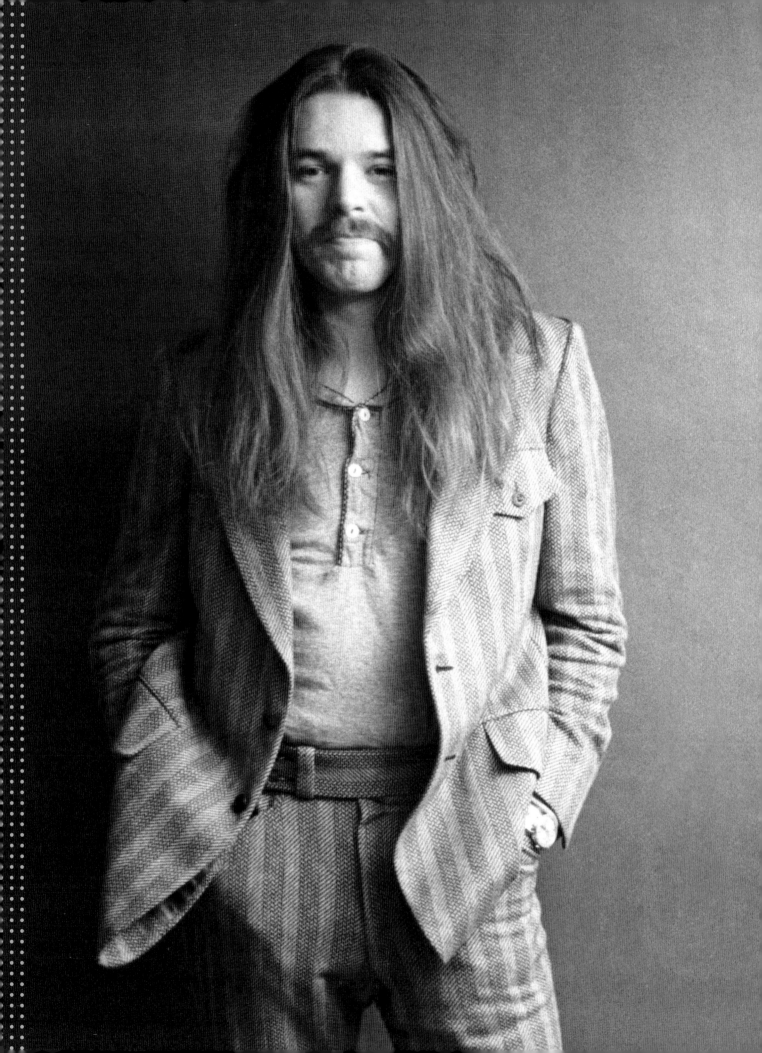

Travelin' Man

ON THE ROAD and BEHIND THE SCENES with

Bob Seger

TOM WESCHLER | GARY GRAFF

Foreword by **John Mellencamp** *Afterword by* **Kid Rock**

A PAINTED TURTLE BOOK DETROIT, MICHIGAN

First paperback edition 2010 (ISBN 978-0-8143-3501-7).
© 2009 by Wayne State University Press, Detroit, Michigan 48201.

14 13 12 11 10 5 4 3 2 1

The Library of Congress has cataloged the hardcover edition as follows:

Weschler, Tom, 1948–
Travelin' man : on the road and behind the scenes with Bob Seger /
Tom Weschler [photographer], Gary Graff ; with a foreword by
John Mellencamp and an afterword by Kid Rock.
 p. cm.
Includes index and discography.
ISBN 978-0-8143-3459-1 (cloth : alk. paper)
1. Seger, Bob. 2. Rock musicians—United States—Biography.
3. Seger, Bob—Pictorial works. I. Graff, Gary. II. Title.
ML420.S447W45 2009
782.42166092—dc22
[B]
2009018201

∞ The paper used in this publication meets the minimum requirements
of the American National Standard for Information Sciences—
Permanence of Paper for Printed Library Materials. ANSI Z39.48-1984

Designed and typeset by Savitski Design
Composed in Leitura, Leitura Sans, and Magneto

All image scans courtesy of backstagegallery.com.
To order photos from this book, visit www.travelinfool.net.

Bob Seger album artwork reprinted with permission,
courtesy of Hideout Records & Distributors, Inc.

To our children, Ian and Dylan Weschler and Hannah Graff—who, like their old men, know that rock 'n' roll never forgets, but when you grow older it takes a while to remember everything.

Contents

Foreword

JOHN MELLENCAMP

In 1969, I'm sixteen years old. I'm riding around with four guys in the small town of Seymour, Indiana, and this drumbeat comes blaring out of the three-inch speaker. Then this voice sings, "I wanna tell my tale, come on." I asked the guys in the car, "Who the fuck is this guy?" So I made the fella driving the car pull to the shoulder of the road where there was no static and waited for the song to end and the DJ to announce who was singing the song. It was the Bob Seger System. The song was "Ramblin' Gamblin' Man." I didn't know it that night but that was the beginning of a long love affair with Bob Seger's music—thoughtful and badass, all in one measure. As time went on, I learned to respect Bob for who he would grow up to be, playing by his rules and staying honest to who he is and where he comes from. If there really is such a thing as Midwest Rock, it started for me that night. And now, all these years later, I am proud to be a part of his brood.

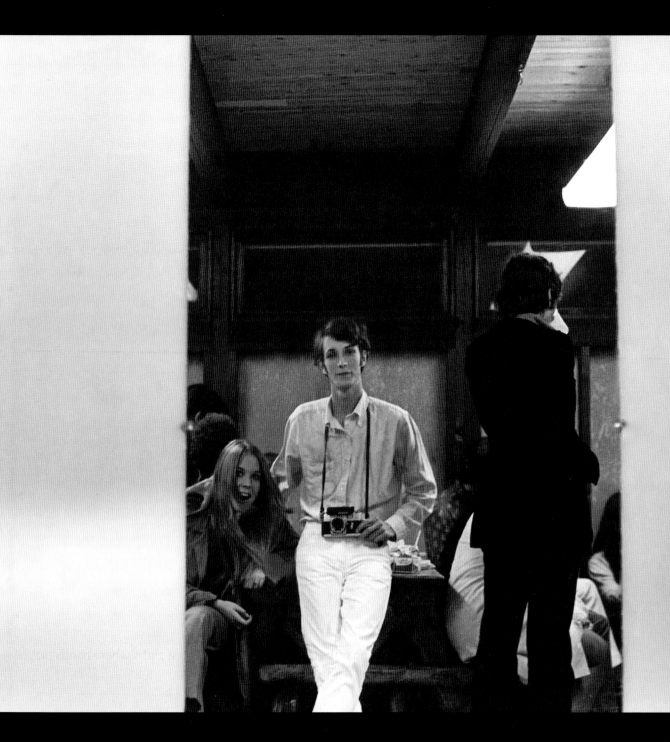

▲ Pat Kamego and Tom Weschler,
Meadow Brook Music Festival
(Rochester Hills), July 1968.

Tales of Lucy Blue: Tom's Story

TOM WESCHLER

When I was six years old, my parents gave me a camera—a Kodak Brownie—and those first snapshots began a lifelong journey in photography that also provided an opportunity to explore my other passions—and not only girls! It was music, too—rock 'n' roll in general, and, specifically, Bob Seger. Every time he played around the Detroit area, my friends and I would go to see him—always plenty of great music and lots of girls.

When I was fifteen, I found a decent job at Patterson's Car Wash in Rochester, Michigan, and was able to save enough money to buy a real 35 mm camera—a Nikkorex. Totally into rock 'n' roll and playing guitar to boot (though I was too stage-shy to perform on stage myself), I began photographing bands in Rochester. Because I was around, they began enlisting me to help them set up equipment and book gigs. I even booked bands for the Officers' Club at the Selfridge Air Base in Mount Clemens, Michigan. One thing led to another, and, in early 1965, I wound up managing a band, We Who Are, opting to play telephone instead of bass.

This would eventually lead me to Bob Seger's manager, Ed "Punch" Andrews, one of the most ambitious, successful, formative—and formidable—players in Detroit's fledgling rock scene. One night when some of my friends and I were skipping catechism and down at the pool hall, a DJ on WKNR-AM told all the Bob Seger fans that, if we wanted to hear his latest record, "East Side Story," we had better call and vote for it or it would not be played again. My friends and I monopolized the two pay phones by table 1, disguising our voices for each call. We kept calling until the DJ said, "Okay, okay, we'll keep playing the record!"

Months later, I went to see Punch, who owned the Hideouts, local teen clubs where bands played on Friday and Saturday nights. I wanted to get We Who Are a gig there, and, knowing a little about Mr. Andrews, I gathered together as many girls as I could to go with me. We went on a Friday night and requested an audition for my group. Perhaps impressed by the girls, who told him they were there to support my band—and promised their friends would come—he said, "No need to audition, just have your band here to open for the Mushrooms next Friday night." That was Glenn Frey's band before he sang on Seger's "Ramblin' Gamblin' Man" in 1968 and then moved to California, where he formed the Eagles. Later that same night, I was dancing with one of the girls when Punch pulled me aside and asked, "Is this band any good?" I assured him they were, and he snapped, "Yeah, well, they fuckin' better be!" and walked away. Whoaaaah! That was my first encounter with Mr. Andrews as a serious businessman.

On gig night, our amp blew up during the sound check, and Glenn Frey, the first time I ever met him, asked me, "What's the matter, man?" "Oh, our amp blew up." "Well, here, you can use my Bogen 100 watt," and he hooked it up for us. He was a good guy—and still is.

After I graduated from Rochester High School, I found a job working at a music equipment store called Artist's Music, driving the truck and delivering amps, guitars, and drums to the four stores they had in the metro Detroit area. I picked up a lot of experience with instruments and band equipment while taking them to gigs and setting them up. But I grew really jealous when I learned my friend Richard Kruezkamp, who we called Krinkle, was working as the road

you're the road manager now." I replied, "Oh, great!" "Yeah, the band likes you. I'm taking a chance, I know. You better be good at this shit." I said, "How much am I gonna make?" "$150 a week." "Great! How much are you paying the other guys?" Punch answered, "I don't care how much you pay 'em. It comes out of your money." We played a lot of high schools, so I'd arrive early and find guys who were waiting to go in and get them to help me in exchange for free admission to the show. That worked for a while—until we got bigger and I had to break down and hire somebody.

When we started to play around the country, I became responsible for much more than just setting up at the gigs. We were going

"Don't be an asshole! You gotta go to college. I want a dope to run my band out there on

manager for the best band in town—Bob Seger & the Last Heard! I was thinking, "Why didn't they call me?! This guy doesn't know anything about this stuff"—though, of course, he did. But one day in December '68 Krinkle called me and told me that one of his roadies was sick and asked me if I could help him set up Seger's stuff for a gig at the University of Detroit. Naturally, I said yes!

For the next few months, I helped with Seger's setups part-time while I was attending Oakland Community College (OCC). Then, in April of '69, Krinkle got sick and had to go to the hospital. Punch called me and said, "Hey,

to places where most Michigan bands had never gone before—Orlando, Florida; Portland, Maine; Washington, DC. I had to make hotel reservations, rent U-Haul trucks (until I convinced Punch to buy our own truck), make sure the guys reached the gigs on time, and, when possible, do sound checks in the afternoon. Some of the things that are commonplace in the touring music world now were just getting started back then. For instance, we had no riders in our contract for food or beer and vodka and other dressing-room amenities. And we didn't have backstage passes; we could only trust that

the people around the band were supposed to be there, and by this time we were attracting "camp followers"—girls who traveled just to see the band and be with us on the road.

Not surprisingly, my work began to be fun, too. I wanted to be on the road forever, and I didn't want to return to college. But Punch's advice to me, which he phrased in his typical manner, was "Don't be an asshole! You gotta go to college. Do you think I want a dope to run my band out there on the road?" So with an associate's degree in commercial art from OCC in hand, I enrolled at Oakland University and studied art history. In the fall of 1969, the gigs were scheduled in such a way that I could both work for Seger and attend school (with a very light class load), although sometimes I opted for the road and fibbed about classes to Punch. He probably knew, but he also knew that Seger was starting to build a much larger following around the Midwest, the South, and the East. It was important to have someone he trusted, with enough experience, at the helm while on the road. College would have to take a backseat.

Do you think the road?"

By the spring of '71, I was finished with college and never looked back. I was either on the road or in the office working daily with Punch and Julie Sherr, our secretary and "gal Friday." I began to oversee other aspects of the "vast music empire" Punch and Bob were building. Gear Publishing Company needed someone to help with the mounting paperwork associated with a recording artist who wrote most of the songs he played live. The booking of the band was a new avenue that Punch wanted me to explore, so in '71 I started booking shows for Bob and made even more money. We were rolling along like gangbusters. Later, there was Palladium Records, our own label. The art department was my domain ever since I'd gotten on board, taking photos and designing the album covers, starting with the inside photo montage and the back of the Bob Seger System *Mongrel* album in 1970. We also had a great young artist working with us, Carol Bokonowicz—one of those gifted people who could actually draw.

The years I spent working with Bob are fabled among Seger fans—the years of hard gigging, heavy traveling, triumphs and frustrations, and a growing reputation that led to the breakthroughs of *Live Bullet* and *Night Moves* in 1976 (with the Silver Bullet Band), which established Bob as an American music icon. These were the days he sang about in "Turn the Page" (1973), a mix of innocent exuberance and hard-traveled frustration. Some days we felt on top of the world; other times we battled debilitating despair, wondering whether the talent we were nurturing would ever reap his due reward. It's easy to say, looking back from the success that finally arrived, that I don't think any of us would have traded these experiences. I know I wouldn't.

I stopped going on the road to every gig with Bob and the band in 1973 and stopped working full-time for the "empire" in 1974 to move on to other endeavors—including teaching, as

well as starting a family. I remained close to all concerned, however, and returned for special projects such as the *Live Bullet* and *Greatest Hits 2* (2003) albums and some personal engagements.

Travelin' Man is a book about my time with Bob, Punch, and all of those within that early Seger universe. This is not a formal biography; this is my story, told through my own personal lens—literally, since my camera was a constant companion during this journey. I am fortunate indeed to have such a great music writer—Gary Graff—to help tell my story. His experience and wisdom have been a blessing beyond measure.

In the following pages, I'll share, through photographs and words, the feel of that ramblin' gamblin' time, with all of its rich adventures and enormously engaging personalities. There's nothing like being there, of course, but hopefully this is the next best thing—an eyewitness account of the rise of someone who is truly one of American music's great artists. Good fortune put me together with this most excellent musician. I'm thrilled to have been a part of his endeavor and privileged to be able to share that experience.

All of the photographs in this book were taken with my Nikon cameras (Nikkorex, Nikkormat, F, and F2). All the lenses were Nikkor. I used Kodak Tri-X for all the black-and-white images. The color film was either Kodak CPS color print film or Kodak Ektachrome. The flash exposures were F/5.6 or F/8 at a 60th or 90th of a sec. The ambient light exposures were variable between F/5.6 and F/16 at a 125th or 250th sec., save one or two.

Heavy Music

GARY GRAFF

I was a Bob Seger fan before I moved to Detroit in 1982—just in time to write about *The Distance*, Seger's twelfth studio album and his follow-up to *Against the Wind*, which was his first to hit No. 1 on the *Billboard* 200 chart and also earned him his first Grammy Award. Expectations, and stakes, were high, and I was excited and also a little apprehensive to be covering such an anxiously anticipated release on Seger's home turf.

I settled into an upstairs office at Punch Enterprises, Seger's management company, so I could digest the new album and gather my thoughts before talking to Seger. Then, during the first chorus into the first track, "Even Now," there was a bounding of heavy footsteps on the staircase and into the room popped Seger—smiling, ebullient with a sharp "How ya doin'?!", sporting a short new haircut, and raring to go. I was able to keep my jaw from dropping, but my heart did beat a bit faster while the thought kept whirring in my head that "Oh God, I hope I like this album!" Fortunately I did, and that December encounter was an auspicious beginning for what's been an enjoyable, long-term relationship with someone whose music I made sure was pounding through my car speakers when I first crossed the Michigan state line on Interstate 75.

Travelin' Man was not conceived as a full-scale, tell-all Seger biography—but it will tell you a lot about the man and his music, particularly those infamous and legendary early days before he became a hit-singles factory and the gold and platinum began to flow. Tom Weschler had a ringside seat to that ascent. He rode on the bumpy road with Seger, often in vehicles in which they literally felt every bump, and witnessed both the triumphs and the setbacks as Seger struggled to find his artistic voice and an audience that wanted to hear it. Best of all, Tom carried his camera with him, chronicling what transpired with a probing eye but also with an empathy that came from being a participant in the story. The resulting images not only show what happened but convey the energy and emotion of the moment and a real *feeling* of being there, a rare achievement borne of both his talent and the circumstances in which he found himself.

The primary thing that strikes you in any encounter with Seger is how much he genuinely loves music and how much it flows through his very fabric of being—and apparently has for most of his life. "My dad made a big deal when I was, like, four years old about the fact that I sang 'I'm Looking over a Four-Leaf Clover' in the back of his '49 Buick," Seger recalls. "He just went nuts over that. I think that was maybe the very first inclination for me"—that music would be a substantial part of his life.

Seger, of course, went on to carve out a four-plus decade recording career during which he sold

more than fifty million albums and launched a chain of enduring rock hits such as "Ramblin' Gamblin' Man," "Night Moves," "Turn the Page," "Hollywood Nights," "Against the Wind," and "Like a Rock." And 1978's "Old Time Rock & Roll" is not only the No. 1 jukebox selection of all time but has virtually replaced Creedence Clearwater Revival's "Proud Mary" as the mandatory anthem for weddings, bar mitzvahs, and similar celebrations.

Moreover, Seger is largely responsible for creating a model for and voice of the midwestern, or heartland, singer-songwriter, a different breed of rock 'n' roll animal than its East and West Coast counterparts. Seger and those who followed, from John Mellencamp to Seger pal and fellow Detroiter Kid Rock, drew the same kind of inspiration from Hank Williams, Woody Guthrie, and Bob Dylan but applied their own regional aesthetic to it—a more narrative form built on earth parables about maintaining everyday ideals amidst all manners of adversity and temptation. These were not plaintive troubadours, however; Seger and company also showed you could deliver these contemplative paeans with the same kind of furious energy that you'd tap for songs about cars and girls.

In his work, Seger celebrates the nobility of the "Beautiful Loser" and the workers on the assembly lines "Makin' Thunderbirds," as well as the metaphorical struggle of running "Against the Wind." The subject of his "Hollywood Nights" grapples with a dual-edged sword as he lives life in too fast of a lane, while the exuberant freedoms of his "Ramblin' Gamblin' Man" and "Travelin'

Man" are not as unfettered as they initially seem but rather tempered by a desire for a more rooted kind of permanence. And the warm nostalgia of "Night Moves," "Mainstreet," and "Brave Strangers" reveals the wisdom of remembering, but not necessarily wallowing in, the past in a pursuit to ensure "The Fire Inside" still burns hot.

Seger is not the first of rock's songwriters to espouse these values—nor are they the exclusive property of the heartland. But he's filled the songs on his fifteen studio albums with a richly interwoven set of place and beliefs that surely speak to a life spent, excepting a couple years in Los Angeles, soaking up inspiration from the Detroit environs where he still lives.

"I don't think it was really a choice; it was where I lived and where I felt comfortable," Seger explains. "By being in Detroit, I can keep things in perspective and just work as much as I can but also have a life outside of it where I'm grounded and where people put me in my place. Everybody there treats me just like a guy and not a rock star, and that's good. It's a more calm and grounded atmosphere to work in."

Seger's earliest influences came from his parents. His father, Stewart, was an auto worker who played a variety of instruments—clarinet being his best—and on weekends performed with bands in the Ann Arbor area. Seger describes his mother, Charlotte, as the kind of music lover who "you name a song, and they'll tell you not only the singer but the writer and when it was

Seger is voice of

recorded. She was like a music encyclopedia."

Seger's father gave him his start around age nine, teaching him some chords on the bass ukulele, which led the fledgling musician to learn songs by Elvis Presley, Buddy Holly, and Little Richard that he heard on transistor radio late at night via stations such as WLAC-AM out of Nashville. Music remained important in the house even after Seger's father left the family when he was ten, plunging them into poverty. Seger was able to live what he calls "a totally

met future Eagle Glenn Frey (a member of the Detroit band the Mushrooms who sang backups on "Ramblin' Gamblin' Man"). He cut his teeth with Doug Brown & the Omens before starting his solo career, hooking up with teen club operator Ed "Punch" Andrews, who became his manager and coproducer.

Seger's regional acclaim—if everyone who says they saw him perform at their school really did, he could have retired by the time he was old enough to vote—helped sell more than fifty

largely responsible for creating a model for and the midwestern, or heartland, singer–songwriter.

free-spirited life" while his mother and older brother, George, worked, but his contribution to the family was musical even before it became his livelihood.

"I brought the music back into the family," Seger explains. "I always sat there and played ukulele and sang . . . and kind of quelled all the anger and disturbance because of the fact that my father left."

Few around him thought ill of Seger's musical dreams; in fact, he notes, "All my friends when I was growing up and going through junior high and high school, they would always envy me. They would say 'You know exactly what you want to do; you want to be a musician.' There was never any doubt."

Seger was a fixture on the Ann Arbor and Detroit club scenes by the early '60s, where he

thousand copies of his first single, "East Side Story." He kept his local hero status intact with "Persecution Smith" and the primal "Heavy Music," while 1968's "Ramblin' Gamblin' Man" earned Seger his first visit to the *Billboard* Top 20.

The fallow period that followed has become the stuff of legend. Seger toured hard and kept recording, but nothing seemed to click. He tried different band configurations, even going solo for a time, and changed labels; he even contemplated quitting music and going to college after recording his 1969 album, *Noah*. The Michigan fan base was always there; the rest of the world, however, was oblivious.

But Seger never doubted himself. "In that seven-year period . . . even though we were playing, like 250 nights a year, I could tell I had something because the audiences wanted

me back . . . and we killed every night," Seger says. "So I knew I had something." In hindsight, however, Seger is willing to guess that the music just wasn't good enough.

"I played too many nights," he says, "and I really didn't have enough time to write."

That changed in the mid-'70s, when he formed his Silver Bullet Band and polished his craft for albums such as *Seven* and especially *Beautiful Loser*, a more carefully crafted and diverse set of material that provided a clear bridge to the greater fortunes that followed. "Glenn Frey . . . heard the *Beautiful Loser* stuff and said 'This is great, Bob. You're on your way. You've got it now; you're a songwriter,'" Seger remembers.

The songwriter quickly became a superstar. The definitive 1976 concert document, *Live Bullet*, became his first platinum album. *Night Moves*—with its Top 5 title track about a teenage love affair ("My first broken heart!" he says)—took Seger into the multiplatinum realm in 1976, where he stayed for his next four albums. For 1980's *Against the Wind*, he acknowledges, "We wanted to really have a No. 1 album; that's what we went for." And he got it, spending six weeks atop the *Billboard* chart.

Seger has been on a different path since his thirteenth album, *The Distance*, however. The album releases have been more sporadic, as have the tours. In private, however, he's still prolific, though while some of his writing has taken on more detailed, cinematic qualities, Seger will tell you his greatest satisfactions have come apart from music—in his marriage since 1993 to third wife Nita and in being a father to son Cole and daughter Samantha. Not surprisingly, the man who was abandoned by his own father is driven to give his children "what I didn't feel when I was a kid, which is a great sense of affection and stability. It's just nice to focus on trying to do a good job." He also took some time to become a championship sailor on the Great Lakes.

But the creative fire still burns inside. "I think I'm writing a little simpler, a little more direct, and a little more out front," he says. "I think I'm just coming into my own kind of groove. You just want to get up there and sing, y'know?"

"You think about how old I thought I was when I was writing 'Rock and Roll Never Forgets'—'Sweet 16 turned 31!'" he adds with a hearty laugh. "But back then, the career arc for most people in entertainment was three good years, five tops, and you were gone. I mean, who'd ever thought we'd be seeing McCartney at sixty on stage? Jagger? Nobody. And here I am—still. It's just . . . interesting. But really gratifying."

Time Line

May 6, 1945: Robert Clark Seger is born at Henry Ford Hospital in Detroit.

1961: After borrowing a guitar from a friend, Seger, then a high school sophomore in Ann Arbor, Michigan, forms his first band, the Decibels.

1963: Seger spends three weeks on the Ford assembly line, filling conveyors for automatic transmissions, working nine hours a day, six days a week, for $4.20 an hour.

1964: Seger joins the band the Town Cryers.

September 1965: Seger releases "T.G.I.F." with Doug Brown & the Omens for Punch Records.

January 1966: Seger leaves the Omens and forms the Last Heard. His first single, "East Side Story," originally written for the Detroit group the Underdogs, is released on the Hideout label, credited to Bob Seger only. A subsequent release on Cameo-Parkway credits the song to Bob Seger & the Last Heard.

July 1967: Seger's "Heavy Music," an ode to high-energy rock 'n' roll, tops the Detroit charts.

Autumn 1967: Seger signs with Capitol Records.

January 1968: Seger's debut single for Capitol, the antiwar protest song "2 + 2 = ?" is released.

December 21, 1968: The "Ramblin' Gamblin' Man" single, released in September, debuts on the *Billboard* Hot 100 chart. It peaks at No. 17, and he won't have another Top 40 hit for eight years.

February 8, 1969: Seger's debut album—*Ramblin' Gamblin' Man*, with the Bob Seger System—is released. Peaks at No. 62 on the *Billboard* Top 200.

August 17, 1969: The Bob Seger System performs at the opening of Hudson's Oakland Mall location in Troy, Michigan.

September 1969: *Noah* is released.

August 9, 1970: The Bob Seger System performs at the Goose Lake International Music Festival in Leoni Township, Michigan.

August 1970: *Mongrel* is released. Peaks at No. 171.

October 1971: *Brand New Morning* is released.

December 10, 1971: Seger performs at the John Sinclair Freedom Rally at the University of Michigan's Crisler Arena in Ann Arbor. Part of his performance appears in the documentary *10 for 2*.

January 21, 1972: Seger's STK performs at the Autorama show at Cobo Hall in Detroit.

August 1972: *Smokin' O.P.'s* is released. Peaks at No. 180.

January 1973: *Back in '72* is released. Peaks at No. 188.

February 17, 1973: Seger and his Borneo Band's show at Masonic Temple Auditorium in Detroit—opening for Dan Hicks & His Hot Licks, though Seger and company went on last—is filmed for ABC's *In Concert* series, but never broadcast.

March 1974: *Seven* is released.

April 12, 1975: *Beautiful Loser* is released. Peaks at No. 131. Certified double platinum.

September 4–5, 1975: Seger and the Silver Bullet Band's two-night stand at Cobo Arena is recorded for the *Live Bullet* album, which is released in April 1976 and becomes his first gold record.

September 12, 1975: Thin Lizzy releases a cover of Seger's "Rosalie" on its album *Fighting*.

April 12, 1976: *Live Bullet* is released. Peaks at No. 34. Certified five-times platinum.

June 26, 1976: Seger and the Silver Bullet Band perform before a sold-out crowd of 76,000 at the Pontiac Metropolitan Stadium (aka the Silverdome) in Pontiac, Michigan.

October 22, 1976: *Night Moves* is released. Peaks at No. 8. Certified six-times platinum.

April 1978: "Night Moves" appears on the film soundtrack for *FM*.

May 15, 1978: *Stranger in Town* is released. Peaks at No. 4. Certified six-times platinum.

September 18, 1979: The Eagles' "Heartache Tonight," cowritten by Seger, is released and hits No. 1 on the *Billboard* Hot 100. It also wins a Grammy Award for Best Rock Performance by a Duo or Group with Vocal.

February 27, 1980: *Against the Wind* is released. Peaks at No. 1. Certified five-times platinum.

June 6, 1980: "Nine Tonight" appears on the *Urban Cowboy* soundtrack.

June 1980: Concerts at Cobo Arena are recorded for the live album *Nine Tonight*.

October 3, 1980: Seger joins Bruce Springsteen on stage at Crisler Arena in Ann Arbor for an encore version of "Thunder Road."

October 1980: Concerts at the Boston Garden are recorded for the live album *Nine Tonight*.

February 25, 1981: *Against the Wind* earns Seger's first Grammy Award, for Best Rock Performance by a Duo or Group with Vocal.

September 4, 1981: *Nine Tonight* is released. Peaks at No. 3. Certified five-times platinum.

December 13, 1982: *The Distance* is released. Peaks at No. 5. Certified platinum.

February 25, 1983: Seger and the Silver Bullet Band receive an award from Convenient Ticket Co. (CTC) commemorating the fastest single-day ticket sale (60,000) in the company's history, during a press conference at the Northfield Hilton in Troy.

August 13, 1983: Seger sings backing vocals on the songs "Christmas in Cape Town" and "Take Me Back" for Randy Newman's *Trouble in Paradise* album.

August 5, 1983: The film *Risky Business* revives Seger's single "Old Time Rock & Roll" thanks to Tom Cruise's underwear-clad, air guitar–playing dance. The song hits the *Billboard* Hot 100 for a second time, at No. 58.

October 5, 1984: Seger releases "Understanding" for the film soundtrack to *Teachers*. The single peaks at No. 17 on the *Billboard* Hot 100 and features the nonalbum B-side "East L.A."

March 8, 1985: The film *Mask*, featuring several Seger songs, is released.

July 1985: Waylon Jennings covers Seger's "Turn the Page" as the title track of his thirty-fourth studio album.

March 28, 1986: *Like a Rock* is released. Peaks at No. 3. Certified platinum.

July 2, 1986: "Livin' Inside My Heart," the B-side to "Like a Rock," is featured in the film soundtrack for *About Last Night*.

August 1, 1987: "Shakedown," which Seger recorded for the film *Beverly Hills Cop II*, tops the *Billboard* Hot 100, his first and only No. 1 single.

October 12, 1987: Seger contributes a version of "The Little Drummer Boy" to *A Very Special Christmas* benefit album for Special Olympics.

May 19, 1989: Seger covers Fats Domino's "Blue Monday" for the film soundtrack to *Road House*.

December 14, 1989: Seger receives an honorary Doctorate of Humane Letters from Wayne State University at its winter commencement ceremony at Cobo Arena.

February 8, 1990: Seger joins Billy Joel on stage for "Old Time Rock & Roll" at the Palace of Auburn Hills, Michigan.

April 16, 1990: Seger joins Don Henley on stage for "Old Time Rock & Roll" at the Palace of Auburn Hills.

March 1991: Seger goes to Katmandu—literally—as part of a Special Olympics trip to Nepal to visit with Min Sejuwal, a fourteen-year-old athlete competing in that year's games. Seger also accompanied Sejuwal to the opening ceremonies during August in Minneapolis–St. Paul.

August 27, 1991: *The Fire Inside* is released. Peaks at No. 7. Certified platinum.

1992: Seger is presented with the Legend of the Jukebox Award from the Amusement and Music Operators Association for "Old Time Rock & Roll," judged the most played song ever by a male artist.

July 10, 1993: Seger marries his third wife, Juanita Dorricott, at the Village Club in Bloomfield Hills, Michigan. They have two children: son Cole, born in 1992, and daughter Samantha, born in 1995.

July 6, 1994: "Against the Wind" is featured on the film soundtrack to *Forrest Gump.*

October 1994: Seger is immortalized in cement on the Rockwalk on Hollywood's Sunset Boulevard.

October 25, 1994: Seger's first *Greatest Hits* album is released. Peaks at No. 8. Certified nine-times platinum.

April 1995: Seger receives a Distinguished Achievement Award at the Fourth Annual Motor City Music Awards at the State Theatre in Detroit.

October 24, 1995: *It's a Mystery* is released. Peaks at No. 27. Certified gold.

April 7, 1998: Seger duets with Martina McBride on "Chances Are" for the film soundtrack to *Hope Floats.*

June 23, 1998: "Roll Me Away" is featured on the film soundtrack to *Armageddon.*

November 14, 1998: Metallica releases its cover of Seger's "Turn the Page" on its *Garage Inc.* album. The song hits No. 1 on *Billboard*'s Mainstream Rock Tracks chart.

March 7, 2001: The Recording Industry Association of America, the National Endowment for the Arts, and Scholastic Inc. together select "Old Time Rock & Roll" as one of its Songs of the Century, ranking it 278 on the list of 365.

July 24, 2001: Seger and the crew of his sailboat *Lightning* win the 77th Annual Bacardi Bayview Mackinac Race from Port Huron to Mackinac Island, Michigan.

July 16, 2002: Seger and the *Lightning* crew defend their championship at the 78th Annual Bacardi Bayview Mackinac Race.

November 4, 2003: *Greatest Hits 2* is released. Peaks at No. 23. Certified gold.

March 15, 2004: Seger is inducted into the Rock and Roll Hall of Fame at the Waldorf-Astoria Hotel in New York City. Kid Rock makes the induction speech, and Seger and the Silver Bullet Band perform "Turn the Page" and "Old Time Rock & Roll."

February 8, 2005: Seger is featured on the song "Landing in London" on 3 Doors Down's *Seventeen Days* album. He performs the song with the band on August 2 at the DTE Energy Music Theatre near Clarkston, Michigan.

February 3–4, 2006: Seger joins Kid Rock & the Twisted Brown Trucker Band on stage at Joe Louis Arena for Super Bowl XL weekend performances of "Rock and Roll Never Forgets."

September 12, 2006: *Face the Promise* is released. Peaks at No. 4. Certified platinum.

April 29, 2008: Seger's 1980 track "Her Strut" is featured in the video game *Grand Theft Auto IV.*

October 26, 2008: "Hollywood Nights" is featured in the video game *Guitar Hero: World Tour.* "Old Time Rock & Roll," "Her Strut," and "Get Out of Denver" are subsequently made available in the download pack released February 26, 2009.

March 29, 2009: "Turn the Page" is a featured track on the *Guitar Hero: Metallica* video game.

Cast of Characters

Behind the Scenes

Edward F. "Punch" Andrews, Jr.: Bob Seger's longtime manager and producer.

Joe Aramini: Seger roadie during the late '60s and early '70s.

Bill Blackwell: Seger's road manager since 1977.

Ken Calvert: Columbia Records promotion man and Detroit radio DJ who introduced Seger and Springsteen in 1978.

Brian Chubb: Seger road manager during the mid-'70s.

Gary "Ace" Gawinek: Seger roadie and promotion man, 1971–74.

Tom Gilardi: Capitol Records promotion man who broke the Beatles on Detroit radio before handling Seger's records.

Richard "Krinkle" Kruezkamp: Seger road manager in 1969, who still works as an active stagehand.

Craig Lambert: Capitol Records promotion man during the '70s.

Walter Lee: Former president of Capitol Records.

Dave Leone: Good friend of Punch Andrews and partner in the Hideout teen clubs.

David "Dancer" McCullough: Seger sound tech and roadie during the late '60s and the '70s.

Denise Moncel (now Denise George): Capitol Records staffer during the '70s who went on to her own career in record promotion.

Michael Novak: Detroit attorney who handles many of Seger's business affairs.

Mike Parshall: Seger's first roadie during the '60s.

Gordy Paul: Seger lighting tech during the '70s and '80s.

John Rapp: Roadie and special assistant to Seger since 1972.

Bob "Sugar" Schwartz: Independent Detroit record promoter who helped get Seger's records played during the late '60s and early '70s.

George Seger: Bob Seger's older brother.

Julie Sherr: Longtime office manager and all-around "gal Friday" in Punch Andrews's office.

Rosalie Trombley: Powerful music director at CKLW-AM in Windsor, Canada.

Russell "Buzz" Van Houten III: Partner in the Palladium Records label.

Don Zimmerman: Former president of Capitol Records.

On Stage

The Decibels, 1961–63
Bob Seger: vocals, guitar
R. B. Hunter: drums
Pete Stanger: guitar

The Town Cryers, 1964–65
Bob Seger: vocals, guitar
John Flis: bass
Larry Mason: guitar
Phillip "Pep" Perrine: drums

Bob Seger & the Last Heard, 1965–68
Bob Seger: vocals, guitar
Dan Honaker: bass, vocals
Carl Lagassa: guitar
Phillip "Pep" Perrine: drums

The Bob Seger System, 1968–70
Bob Seger: vocals, guitar
Dan Honaker: bass, vocals
Tom Neme: guitar, vocals (1969–70)
Phillip "Pep" Perrine: drums
Bob Schultz: keyboards (1968–70)
Dan Watson: keyboards (1970)

STK, 1971–72
Bob Seger: vocals, guitar
Mike "Monk" Bruce: guitar
Crystal Jenkins: backing vocals
Skip Knape (aka Skip Van Winkle): keyboards, vocals
David Teegarden: drums
Pam Todd: backing vocals

Julia/My Band/The Borneo Band, 1972–73
Bob Seger: vocals, guitar, piano
Tom Cartmell: saxophones
Calvin Hughes: guitar
Mike Klein: bass
Marcy Levy: backing vocals
Randy Meyers: drums (1972)
Bill Mueller: guitar, vocals
Jamie Oldaker: drums (1972–73)
Sergio Pastora: percussion
Stoney Reese (aka Shaun Murphy): backing vocals
Dick Simms: keyboards

The Silver Bullet Band, 1973–present
Bob Seger: vocals, guitar, piano
Drew Abbott: guitar (1973–82)
Kenny Aronoff: drums (1996)
Dawayne Bailey: guitar (1983)
Colleen Beaton: backing vocals (1980)
Don Brewer: drums (1983–87, 2006–7)
Jim "Moose" Brown: guitar, keyboards (2006–7)
Chris "C-Note" Campbell: bass (1973–present)
Tim Cashion: keyboards (1996)
Mark Chatfield: guitar (1983, 1996–present)
Laura Creamer: backing vocals (1977–present)
Craig Frost: keyboards (1980–present)
Mary Kay Lalla: backing vocals (1983)
Kathy Lamb: backing vocals (1980)
Rick Manasa: organ, piano (1973–75)
Charlie Allen Martin: drums (1973–77)
Tim Mitchell: guitar (1996)
Pam Moore: backing vocals (1980)
Motor City Horns: Mark Byerly and Bob Jensen,
 trumpets; Brad Fowler, Keith Kaminski, saxophone;
 John Rutherford, trombone (2006–7)
Shaun Murphy: backing vocals (1973–present)
Karen Newman: backing vocals (1996)
Bill Payne: keyboards (1986–96)
Barb Payton: backing vocals (2006–7)
Alto Reed: saxophone (1973–present)
Arnold "Robyn" Robbins: keyboards (1975–79)
Fred Tackett: guitar, trumpet (1986–87)
Crystal Taliefero: percussion, guitar, saxophone,
 backing vocals (1986–87)
David Teegarden: drums (1977–82)
June Tilton: backing vocals (1980)
Rick Vito: guitar (1986–87)
Kurt Wolak: road tech, keyboards (2006–7)

Travelin' Man

ON THE ROAD and BEHIND THE SCENES with

Bob Seger

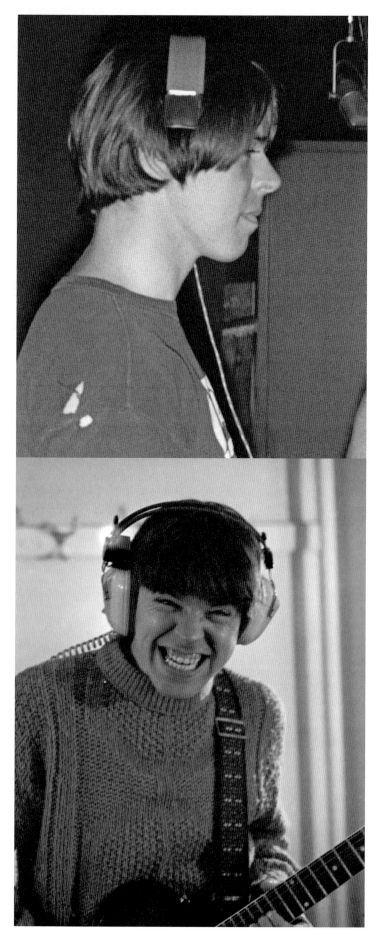

We recorded the album *Noah* at GM Studios (East Detroit) in the spring of 1969. Bob was very adroit at recording; he wanted to make sure everything sounded exactly the way he wanted it to sound, even to the point of tuning the drums himself if they weren't the way he wanted them to sound. He was particular about recording his voice straight up, without effects on it, and then playing with it later if he wanted to tweak it, which most of the time he didn't. He made absolutely certain it sounded the way he wanted it to sound—a perfectionist, to be sure.

We played in Madison, Wisconsin, in the summer of 1969 for some sort of sociology class or something. It was the weirdest gig we'd had—$4,500 to play forty-five minutes a day during school for four days. Kids would come see us, write things down, and analyze what they saw. Very strange.

We did some shows in Iowa in 1969 with Alice Cooper as our opener. We had three more dates with them, and I called Punch and asked, "Can we please not be the headliner?" Punch is going "Fuck you!"— which was a typical response from the boss. I explained to him that it was taking forty-five minutes to clean all the chicken feathers off the stage and our equipment—thanks to Alice Cooper's last tune, which called for a real pillow bustin', feather flyin' show-stoppin' mess. Pep Perrine would be hitting his drums and feathers would be flying all over the place. But my call didn't work; Punch yelled, "We're the headliner!" so we had to put up with chicken feathers for a few more dates.

▲ GM Studios (East Detroit), spring 1969.
◄ Winter 1969.

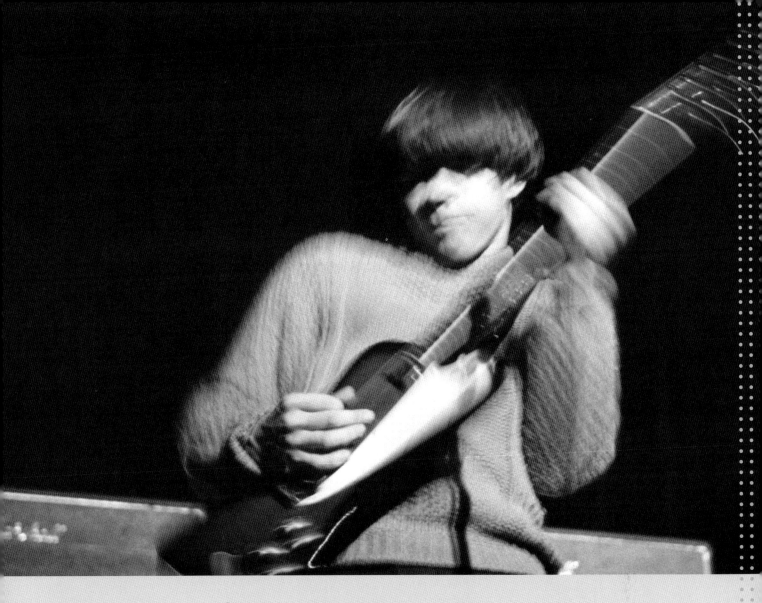

▲ Winter 1969.

I sold Bob a guitar once, a beautiful "backwards" Gibson Firebird, just all gorgeous dark wood. I paid $300 for it. He said, "I'll give you $375, cash," so I sold it to him and bought myself a Fender Telecaster. A week later, when I went over to his house, I saw the Firebird on a guitar stand, and he had painted it red, white, and blue with stars on it like Wayne Kramer's guitar in the MC5. I was shocked: how the hell could anybody fuck up a great-looking Gibson like that! But I got over it. After all, he bought it fair and square, and it stood out a lot more. Bob was a showman, and the paint didn't hurt the sound.

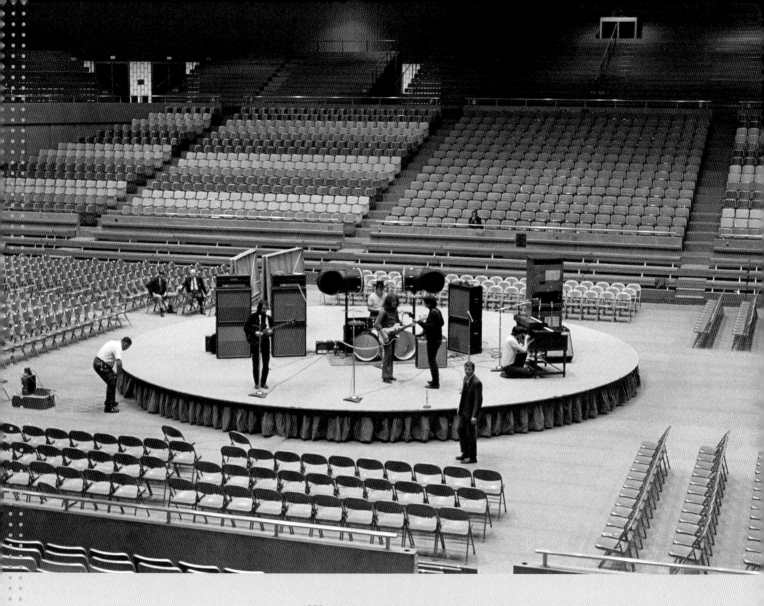

▲ Southern Illinois University (Carbondale), spring 1969.

We were booked to play in Carbondale, Illinois. They had a round stage that revolved while the band played. But the setup, with a hole in the middle for the electrical plugs, meant that everything would come unplugged as the stage rotated. We pointed that out to the union electricians, and they figured out how to drop a cord from the ceiling and set it up so the plugs would rotate with the stage. The setup was very odd.

When Seger was recording *Noah*, his band, the Last Heard, became the Bob Seger System, with Tom Neme replacing Carl Lagasa on guitar. So Seger was in this transition; they were going out and playing a lot of covers, Beatles and stuff like that. Then Schultz left, and we got Dan Watson, an interesting character from Kalamazoo who could play really, really well—and drank three quarts of milk a day! It was a weird mix; usually with rock bands you had to make sure there was vodka and lots of beer, but Danny had to have his milk.

We would talk politics. Bob was politically oriented and very sharp, really into foreign affairs. Craig Lambert, one of our Capitol Records promo guys, used to say, "I wish he wouldn't talk about this shit. I don't know what he's talking about. I don't care where oil's coming from. I'm just trying to get the records played. That's what I do." But Bob was very attuned to politics, and he was interested in criminology. He mentioned to me once that, prior to his musical endeavor, he considered becoming a criminologist.

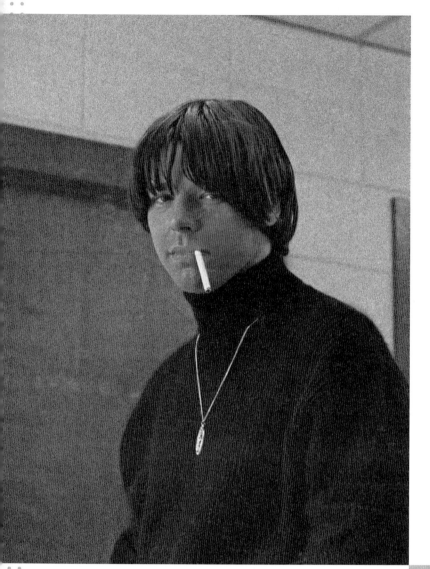

We were playing in Indiana, and before we left for home Punch Andrews called the hotel to say, "You can't come home yet. You've got to go do this TV show," *Scene 70* in Indianapolis. Bob didn't want to do it; he never liked to do stuff like that. I had to talk him into it. I said, "Listen, man, you think 5,000 or 10,000 people at a gig is a lot, but if you do a TV show you're gonna get 100,000 people seeing you." Now, Seger's smart; he figured I was stroking him. But Punch would've shot me if Bob didn't play on that TV show, so I had to tell him it was very important to do this. Then I added, "Besides, there's a really hot girl at the front desk of this place." I was lying. I had no idea if there was or not. But when we arrived there—thank you, Lord—a real pretty girl was sitting there at the front desk, typing, answering the phone, and unwittingly boosting my credibility!

Bob Schultz was about to leave the band at the time we did that show. If you look at the photo, they set the stage up like a back alley with a fence and stickers; on Schultz's organ is a sticker that says "Dead End." How appropriate.

▲ ▶ *Scene 70* (Indianapolis), fall 1969.

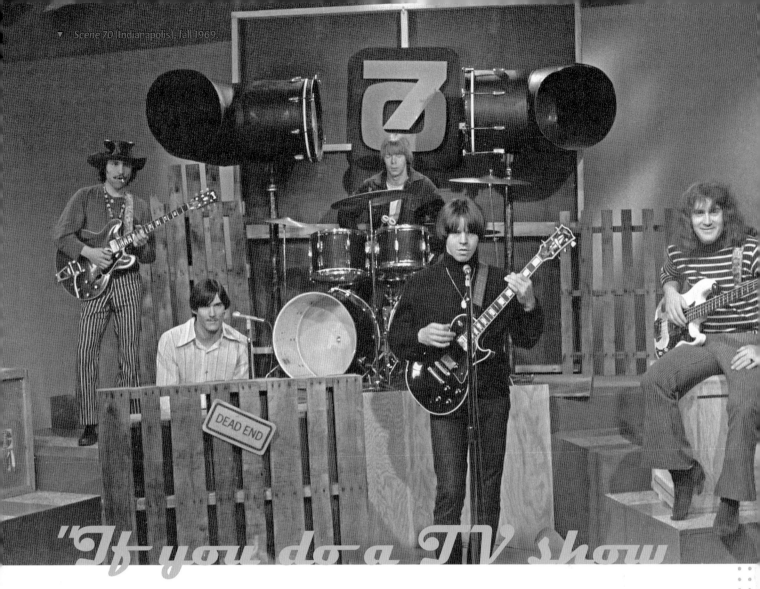

DEAD END

"If you do a TV show you're gonna get 100,000 people seeing you."

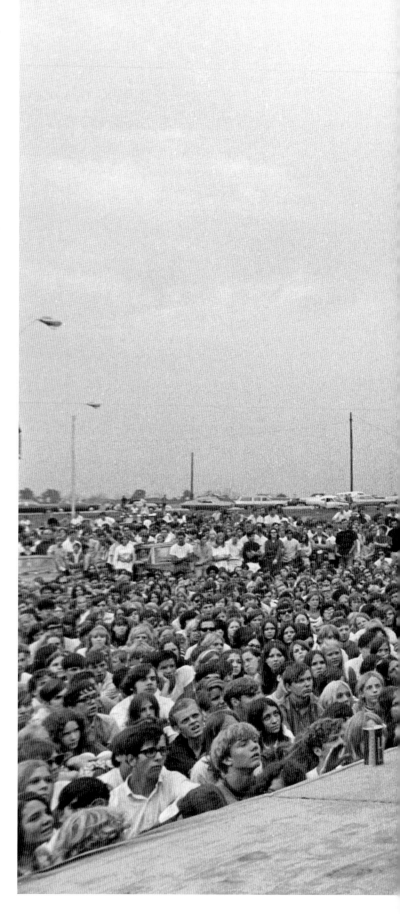

The Oakland Mall was already open, but they were throwing a big party to celebrate the second phase and the opening of Hudson's department store on August 17, 1969. That was a gig I really lobbied hard for. Punch wasn't really into it; he thought it was just a commercial thing for Hudson's. He was like, "Who the fuck's gonna come to that?" But Hudson's really advertised it, and we drew 20,000 people to the parking lot. The Troy police were not ready for that. They'd never seen anything like it before. There were other bands on the show— Savage Grace, The Third Power, The Sky all played—but Seger was the main attraction. Punch was really surprised when I called him from a pay phone and told him there were between 15,000 and 20,000 people there, he was, like, "Wow! That's great, Weschler!"

Some interesting stuff went on backstage with the girls. A lot of women were following Seger around by this time, and we were at home, so we had all the girlfriends there, plus some girls we had met in Ohio, Pennsylvania, and other places came up for this gig. I was trying to play the diplomat that day, pressed into service to quell the angst. It was very tricky.

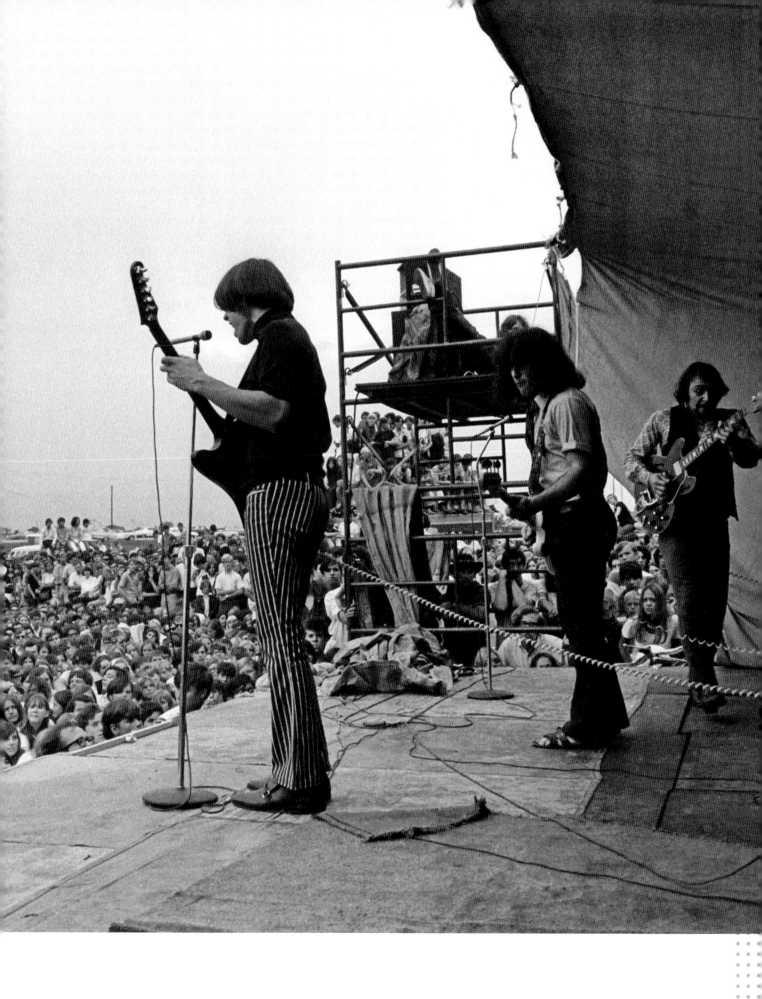

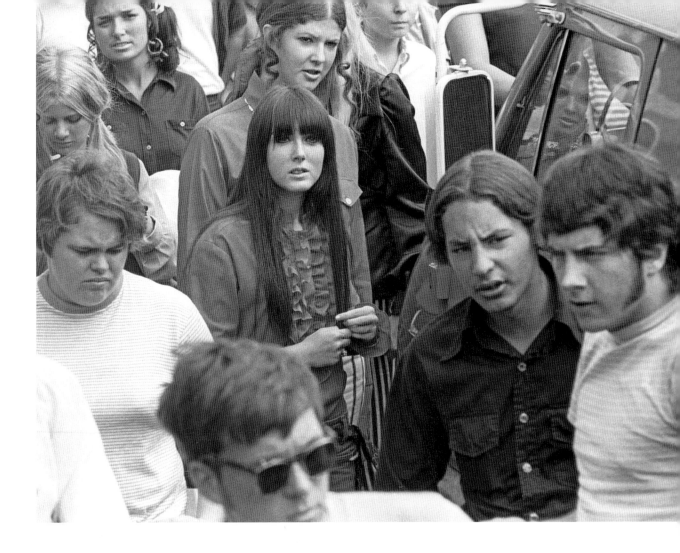

TRAVELIN' MAN

◄ ▼ Oakland Mall (Troy), August 17, 1969.

TRAVELIN' MAN

◄ Oakland Mall (Troy), August 17, 1969.

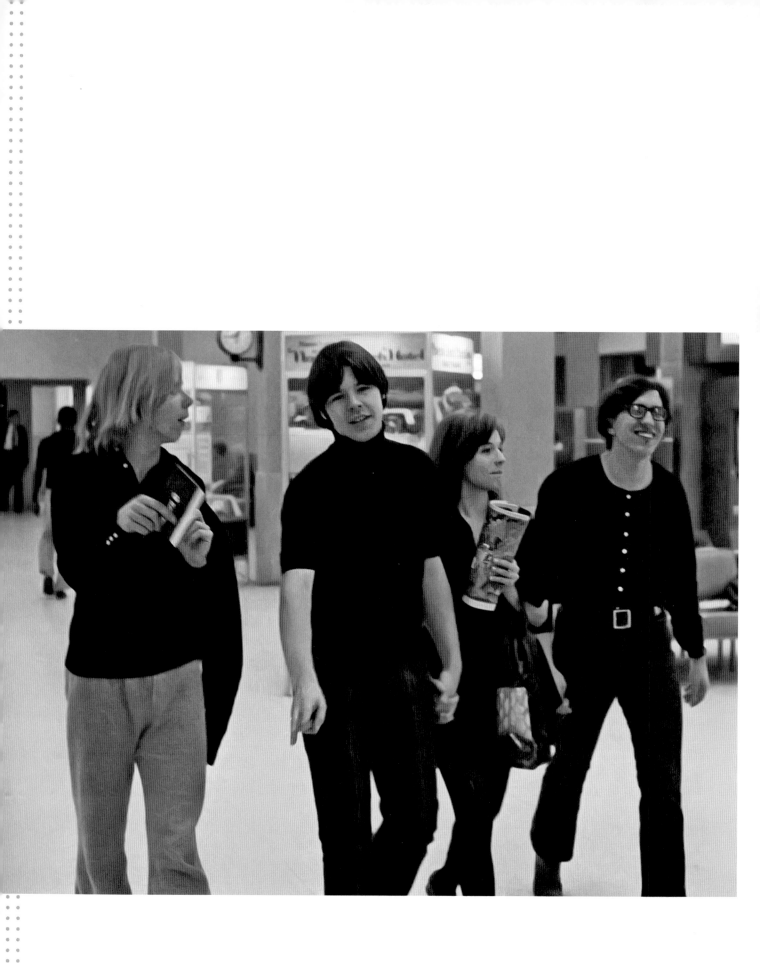

▲ With Rene Andretti, Eastern Airlines
 airborne, fall 1969.

◄ Miami Airport, fall 1969: Pep Perrine,
 Bob, Rene Andretti, and Gary Gawinek.

The Milwaukee Pop Festival was the same summer as Woodstock (1969). We were playing there with the Beach Boys, Gary Lewis & the Playboys, and Tommy James & the Shondells. I was in the dressing room, tuning up the guitars and playing a little for myself, when Gary Lewis walked in and said, "That's pretty good. You want to be in my band?" I just replied, "I like to be behind the scenes, man." Then Seger came in and said, "Wow! You sound pretty good, man. Want to be in my band?" I figured he heard Gary and was kidding around.

On the plane ride home, Tommy James and his group boarded before we did. I went up to their tour manager and asked, "Are you going to Detroit, too?" "No, we're going to Pittsburgh." I said, "Well, this plane is going to Detroit." He said, "Oh, no! Shit! We must be on the wrong plane. . . ." I figured it must have been too much "Crystal Blue Persuasion."

Punch had a friend, Joe Salaka, who owned a place down in San Juan, and he wanted us to play there. They paid us front money to go, bought us plane tickets, set up an apartment building for us to stay in, a really nice place. They treated us like royalty. When we got to the gig, there was cyclone fencing in front of the stage. "What's this for?" I asked our guide, Sirius Trixon. "If they like you, they'll throw beer bottles, and you don't want to get hit." "What if they don't like us?" "You don't want to know." They liked us.

Crosley Field (Cincinnati), June 27, 1970. ▶

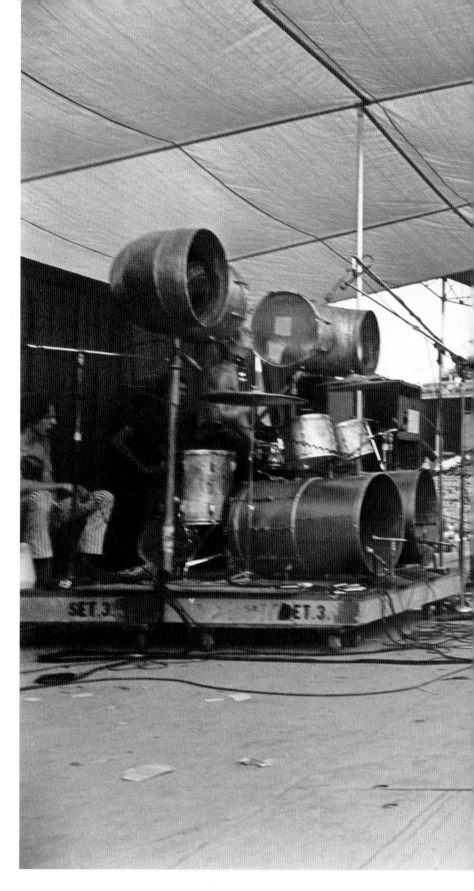

We were playing a gig in Cincinnati in 1970. A bunch of us piled into my car, a '65 Ford Galaxy, for the ride to the airport. When we got there, Bob, who lived in Ann Arbor, was not there, so we called him . . . no answer. Punch looked at us and said, "Alright, you guys fly down there I'll go wake him up. Gimme your keys, Weschler." I looked at him in horror because he was notorious for not being someone you'd want driving your car—especially when he was pissed, which he was. But I gave him my car keys and flew to Cincinnati with the band, while Punch went straight to Seger's house in Ann Arbor, pounded on the door, woke him up, got on the next flight to Cincinnati with him, and arrived at Crosley Field just in time. The gig went off fine, and I flew back that night with Punch. As we walked out of the terminal I asked him, "So where's my car?" He said, "I don't know. Over there somewhere," gesturing toward the parking structure. "What do you mean over there? There's forty acres of cars!" He had a girlfriend come to pick him up and told me, "Just look for it." I finally found my car—and there was no gas in it, the oil light was on, and it was three in the morning. I figured Punch wouldn't mind if I came in late the next day. He didn't—and he gave me an extra C-note to boot.

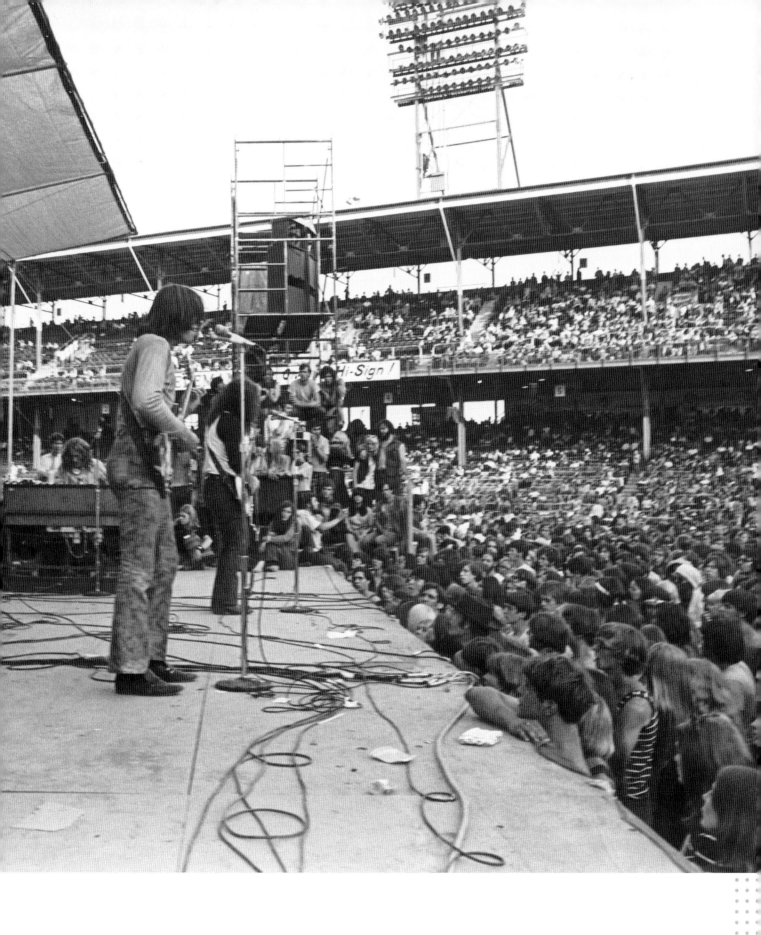

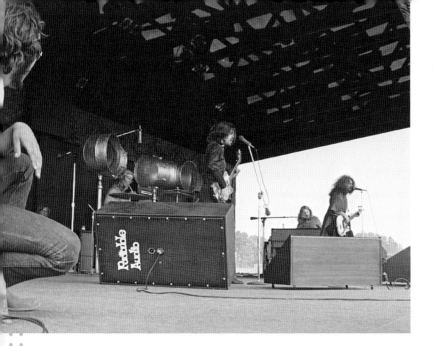

◄ Goose Lake Pop Festival (Goose Lake Park, Jackson, Michigan), August 9, 1970.

Back in 1970, we would play at clubs, halls, and all sorts of places and use the house PA, until we finally had to buy a PA system of our own because nobody could really hear Bob as well as they should have. I kept really bothering Punch and Bob about it. We found an electronics wizard guy in Ann Arbor named Stanley Andrews—one of those wire freaks who knew everything about transistors and amps and speakers. His memorable quote to me was "Someday there's gonna be a tape recorder without any moving parts. That's gonna happen"—turns out he was right. He built us a great, relatively inexpensive PA with Crown DC-300 amps that was easy to move around and loud as hell, with minimal feedback.

I talked Punch into buying a truck. I said, "Look, for $130 a month, we can make a payment on a truck we're renting for $150 a week." He replied, "But then you've got to insure it," and I said, "Yeah, that's another $150 a month, so it's like getting two weeks free." It made sense to him, so we bought a Ford truck with a large cargo box in the back. We had Carol Bokonowicz (our favorite artist) paint the *Ramblin' Gamblin' Man* album cover on the sides, but then the truck was robbed so we took the artwork off and never marked it like that again.

I liked to drive—I didn't trust the other guys driving, to be honest. The band had a Ford station wagon. Prior to that, the band members were on their own getting to gigs, which meant they occasionally were not on time. But Punch finally bought our own blue Ford station wagon, which was a nice car and big enough to carry everybody, as well as some road gear. Bob, Dan Honaker, Pep Perrine, Dan Watson, and I were usually in the car, along with some baggage. The five of us were together often. The roadies traveled in the U-Haul or, later, our own truck.

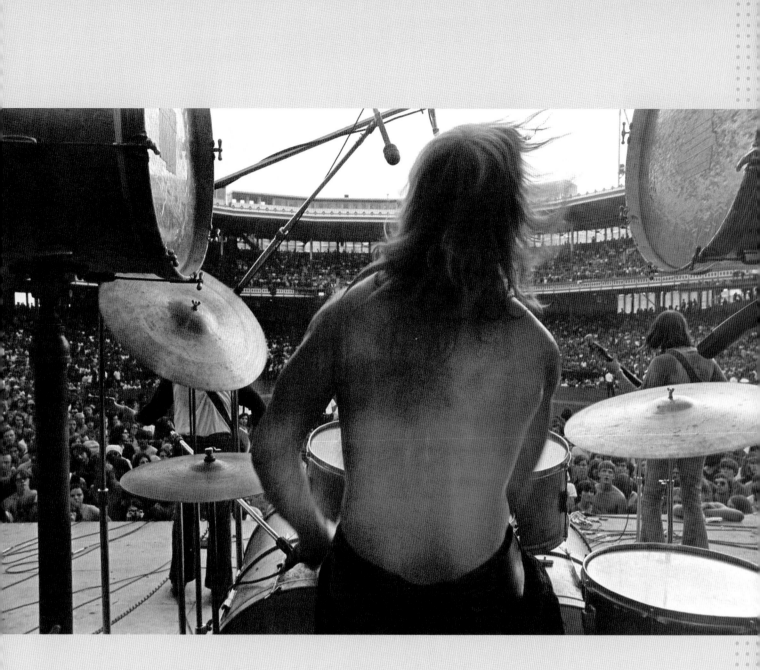

▲ Pep Perrine, Crosley Field (Cincinnati),
June 27, 1970.

Pep Perrine's drum kit, with the four bass
drums, is legendary. Back then, Ginger Baker
was out with Blind Faith, and there were a
bunch of bands with drummers who had a
double bass drum setup. But Pep decided he
should have four bass drums so he'd be like
nobody else. It was a real project to set up.
He built a 4-by-8-foot double-thick plywood
base. He had four-inch pipes screwed inside
four-inch bases so they wouldn't collapse, and
I had to screw those things in and out every
night and then lift the bass drums onto this big
flange setup and tighten them. I asked Pep,
"You aren't going to have six, are you?" "No."
But everyone liked it and it looked good, and
when he started "Ramblin' Gamblin' Man" the
whole crowd went nuts.

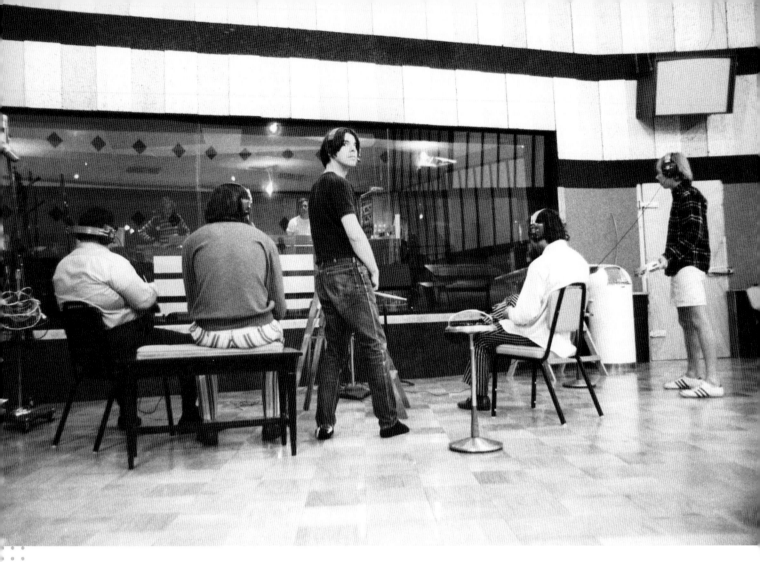

We were just fooling around inside the studio, Pampa Studios over on Van Dyke Avenue near Fourteen Mile Road. Jim Bruzzese, the engineer, told everybody to get out unless they were playing. I was just kind of hanging in the back, and when I took this picture Bob turned around and was like, "What are you doing in here? Get the hell outta here! I don't want any clicking noises on the tape." I left right quick.

Mongrel was recorded at GM Studios—the GM stands for its owner, Guido Morosco. It was next to a bump shop on Nine Mile Road in East Detroit. Sometimes when the bump shop workers were knocking off some hubcaps or something, we'd have to stop because the noise was too loud and leaking into the studio. A similar thing happened at Pampa Lanes (a recording studio in the basement of a bowling alley) before it became Pampa Recording, where Bob recorded much earlier; Punch told me when they were recording "Ramblin' Gamblin' Man" they had to actually stop because of the noise from the bowling alley upstairs.

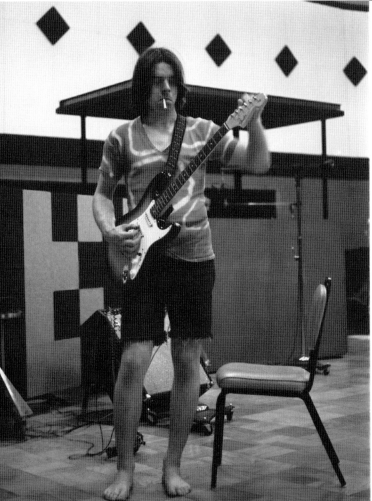

◄ ▼ ► *Mongrel* sessions, Pampa Studios, spring 1970.

What counted most was that Bob dug what was going on. If he was happy, everybody was happy. If Seger wasn't happy, nobody was happy. He was the boss. Even though Punch was the producer and Bob's manager, Seger was the boss, without a doubt.

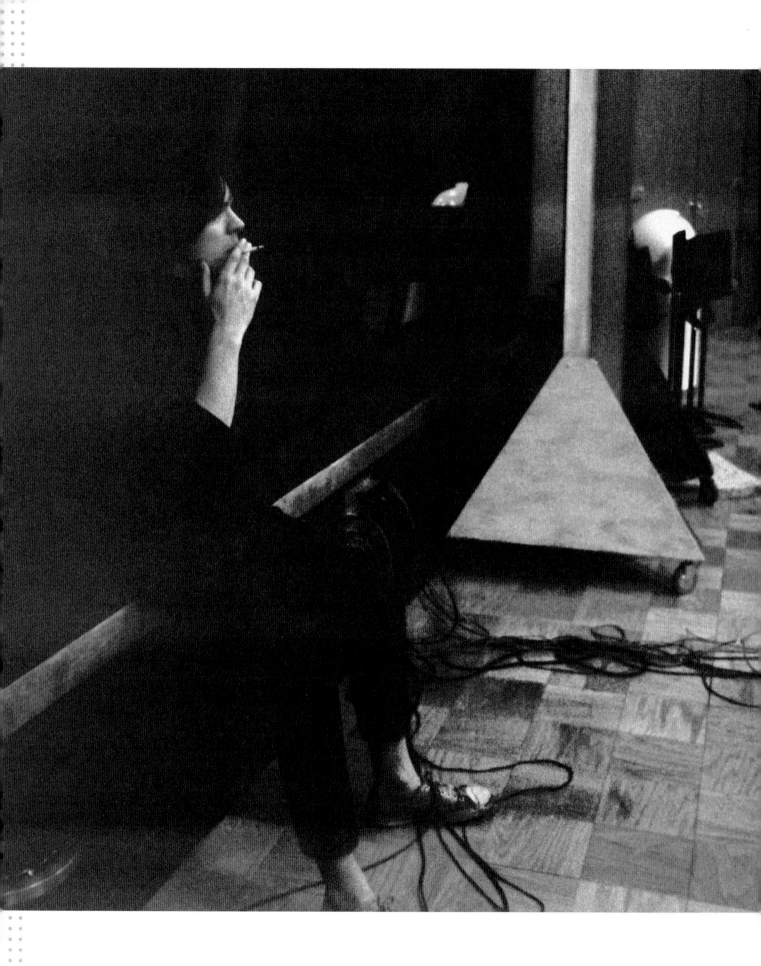

◄ *Mongrel* sessions, Pampa Studios, spring 1970.

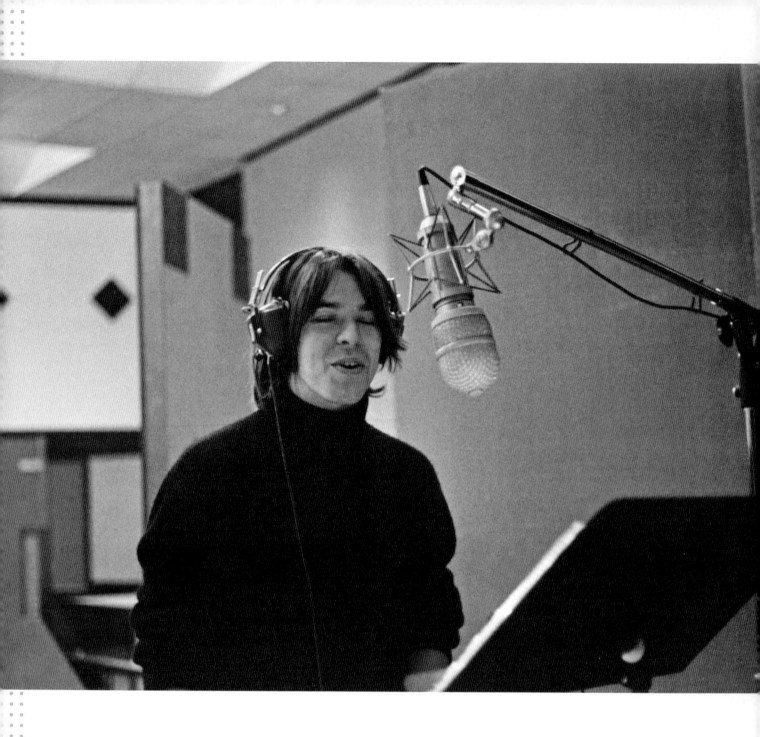

When Bob got an idea for something, he'd start writing it out. You couldn't talk to him; if you tried, it was like talking to a wall. He was on it *heavy* when he was working. He'd have an idea for a tune, write it down, and then just go with it— total focus. He wrote the songs and sang them the way he wrote 'em. He had an emotional quality, based on what he had written, that he delivered in the performance. Even if it was a simple set of lyrics, the way he "told" it was the way it was going to be.

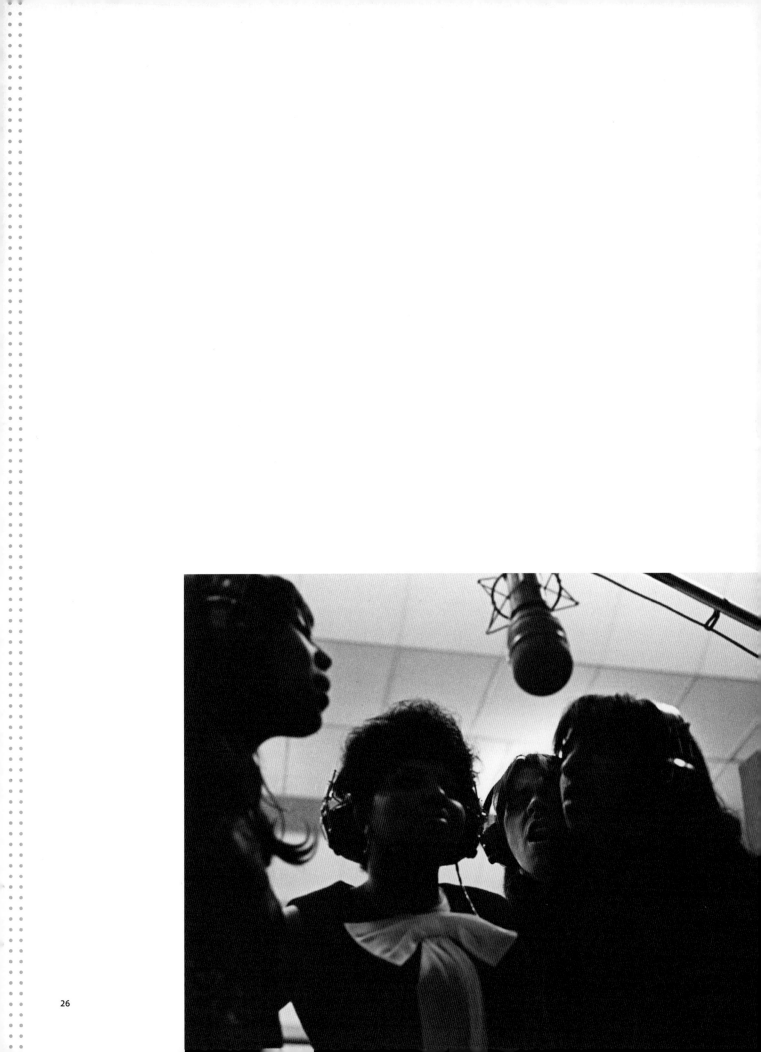

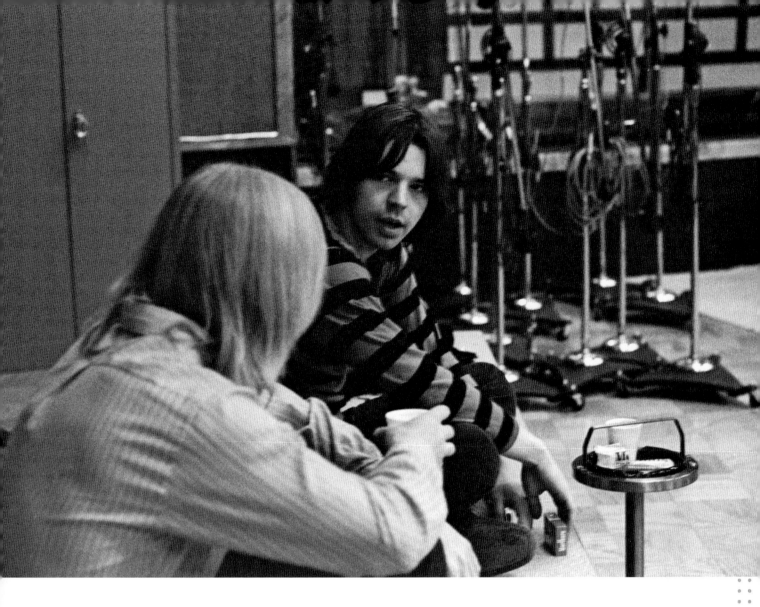

▲ With Pep Perrine, *Mongrel* sessions, Pampa
 Studios, winter 1970.

◄ *Mongrel* sessions, Pampa Studios, spring 1970.

Seger and I used to jam once in a while—always the blues, baby.

Mongrel sessions, Pampa Studios, spring 1970. ▶

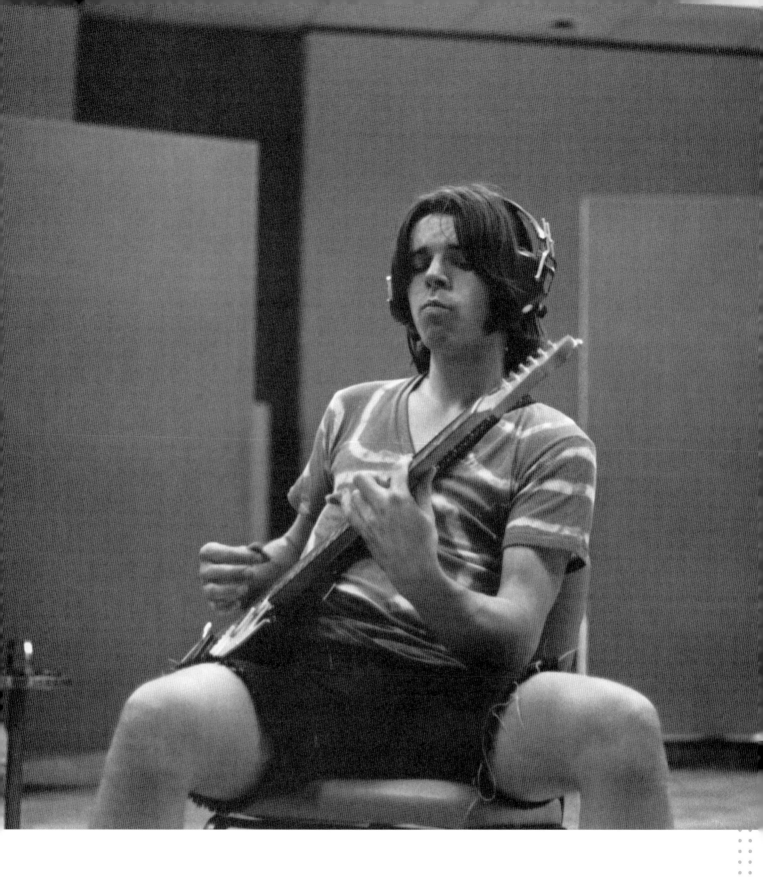

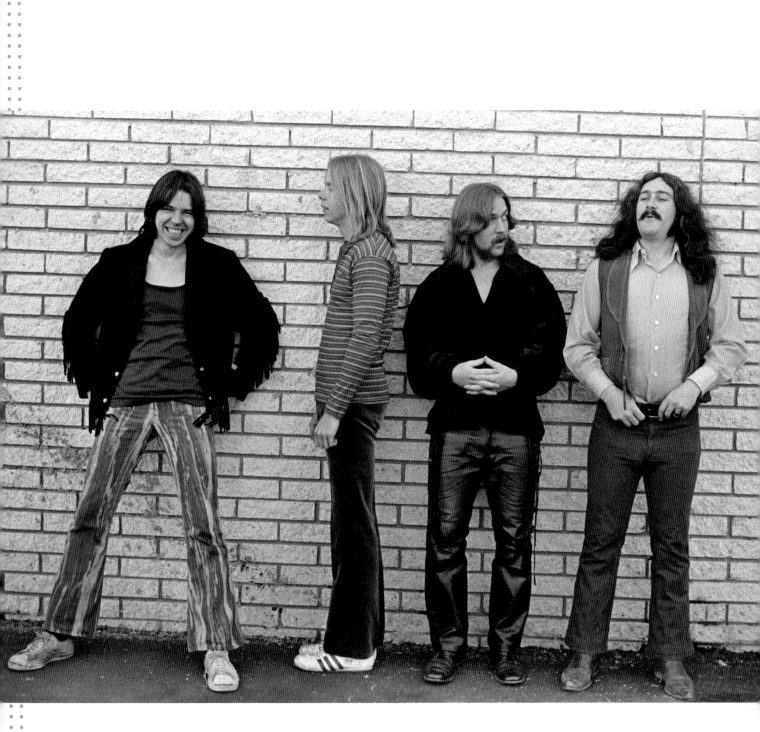

▲ The Bob Seger System, GM Studios
(East Detroit), fall 1969.

One of the first things Bob did with some of the money from royalties was buy the winner of a Detroit motorcycle show in 1970. It was a show bike, not for everyday use, but he would ride it back and forth from Ann Arbor. We warned, "You shouldn't be driving it. That's like a Porsche, man." But he did, and when stuff started falling off he went back to driving his car. It was a bizarre bike but looked cool. And he looked like a movie star riding it, like someone in *Easy Rider*.

We used to race and play sports. A lot of the guys liked to play baseball. Scotty Morgan of the Rationals was quite a baseball player. Punch was real good. Seger was good at first base, and he could hit. He was an athlete—good and fast. I was a track star (ha!) when I was a kid; in ninth grade, I set a record for the half-mile, so I thought I was fast. Nobody beat me before Seger beat me like I was standing still. The most unexpected things can happen in sports.

◀ University of Michigan campus (Ann Arbor), June 1970.

▼ Ed "Punch" Andrews, University of Michigan campus (Ann Arbor), June 1970.

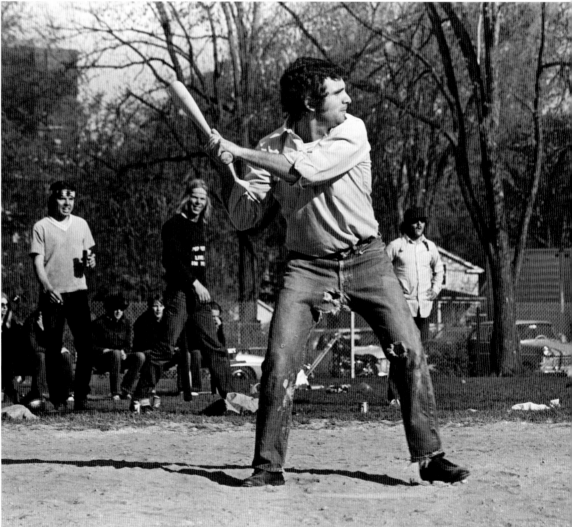

▲ Goose Lake Pop Festival (Goose Lake Park, Jackson), August 9, 1970.

The Goose Lake International Music Festival was big fun. Seger played on Sunday, the third day, in front of maybe 175,000 people. We heard the total was everything from 150,000 to 300,000; there certainly weren't 300,000 people, but there were a lot, so it was a great gig. We did our show and then Richard "Krinkle" Kruezkamp and I had brought a ton of Coca-Cola there to sell to people and supplement our income. That gig was a great for us, too.

I still remember the stage. I'd never seen a stage like this before. It was designed by Tom Wright, the photographer and author (*Roadwork: Rock & Roll Turned Inside Out*, Hal Leonard Books, 2007) and former Grande Ballroom manager. He was brilliant. He designed a big, round turntable with a wall in the middle. While one band would play on the front part of the turntable, the next band set up behind it on the other half. When it was time to switch, the crew guys would put metal poles into holes on the front of the circular stage and rotate it. Very cool.

The farm was great. One of our friends and part-time roadies, Gary Gawinek, found it. Rent was $300 a month (Gary, Punch, and I paid $100 each) for about twenty acres, with a big ol' barn and a pond, on Tienken Road in Rochester, between Livernois and Brewster Roads. The band could practice there, too. We rented it in the summer of 1970. Two of the band members and two of the roadies moved in immediately. Joe Aramimi was in charge of the farm, basically; he and Pep Perrine, our drummer, kind of ran it—made sure it was clean and took care of it. Seger was living in Ann Arbor, so he had to commute there and the farm was a long way for him. We played football games there, baseball, a lot of sports.

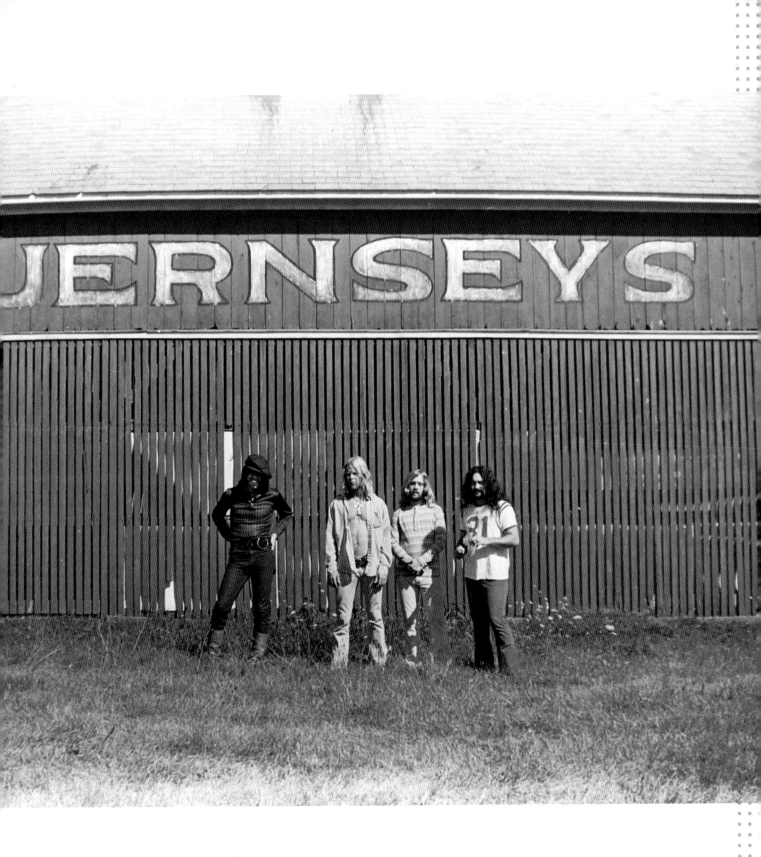

▲ The Bob Seger System at the farm
(Rochester), summer 1970.

When Punch started the Palladium, the teenage nightclub in downtown Birmingham, Michigan, we'd drive to the farm every Friday and Saturday night after the music ended. Most times, the bands would drive out there, too, as well as girls. There'd be a big party both nights. Rod Stewart, Ted Nugent, Alice Cooper, Steve Marriott, Johnny Winter, and many others enjoyed going there. We also had an illustrious neighbor: Madonna and her family lived about two blocks from the farm. Her subdivision was around the corner when she lived on California Street. In later years, I heard from somebody that she used to come to the farm and hang out there, but I don't really believe that. We wouldn't let girls that young hang out there.

▼ People at the farm (Rochester), summer 1970.

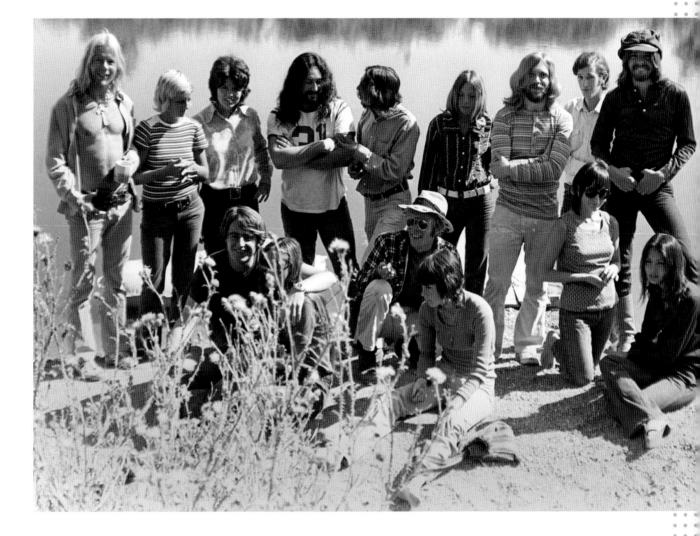

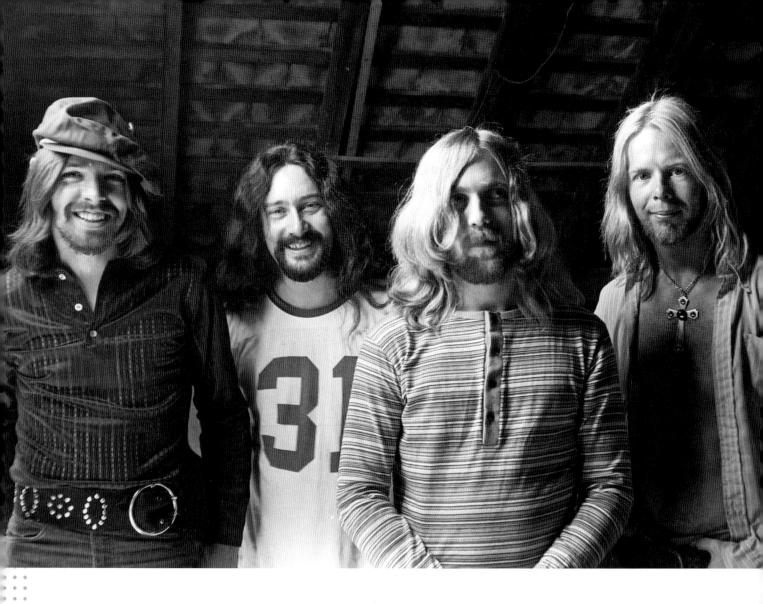

◄ The Bob Seger System at the farm (Rochester),
summer 1970: Bob Seger, Dan Honaker,
Dan Watson, and Pep Perrine.

▼ Mike Parshall at the farm (Rochester),
summer 1970.

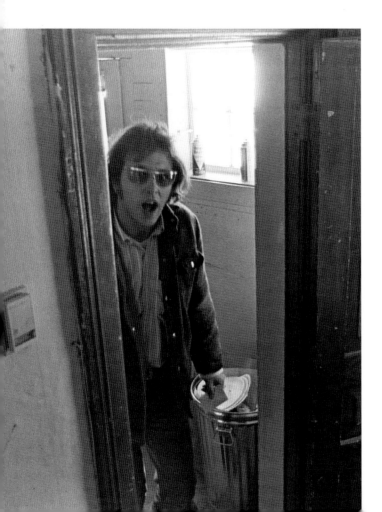

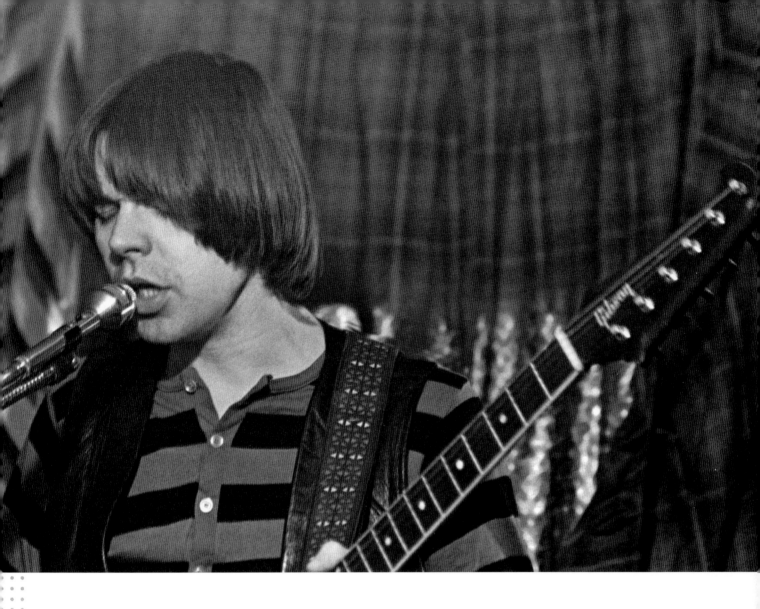

Gilligan's, a large Buffalo (New York) bar, was one of our regular places. The guy who ran it was cool, we always got big money, and there were always a lot of girls there. We had a show on January 30, 1970. Seger stepped on stage after the first two bands, played one song, and the power went out—but only in the stage area. The rest of the bar was all lit up. So we went back to the dressing room and waited about ten minutes while the owner had his people try to fix the problem. They told us the problem was fixed, so Bob and the band came back out, and the power went off again. Seger said to me, "You gotta fix this or I'm not goin' out there again."

I answered, "Don't worry, we *will* get it right." We ran power cords up into the rafters of the club and over to the bar, where there was power, and got everything going so Bob and I didn't have to worry anymore about the power and he could concentrate on the show. I sat there with my fingers crossed, because if the power went out again Seger would have been in a very nonperformance mood, and when Punch heard about it the fault would have been mine. And rightly so. My point here is this: what*ever* it takes to get the show on you do it, even if you have to get power from the utility poles outside!

◄ Bob Seger at the farm (Rochester),
 summer 1970.

▼ Dan Honaker at the farm (Rochester),
 summer 1970.

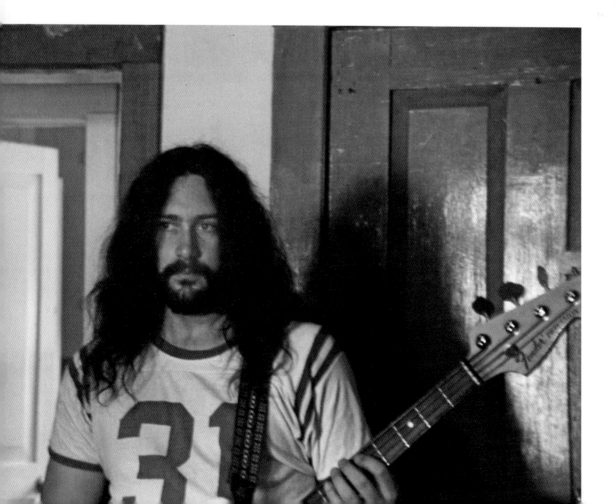

We had this troupe of high school girls who we called "the babies" because they were kids, very cute kids: Leslie, Gracie, Diane, Carol, Michelle, and two Debbies. We had a bunch of telephones, and they'd come in after school and call radio stations and record stores, just to keep the Seger beat going. "Can you play that Bob Seger record?" "Hey, do you have that Seger record in stock?" Imagine their day: they'd go to school and then go into downtown Birmingham and hang out in this rock 'n' roll office, help us out, and then go home. Of course, they would not have to pay to get into our teen nightclub (the Palladium), a real perk in those days because we had great bands playing there every week—the Faces with Rod Stewart, Johnny Winter, Chuck Berry, and on and on.

▼ "The Babies," Oakland Mall (Troy), August 17, 1969.

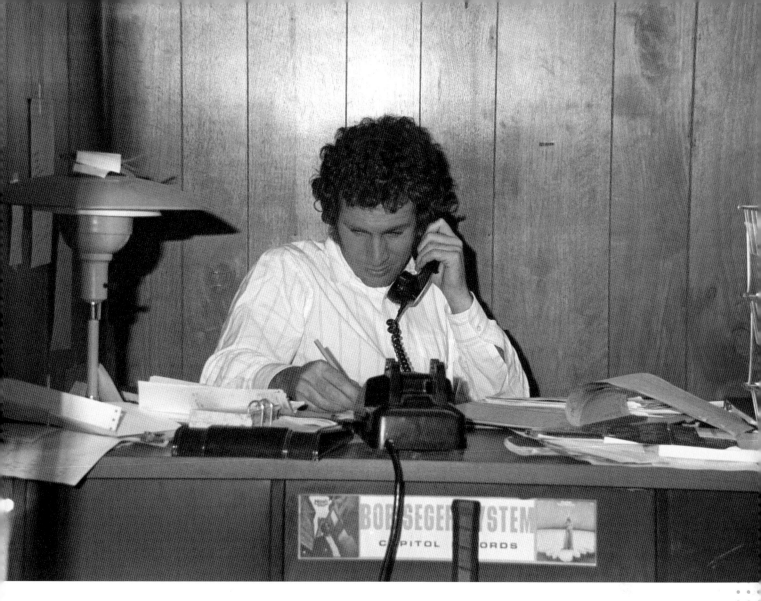

Our first "office" was on the Fruehoff estate, out in West Bloomfield, Michigan, near Walnut Lake. Mrs. Fruehoff rented her carriage house to Punch, and he used that for an office and one of her barns for the equipment truck. My first few times working for them, I had to return the truck there and drive my car home. Later on, Punch began to trust me to take the truck home. Seger actually lived on the estate for a while, but we got kicked out—let's just say that Mrs. Fruehoff and rock 'n' roll were not entirely compatible. We moved to a second-story office at 124 South Woodward in Birmingham, over the Handlesman's clothing store. Zelig Handlesman, the landlord, was a very "by the book" type, and I think he figured we were a little nuts. We had two small offices in that building at first and later expanded across the hall to two more small offices when Palladium Records started up, but we couldn't play loud music up there because of the other tenants, so we had to split. Today, at the same location is a store called Purple Haze selling paraphernalia and posters, hippie-style clothes, etc.

▲ Punch Andrews, Punch Enterprises, 124 South Woodward Avenue (Birmingham), February 1971.

▶ Punch Enterprises, Birmingham, February 2009.

▼ Julie Sherr, Punch Enterprises, 124 South Woodward Avenue (Birmingham), February 1971.

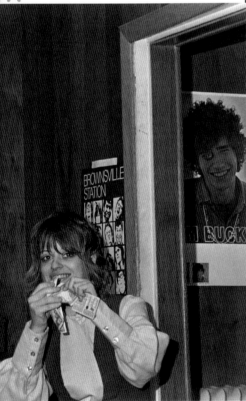

In December of '71, when I was walking on Purdy Street, in Birmingham, to the office at 124 South Woodward Avenue, I passed a man pounding a "For Rent" sign in the grass in front of this house only a hundred yards from my apartment. I asked how much he wanted. He said $300 for the house and $450 if we wanted a second house that was next to it. I ran back to my apartment, called Punch and told him about it. He said, "Go through the house, make sure we want it, make sure it isn't falling apart, then book it!" We used the second house as a band house, and every band in the city wanted to practice there—they hoped Punch would sign them to a record contract if he heard them, but we kept it strictly for people we knew.

Birmingham was a little different back then; Punch was very adroit at handling relations with city officials because of his past experience running teen nightclubs in several cities in the Detroit area. We had an interleague baseball team with the police, so we were solid with them. They liked us even though sometimes there were pot-smoking hippies in both houses at the corner of Danes and Purdy, but never when Punch was around. The band practice house was torn down, but the main office hasn't changed in thirty-seven years.

Punch and I had decided that during the downtimes from gigs, we wanted to put a submarine sandwich shop in the Palladium. So we came up with the name Krink's. Krinkle (Richard Kruezkamp) used to make the best subs, and he would bring them to the office and feed us. So Punch put some money into the sub shop and started selling subs. Then we found out that a Birmingham city law required you to have a license to sell food, so we had to shut it down.

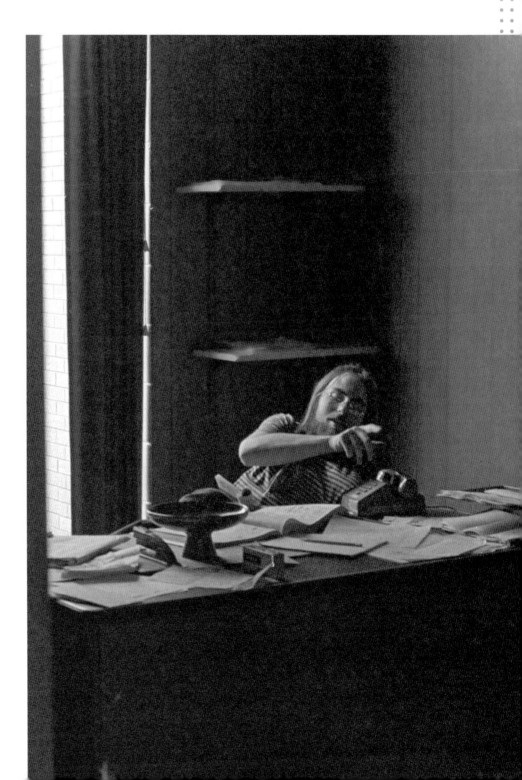

▼ Richard "Krinkle" Kruezkamp, Punch Enterprises (Birmingham), spring 1970.

One of the highlights of my time with Seger was playing the John Sinclair Freedom Rally, which was held on December 10, 1971, at the University of Michigan's Crisler Arena in Ann Arbor on behalf of Sinclair, who was serving a ten-year jail term for possession of two joints. We could certainly get behind the cause (check out Bob's song "Highway Child" on *Mongrel*), and John Lennon was going to be there, so we could certainly get behind *that*! Punch was initially reticent, mostly because they had already printed the posters and Bob's name wasn't on them. But Punch understood that John Lennon was playing, so there was no way we weren't going to do it. We were recording at Pampa Studios that night with Dave Teegarden and Skip Knape, who went by Skip Van Winkle, and it was getting late. I kept saying, "C'mon, c'mon, we gotta get out of here." We finally loaded everything in the car and sped up to Ann Arbor in the snow and made it by the skin of our teeth. We drove *inside* Crisler Arena and unloaded the equipment directly on stage. About a half-hour later, a white limo pulled in, and John Lennon and Yoko Ono stepped out and walked right by us. Lennon looked right at me and did this little raised-eyebrow thing, and he said hello to Bob—no formal introductions or anything, he just said "Hello." So it all worked out, and Bob got to be in the movie (*10 for 2*) and part of a cultural event none of us will ever forget.

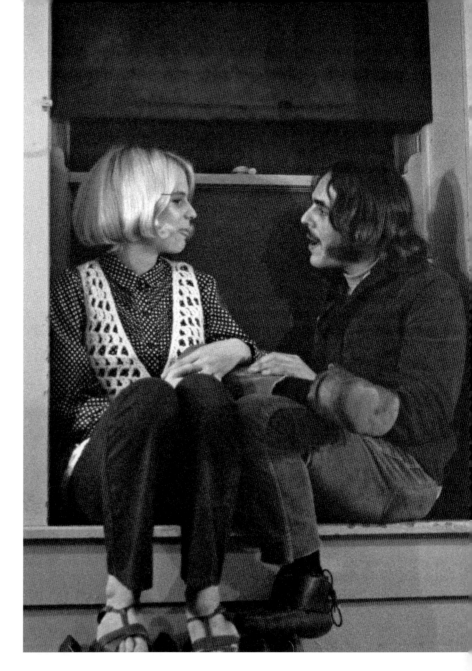

▲ Joe Aramini and friend, the Palladium (Birmingham), fall 1970.

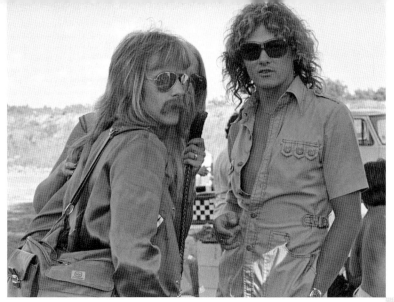

▲ Chris Campbell and Robyn Robbins,
Michigan Jam (Martin), July 2, 1977.

▶ Bill Blackwell, Punch Enterprises
(Birmingham), fall 1976.

▼ Gordy Paul, Cobo Arena (Detroit),
winter 1977.

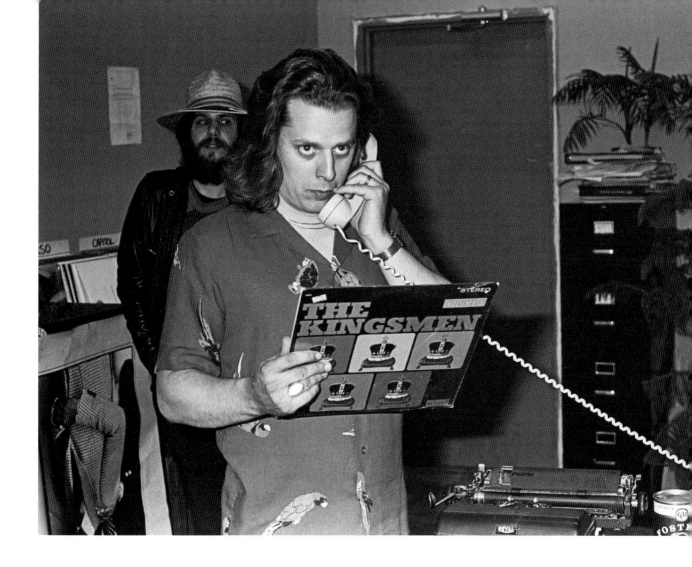

Punch's father had a Cadillac convertible with a phone in the trunk—in 1971. David "Dancer" McCullough and I had to drive down to Cleveland Recording to meet Punch, who then was going to drive to Florida, where his dad was. We thought we'd have some fun, so when we arrived we called from the car in the parking lot of the studio. Punch was like, "Where are you idiots?" "We're just leaving. We'll be there in a couple of hours. We'll be a little late." That got him all pissed off. Then we walked in a minute later, and he was like, "You assholes" . . . Then came this look of fear on his face: "You didn't use my old man's phone, did you?" we answered, "Uh . . . yeah." "I'll never hear the end of it—you're payin' the fucking bill!" Back then car phones were very, very expensive.

◄ David "Dancer" McCullough,
Cleveland Recording (in Cleveland),
summer 1971.

▼ Brian Chubb, Wings Stadium
(Kalamazoo), fall 1976.

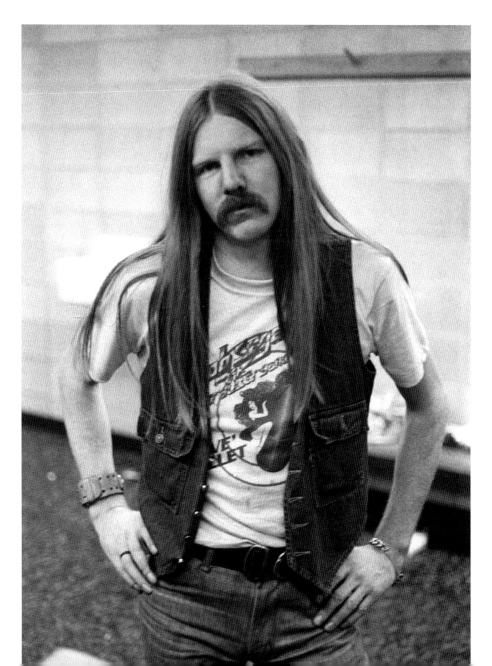

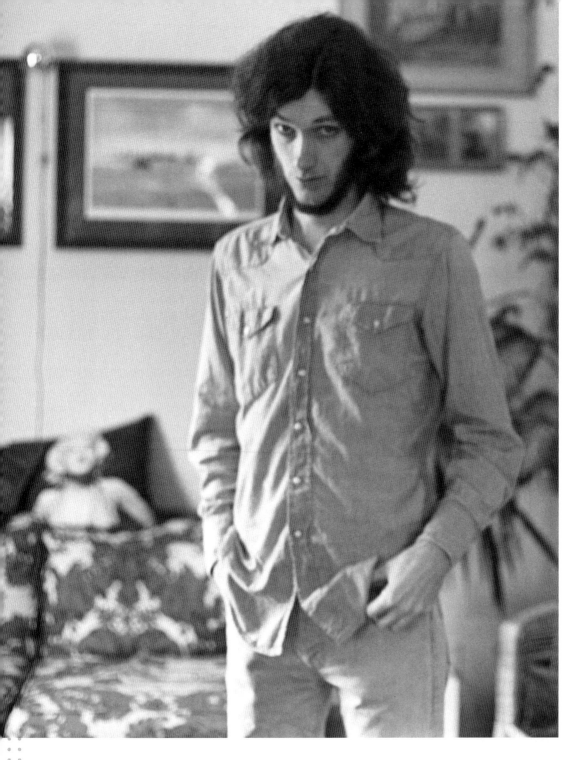

▲ Tom Weschler (Birmingham), fall 1978.

Bob and I used to hang out on the road, the two of us. We both liked movies, so instead of going back to the hotel after gigs, sometimes we'd find a movie to go to. Or, if we were home and his girlfriend was out of town, we'd go out to a movie. Movies were a big interest for both of us. Later, after I left his employ, I had my first date with the girl who would eventually become my wife. We went to see *Taxi Driver* (1976), not exactly a romantic, first-date type of movie, but there we were. Just before the movie started and after the lights had gone down, this guy came down the aisle to me (I was seated on the end) and said, "Hey, after the movie is over let's meet in the lobby and talk about this one." I answered, "Sure man. I didn't expect to see you here." Lisa Parks, the new girl in my life, asked me who that was. I said, "Oh, a guy I know who loves movies like I do." Now, for the record, she was a big Bob Seger fan and had no idea the "guy" was Bob. So after the movie we met in the lobby and traded opinions about the flick. Her reaction was—well, one could say it was a very good first date.

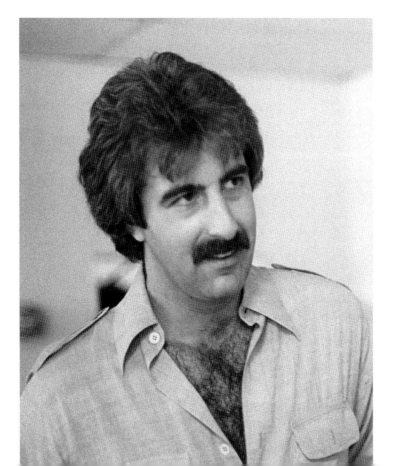

◀ Russell "Buzz" Van Houten III,
Cobo Arena (Detroit), September 1975.

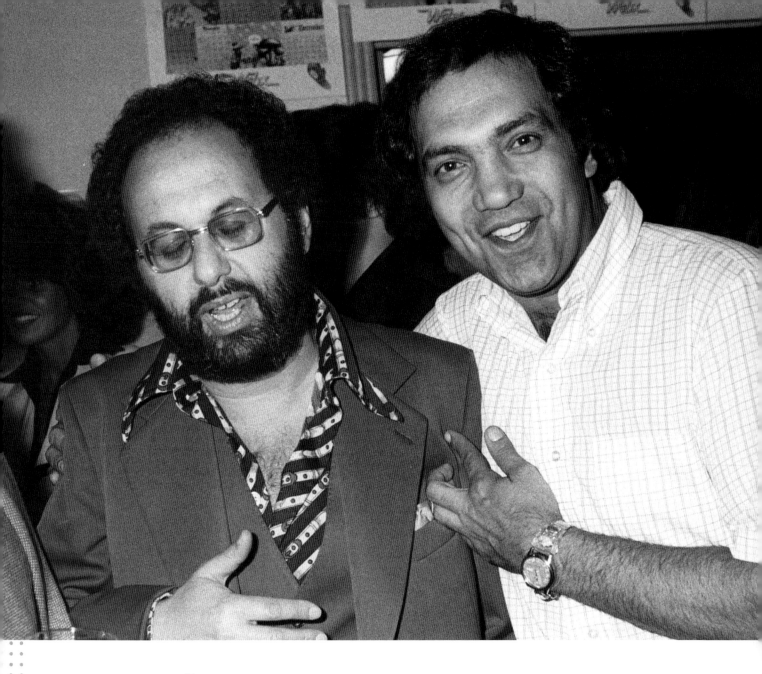

Dave Leone and Bob "Sugar" Schwartz were two players in Seger's early career. Dave was Punch's good friend and his partner in the Hideout clubs. Schwartz was my "godfather" in the music business: he taught me all about going into radio stations and getting records played. He was brilliant at it, really old school. Seger used to be afraid of Schwartz: he'd say, "He scares me, man. He looks like some gangster." I didn't do anything to dissuade that feeling, either.

▲ Bob "Sugar" Schwartz and Dave Leone, WABX (Oak Park), summer 1976.

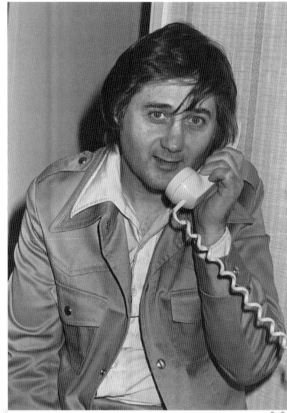

▶ Tom Gilardi, Michigan Inn (Southfield),
winter 1978.

▼ Denise Moncel and Walter Lee,
Capitol Records offices (Madison Heights),
fall 1977.

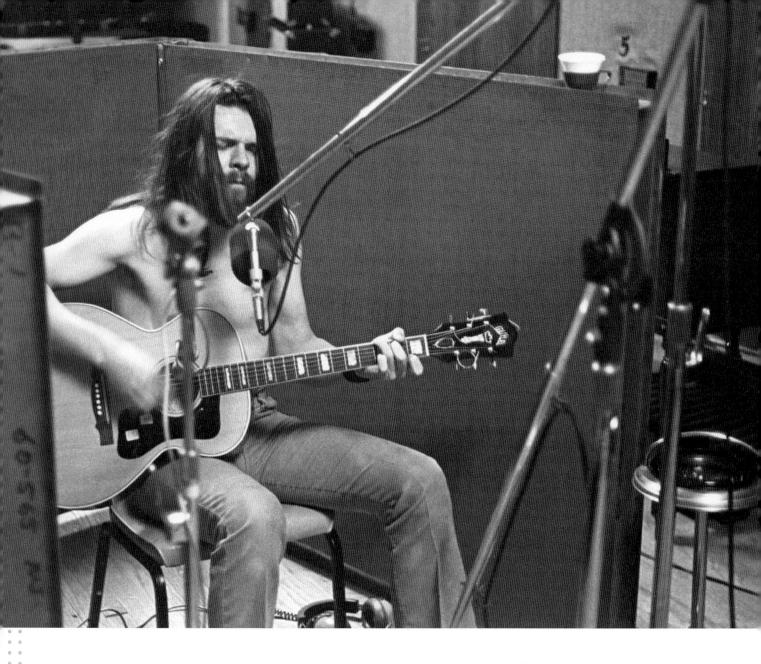

▲ *Brand New Morning* sessions, GM Studios
(East Detroit), spring 1971.

Right after the System broke up and he recorded the album *Brand New Morning* (1971), Bob wanted to go solo. He said, "Well, looks like it's you and me," and I'm thinking, "Okay, that'll be easy to set up. I don't have to set up those damn drums anymore!" Then I asked, "What are we gonna do? We've got gigs booked as the Bob Seger System. They'll be expecting a band." He replied, "Don't worry. I know what to do. I'll get the crowd." I was reticent, and so was Punch. But we went ahead. Bob had his guitars and an amp. I took $20 out of petty cash and bought this yellow rug, plopped it down on stage, put up a microphone stand, set up the PA, lit a cigarette, and watched Seger play.

The first gig was at Olivet College in Michigan and I was afraid. We were getting paid $1,500, and they were expecting a band. When we arrived, the kid in charge said, "Well, if you don't have a band, man, I can't pay you." I replied, "How about this? If people are disappointed and you have to refund their money, don't pay us. But if they come and they like it, give us the check." We drew a big crowd and they loved Bob. To me, it was a mixed blessing. Here's Seger thinking: "I can do gigs like Simon and Garfunkel without Garfunkel." And it worked. He was very good. But it wasn't as good as the full-on thing. Fortunately he quickly rekindled his appetite for a band.

"I can do gigs like
Simon and Garfunkel
without Garfunkel."

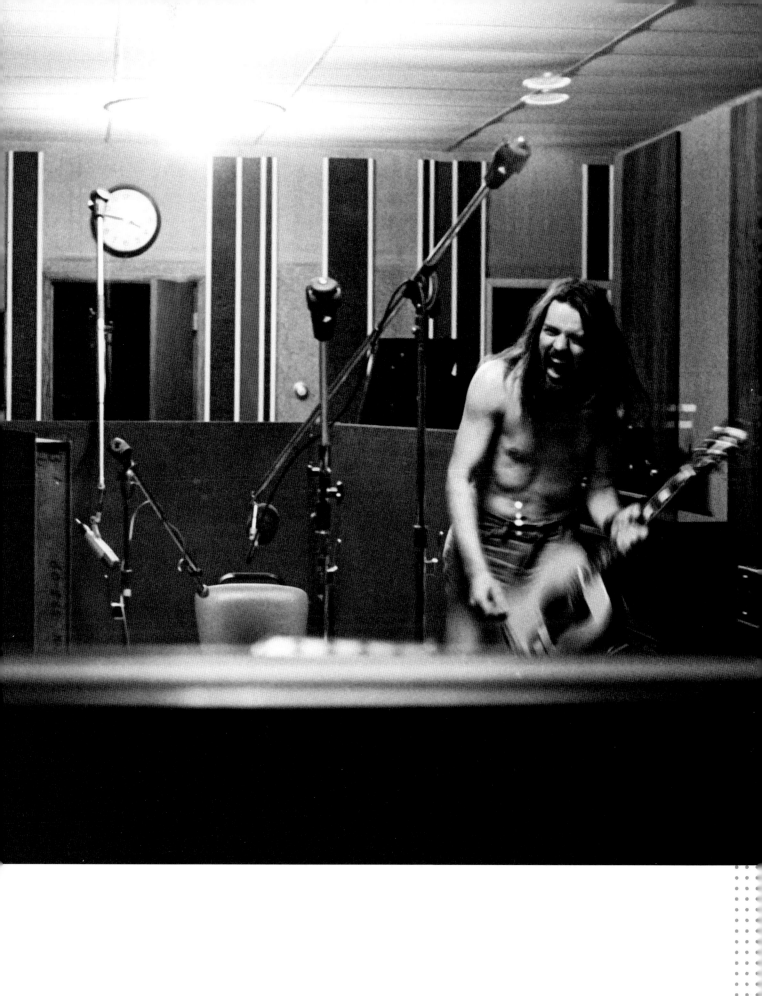

Seger hooked up with Teegarden and Knape (Van Winkle) and went on the road with them. So Seger had a band called STK (for Seger, Teegarden, and Knape) for a while. It was a pretty good act. Everybody loved Teegarden and Van Winkle; they were from Tulsa, with serious southern accents, and fun to listen to. That's how we hooked up with Leon Russell and wound up doing part of the *Back in '72* album down at his Paradise Studios near Tulsa.

▼ David Teegarden, Michigan Jam (Martin Speedway, Martin), July 2, 1977.

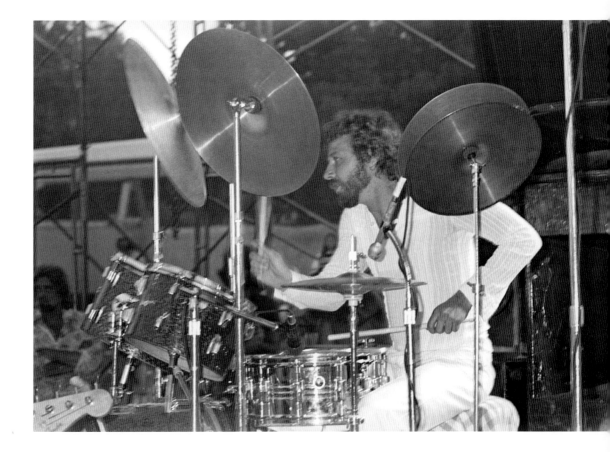

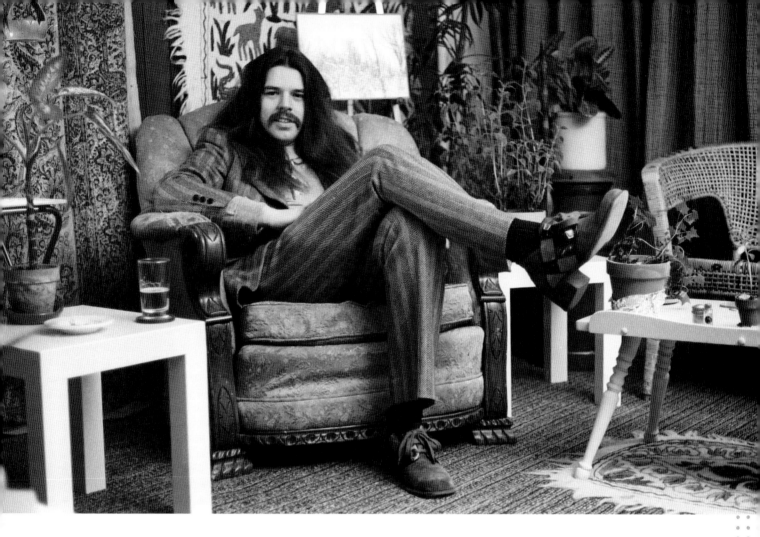

Bob had bought a brand new suit and needed some photos. Note the shoes— real patchwork leather!

Our first real big, paid gig was at the Orlando Sports Stadium, with an audience of around 15,000. *Smokin' O.P.'s* was the album we were working on at the time, and it was a really good show—no equipment problems and lots of dough!

▲ Bob in Tom Weschler's apartment (Birmingham), October 1972.

Bob has owned dogs as long as I've known him. In 1999, I went to his home to help him with a project and when I arrived he introduced me to his newest dog, Sirius. When I asked if the dog was named after our Puerto Rican guide Sirius Trixon, Seger replied, "Yep."

▼ Bogey Lake (White Lake Township, Michigan), August 1971.

Bob's place on Bogey Lake was really isolated, which is why he liked it. That's where I shot the photographs of him for *Brand New Morning* and the back of *Smokin' O.P.'s*. He had the weirdest driveway at that house. We would practice there once in a while, and the driveway was really steep. When I was backing the truck down, anything that wasn't strapped would fall. In winter it was nearly impossible to navigate.

▲ Bogey Lake (White Lake Township), August 1971.

"Turn the Page," Bob's great road song, came along in '72, while we were driving home from a gig. I think we were in Dubuque, Iowa, in winter and stopped at a restaurant. We stood out when we entered a store or a gas station or a restaurant en masse. At this restaurant it was particularly bright inside, so there weren't any dark corners to hide in. All these local guys were looking at us like, "What are these guys? Is that a woman or a man?"—just like in the song. Then Pete Lumetta, one of our roadies at the time, walked in. He was a rather large Detroit greaser with a black leather jacket and, if need be, a scowl from hell. We didn't get into any trouble that time. Bob was writing the song in the station wagon on the way to Chicago that night. That was one incident, but there were so many others on the road that led Seger to write that song. "Turn the Page" is an accurate portrayal of our lives back then.

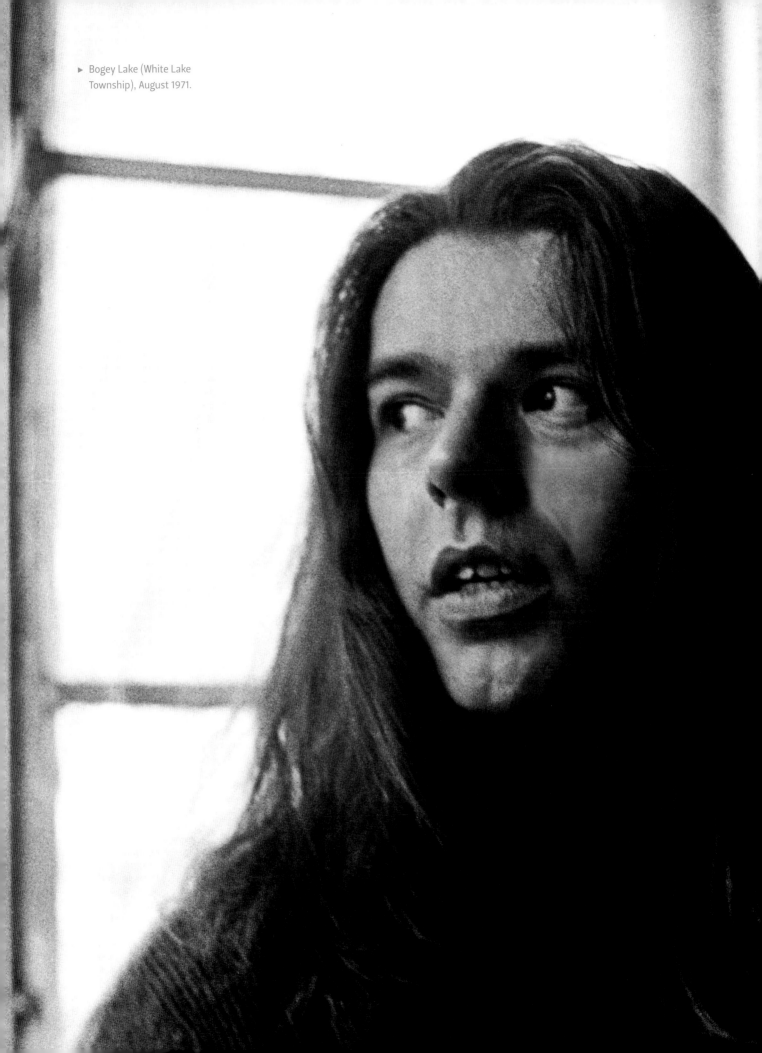

▶ Bogey Lake (White Lake Township), August 1971.

We recorded "Turn the Page" at Paradise Studios at Leon Russell's home near Tulsa. Punch missed his flight and wasn't going to arrive until the next day. He told me not to waste any time: "Just go in there and lay some bed tracks. Seger will know what to do." Alto Reed started fooling around with the intro to "Turn the Page." I had a story to tell him so I pushed the intercom button and said, "Alto, think about it like this: You're in New York City, on the Bowery. It's 3 a.m. you're under a streetlamp. There's a light mist coming down. You're all by yourself. Show me what that sounds like." And he plays the beginning to the song just like it is on the record today! Hearing it for the first time, I said to the engineer, "Whoa! Did you get that?" And Seger said to me, "Tell him another story!" Punch came in the next day and heard it and he liked it so it stayed.

◄ Punch Enterprises (Birmingham), summer 1973.

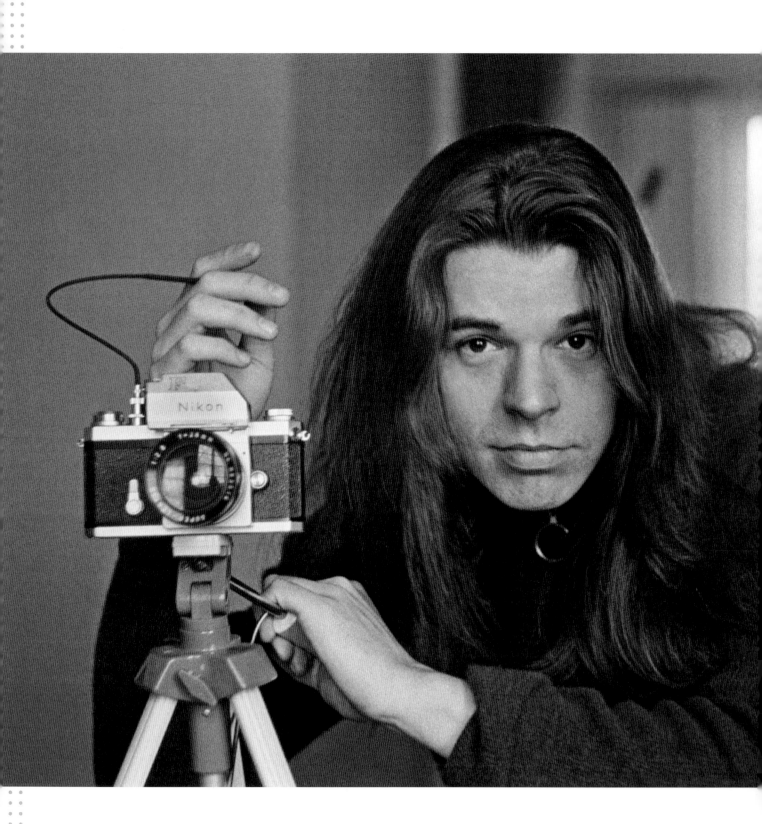

▲ Bob in Tom Weschler's
apartment (Birmingham),
fall 1972.

My apartment in Birmingham was right down the street from the office. We took photographs of Seger there for a promotional shot. It was Bob's idea to shoot a picture of me taking a picture. I put the camera on a tripod and hooked up a cable release for him. I thought it was a really cool shot of Seger. Punch kind of liked it, too.

Seger became disillusioned with STK. He wanted more: more musicians, more background singers, more of a sound. So he started a band with people from a group called Julia that I was managing on the side—with Billy Mueller, Calvin Hughes, Randy Meyers, and Marcy Levy. The Borneo Band is what they called it, although the name didn't get much play. It was referred to as Bob Seger's band most of the time, and that group led to the Silver Bullet Band.

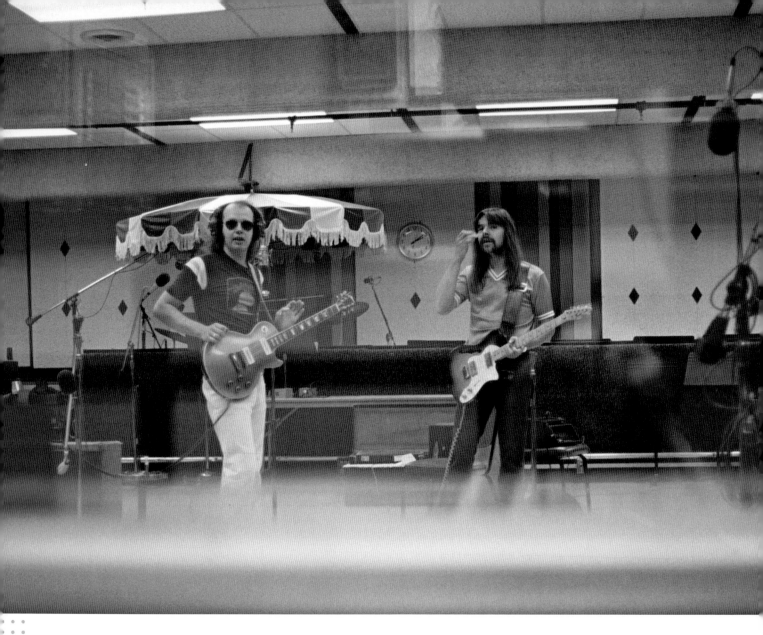

Just before Seger's *Seven* album project began, Glenn Frey sat me down at Punch's office. He was getting big with the Eagles at that point, and this was just after *Smokin' O.P.'s* was marginally accepted and we were bubbling under *Billboard*'s Hot 100. Frey and Don Henley loved Seger. They thought he was great. Glenn told me, "You gotta tell these guys, man, *this* is the time for Seger. *This* album. *This* is it. If you've got to, make them spend a whole day on a guitar lick if that's what it takes to get the solo right." He really wanted to see Bob become successful.

We played New York City in the fall of 1973—a place called Ungano's. That was our first time playing in New York, and we got a favorable review in *Billboard*.

They seem to have electronics stores on every street in New York City. One had a Super 8 movie camera for $60. I went in, bought it, returned to the hotel, and showed it to Seger. He said, "Wow! We've got to make a movie," so we went to Central Park, and he filmed me with a trench coat and a cigarette in my mouth, and I filmed him, too. That was me and Bob making a movie—not exactly Scorsese, but so what?

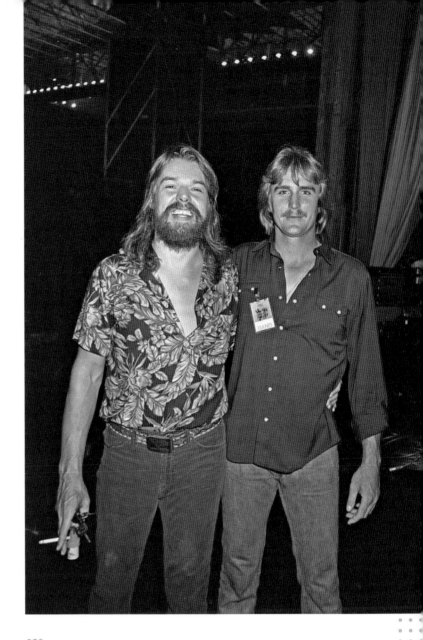

◄ With Drew Abbott, *Seven* sessions, Pampa Studios, summer 1973.

► With John Rapp, Madison Square Garden, September 3, 1980.

Punch decided he was going to release "Get Out of Denver" as a single. Seger did not want that to happen and was really pissed off about it. One day he walked into the office when Punch wasn't there yet and asked me, "Do you want that single out?" I said, "Yeah," and he said, "Fine, you can have the damn royalties!" He grabbed a piece of paper from the copy machine and wrote "Tom Weschler gets any royalties from 'Get Out of Denver,'" signed it, and handed it to me. He washed his hands of the whole affair. Punch arrived and I gave him that paper. "Get Out of Denver," in time, became a classic—so much so that, on the night of Bob's induction into the Rock and Roll Hall of Fame, Bob Dylan was in Detroit at the State Theatre and introduced his version of "Get Out of Denver" and dedicated it to Seger!

We hired John Rapp in 1972 to be one of our road crew. He had been a Navy Seal Support Team member and was a great, warm, friendly, dedicated guy. By the time I left, he was still with the band. To this day, he still works for Bob.

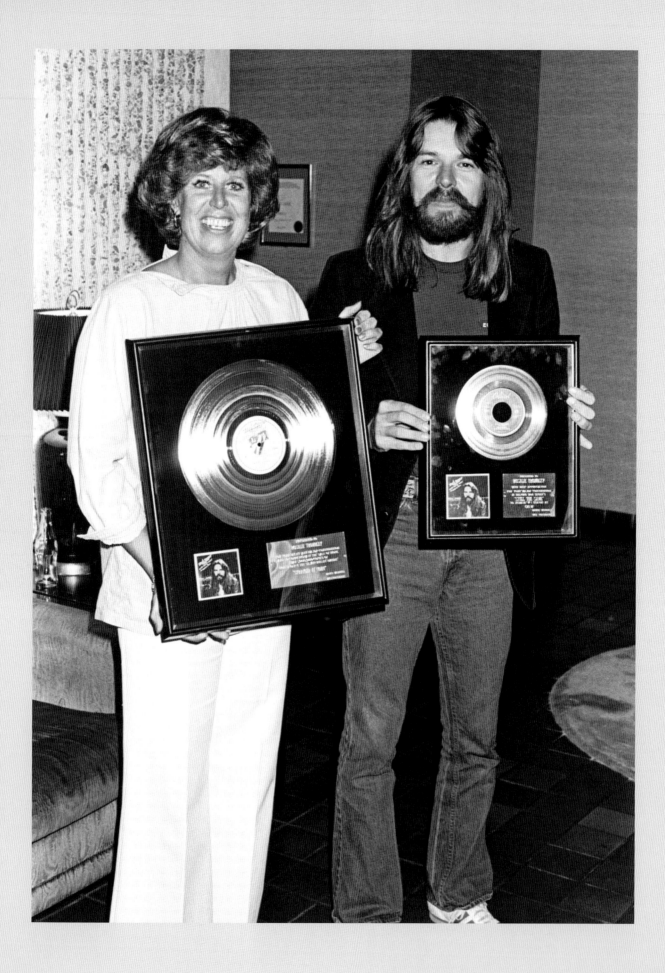

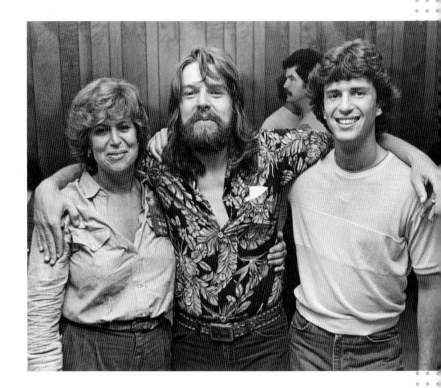

◄ With Rosalie Trombley, CKLW (Windsor, Ontario), 1978.

► With Rosalie Trombley and Tim Trombley, Pine Knob Music Theatre (Independence Township, Michigan), summer 1980.

At CKLW in Windsor, Rosalie Trombley was one of the most powerful people in radio. Seger wrote the song "Rosalie" (*Back in '72*) about her reticence to play his records. He was not happy because she wouldn't play some of his earlier stuff. They obviously played "Ramblin' Gamblin' Man" but never really gave him a solid shot after that, so he wrote "Rosalie." He was saying, "I know music, too." A funny thing happened: she loved the song, even though it was marginally critical of her. She thought it was cool that he expressed his feelings about her in a song and went on to support Seger with airplay on CKLW after that.

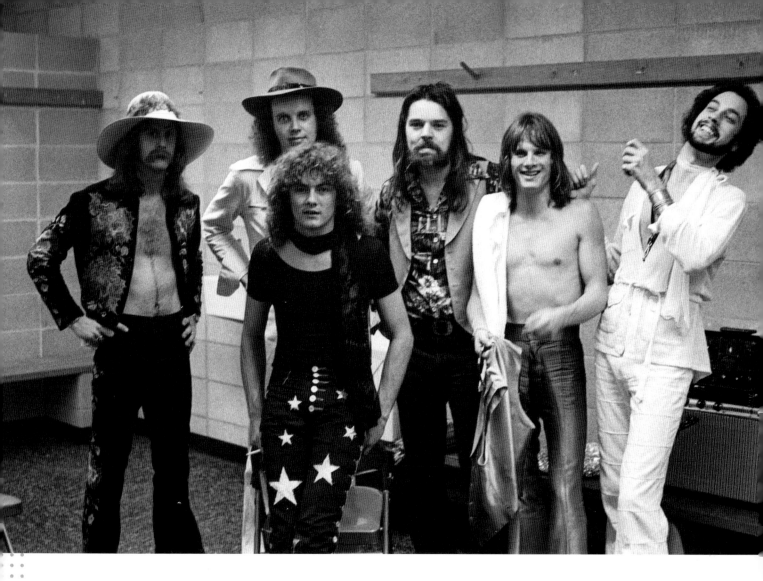

▲ Silver Bullet Band, Wings Stadium
(Kalamazoo), fall 1976: Chris Campbell,
Drew Abbott (with the hat), Robyn Robbins,
Bob, Charlie Martin, and Alto Reed.

► Chris Campbell, Pine Knob Music Theatre
(Independence Township), summer 1978.

In 1973 we started actively looking for people for what became the Silver Bullet Band. I found Alto Reed. He had a band called Ormandy, named after Eugene Ormandy, the conductor of the Philadelphia Philharmonic at that time. His group played at a club called Something Different, which I was managing with Punch and George Goulson. I went up to Alto after a gig there and asked if he would be interested in trying out for Bob's next band. He and Seger hit it off. Alto was a showman, this dude who was all over the place with his sax. We needed that, because Bob mostly stood there with his guitar and delivered the vocals like nobody else but didn't move around much. People like movement, so serious stage activity can get you over with the crowd real good!

Another band that played at that club was Toby Wesselfox, with Chris Campbell as the bass player. He and I talked about Seger's new group, and Chris was a really nice guy and had real good equipment. Then we found out he was looking to join us, too. We were thinking, "This guy plays a great bass and bottom is sooooo important." Then Drew Abbott came on board and then Robyn Robbins, a friend of mine from the East Side of Detroit, came with us and that was the beginning of the Silver Bullet Band, just before I left the fold.

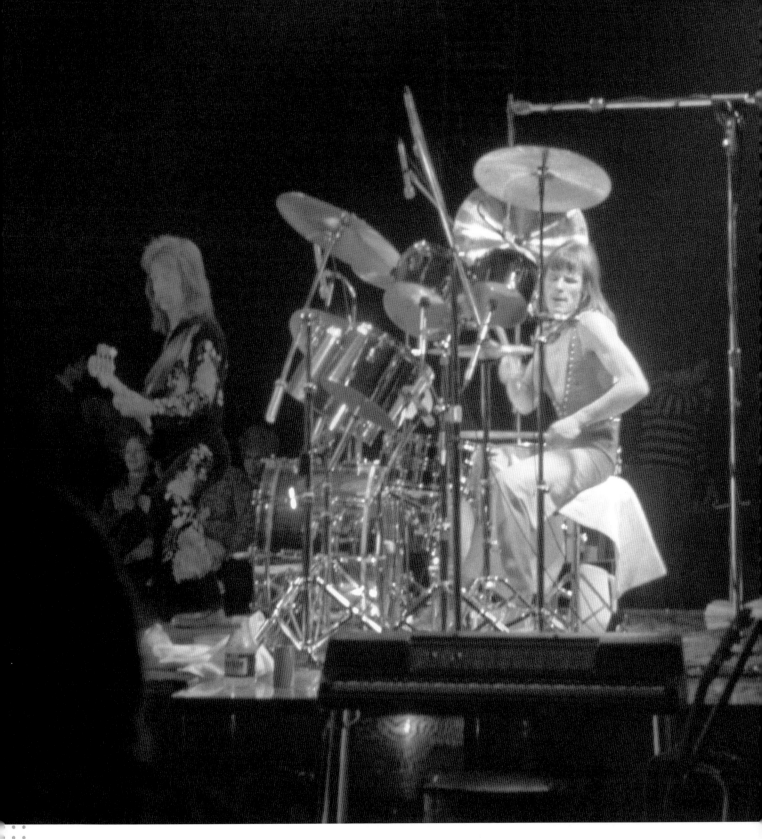

▲ Charlie Martin, Cobo Arena
(Detroit), September 1975.

Charlie Martin is a fabulous drummer and a real smart-ass and hasn't changed his musical attitude at all even though he was paralyzed from the waist down after a car hit him in 1977. All of us were devastated when that happened, but he keeps on going. He's still an entertainer, still can sing real good. He used to do a lot of the harmonies when he was with the band. I went to see him perform in the fall of '08. He still keeps the audience happy!

The Detroit gigs were always packed; that's one of the things I liked. When I first started getting into Seger and going to see his shows, he always drew a good crowd and played great music with a voice from hell, and a good voice is hard to find. I think that's the toughest thing to find in music, someone with a great voice. And there were lots of women around, too. That's why I liked going to see Bob Seger—the band was great, the women were great, and *that* was great.

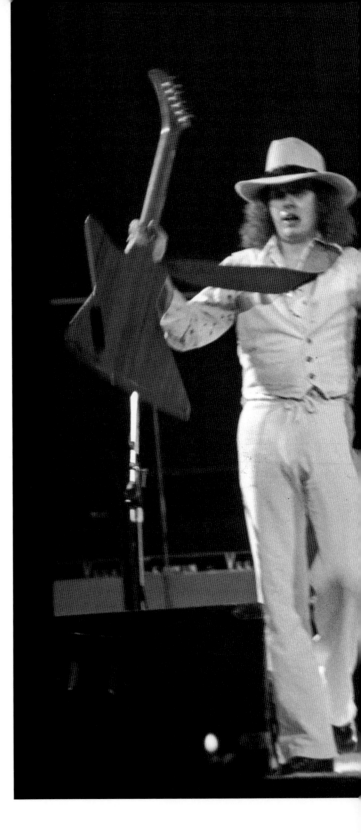

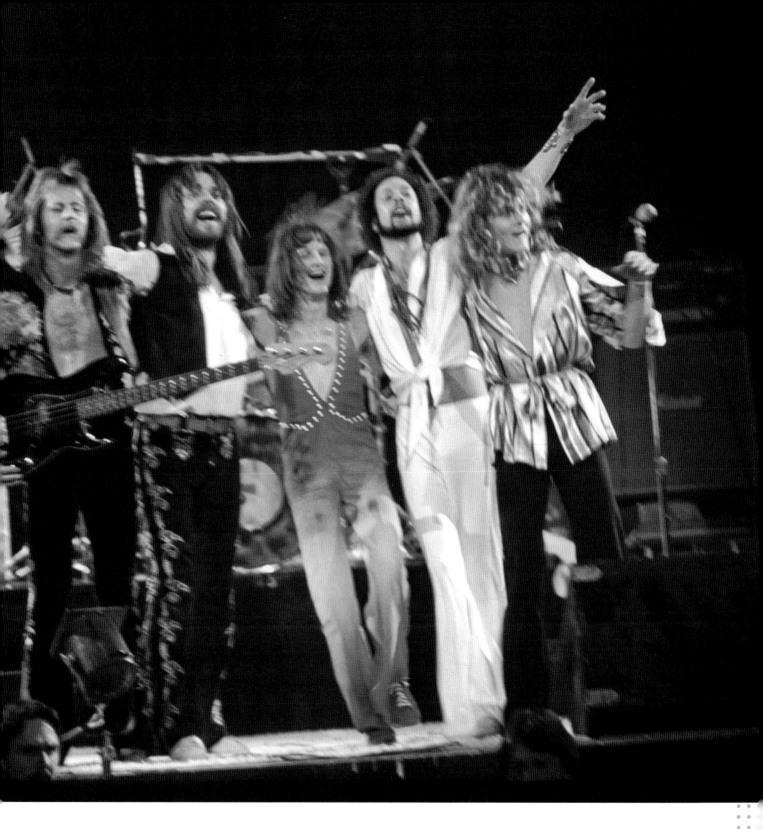

▲ Silver Bullet Band, Cobo Arena (Detroit),
September 1975.

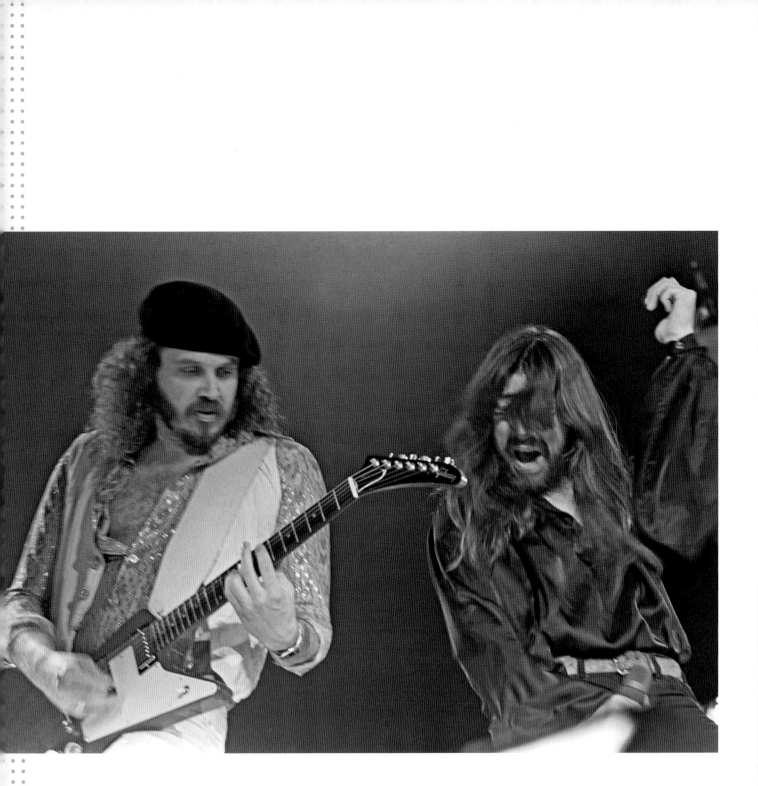

▲ With Drew Abbott, Cobo Arena (Detroit), winter 1978.

During the KISS tour in '75, it was apparent Bob Seger & the Silver Bullet Band were going to get big because they were going over like gangbusters. Nobody expected them to do that well on a tour with a band that was so comic-book oriented in their look but played their music like the real deal. The crowds really loved them.

Bob's album *Beautiful Loser* was out; this was just before *Live Bullet.* That tour just changed everything for Seger. KISS was so popular and drew such large crowds that people all over the country saw Bob and the band, not just Florida; Lubbock, Texas; Portland, Maine; Washington, DC; Cleveland and Columbus, Ohio, all the usual places we'd go. This time they were everywhere, and everyone loved them.

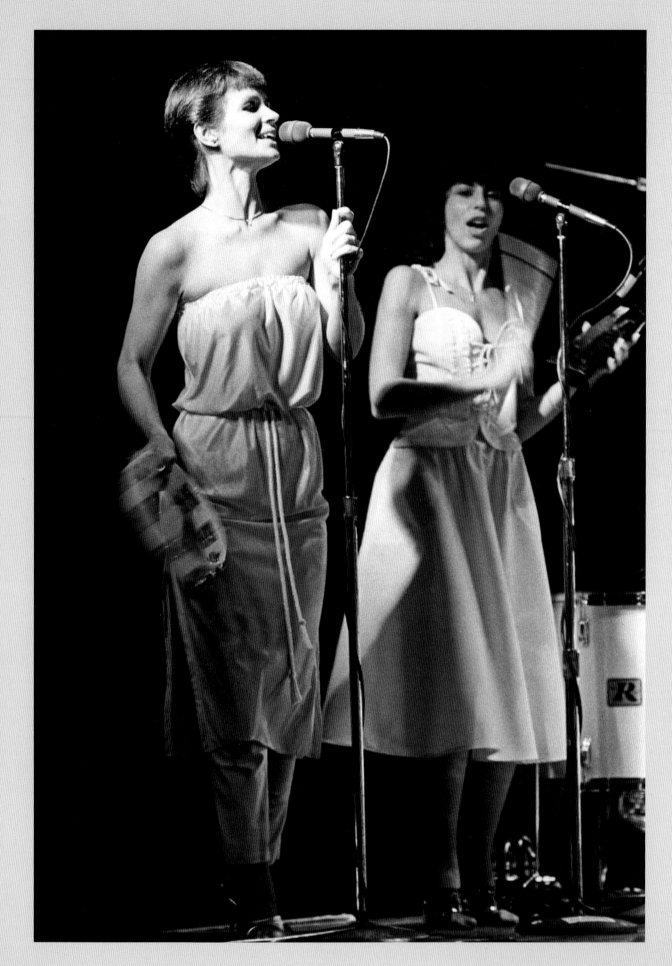

TRAVELIN' MAN

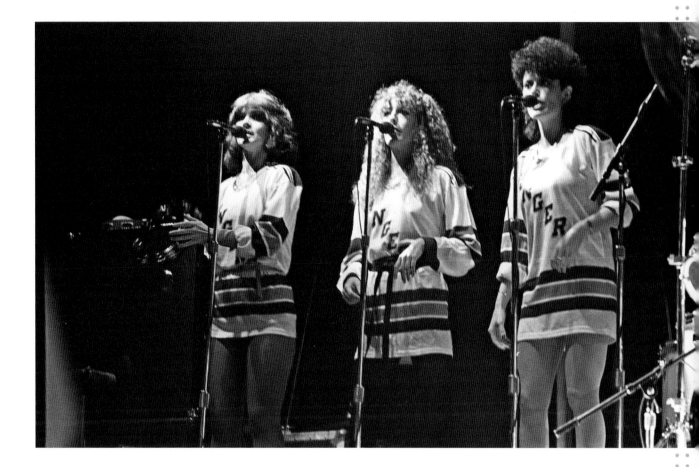

▲ Backup singers, Madison Square Garden,
September 1980.

◄ Shaun Murphy and Laura Creamer,
Madison Square Garden, September
1980.

► Chris Campbell and Drew Abbott, Cobo
Arena (Detroit), 1980.

▼ Cobo Arena (Detroit), September 1975.

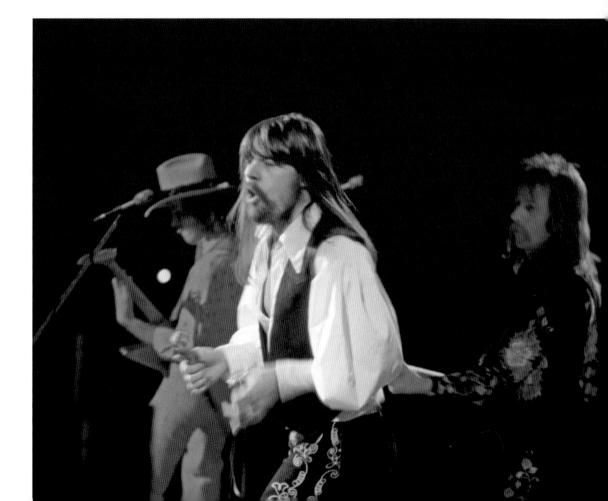

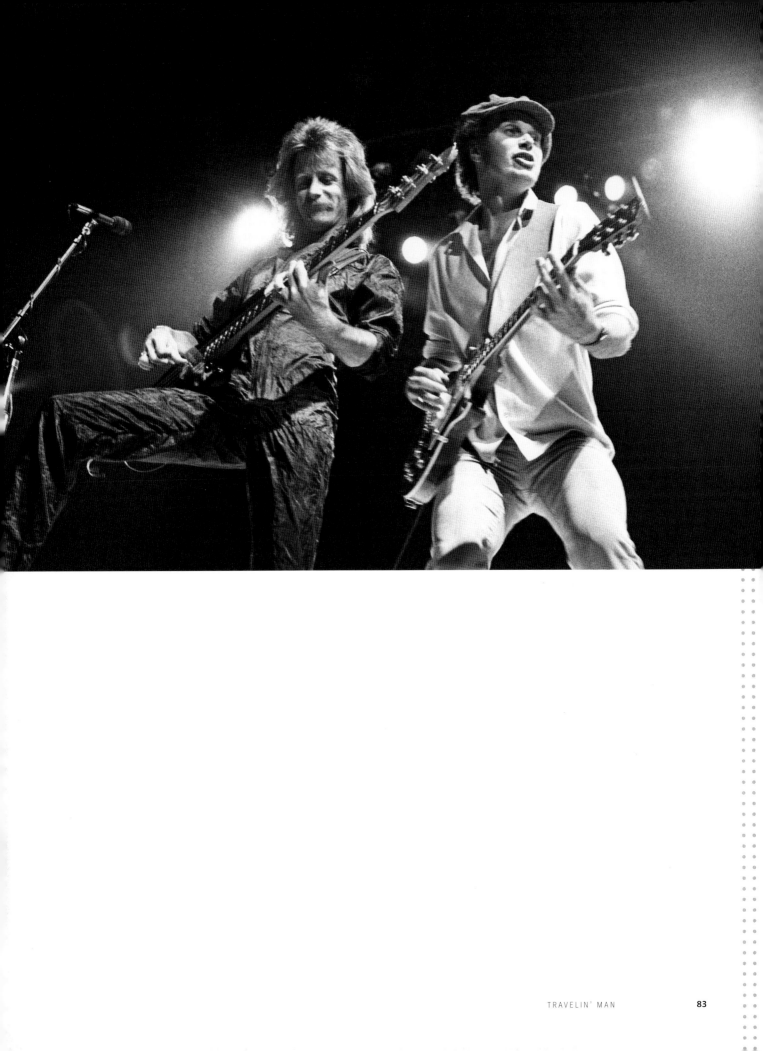

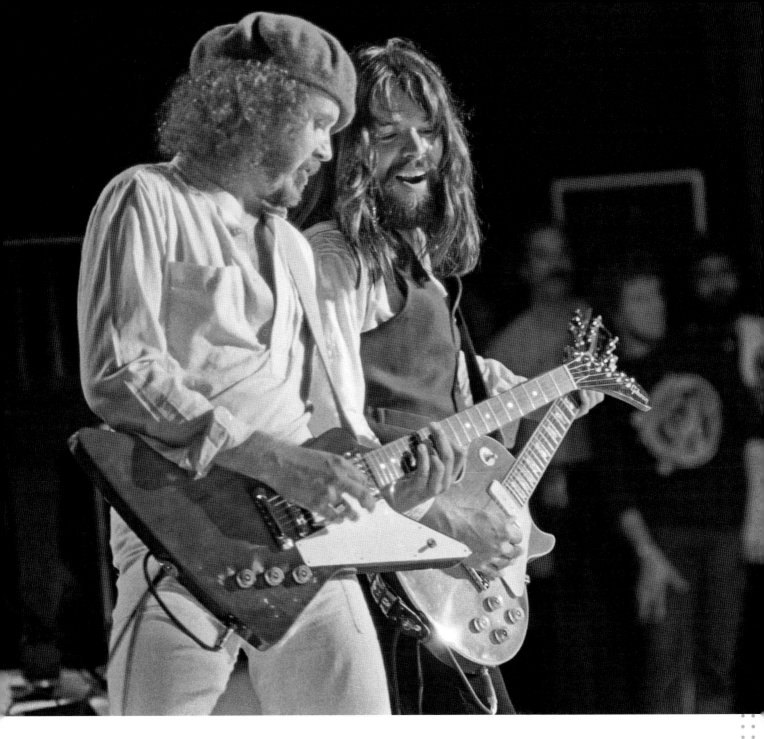

▲ With Drew Abbott, Cobo Arena (Detroit),
winter 1978.

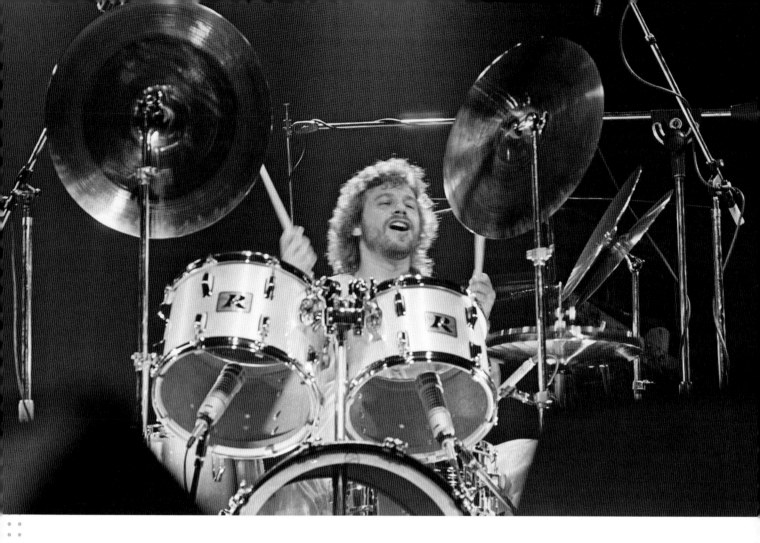

▲ David Teegarden, Madison Square Garden, September 1980.

TRAVELIN' MAN

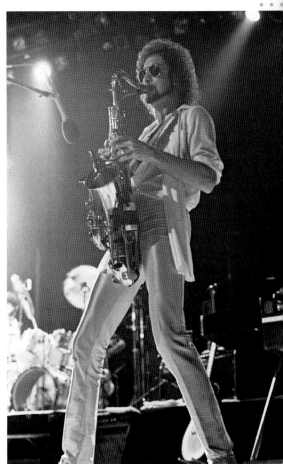

At Bob Seger & the Silver Bullet Band's September 1980 gig at Madison Square Garden, one of the backstage visitors was Cheryl Rixon, who was the 1979 *Penthouse* Pet of the Year. I was following her around like a puppy with my camera, while Alto was like, "Leave her alone, Weschler . . ." What a gentleman.

▲ Alto Reed, Cobo Arena (Detroit), winter 1978.

◄ Alto Reed with Cheryl Rixon, Madison Square Garden, September 1980.

◄ Alto Reed, Martin Speedway (Martin), summer 1977.

◄ Alto Reed airborne, Pine Knob Music Theatre (Independence Township), summer 1977.

► Alto Reed, Madison Square Garden, September 1980.

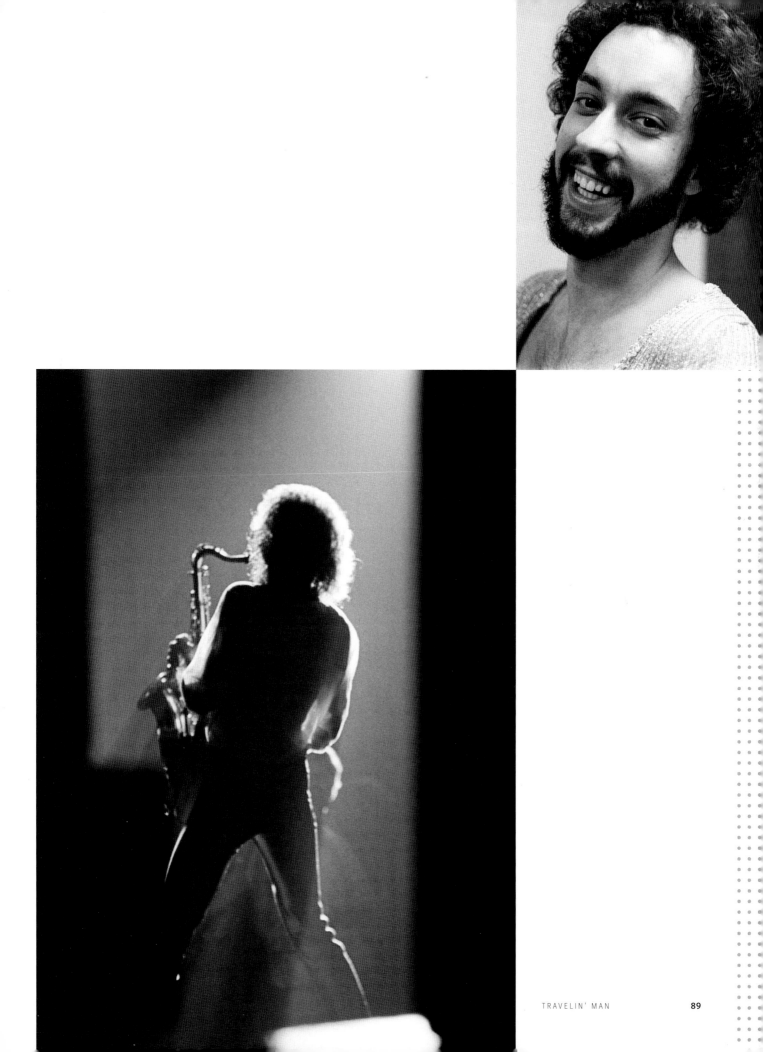

Alto was a showman, this dude who was all over the place with his sax. We needed that, because Bob mostly stood there with his guitar and delivered the vocals like nobody else but didn't move around much. People like movement, so serious stage activity can get you over with the crowd real good!

▸ Alto Reed, Cobo Arena (Detroit), September 1975.

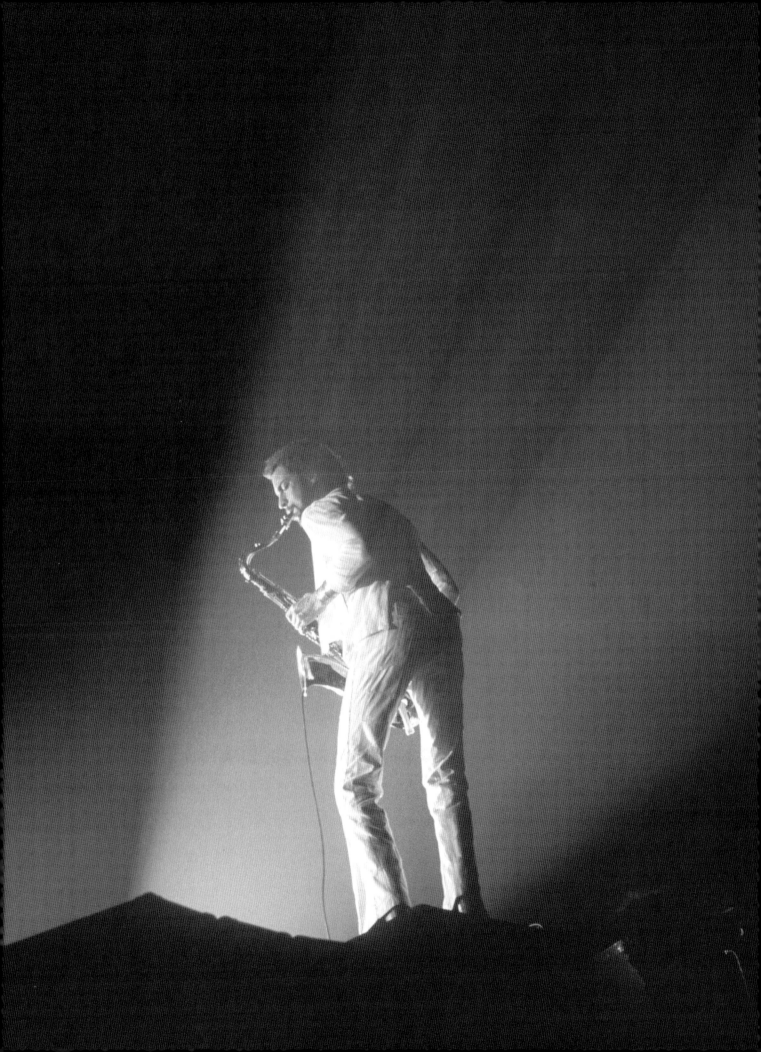

Bob accepted his gold record for the *Night Moves* album at Cobo Arena. Most of the first gold and platinum record parties were held there after a gig. The party for the *Live Bullet* gold record was great—people were blowing little noisemakers, and someone even sprayed Punch with Silly String. The party surprised Seger because he didn't know what was coming. All the Capitol execs were there, even guys from Japan. They presented him with a special gift: a portable suitcase phone, which at that time seemed like something from *Star Trek*. Everybody was flying high. Punch had a smile from ear to ear. Gold records were distributed to everybody in the band and the crew—I even got one!

▼ *Night Moves* gold record presentation, Cobo Arena (Detroit), winter 1977: (left to right) Walter Lee (Capitol Records, Hollywood), Bob, and Craig Lambert (Capitol Records, Detroit).

▶ *Night Moves* gold record presentation, Cobo Arena (Detroit), winter 1977.

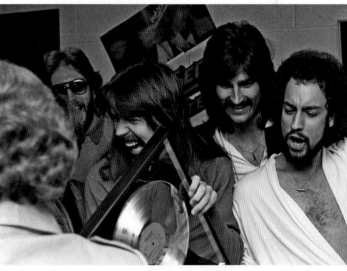

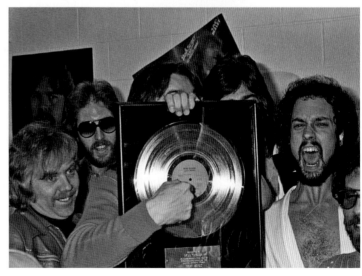

Capitol had good promotion men. Craig Lambert was our main promotion man in Detroit. There were others before him, but he would go to any length to help Seger. Let's say a DJ at WTAC in Flint called Capitol and said, "I ran out of Seger singles." Lambert would drive up there and give him records the same day—not mail them—just to keep Seger going all the time. He worked his ass off for Seger and found him airplay everywhere. Plus, every girl in the record business had a crush on Lambert because he was, well, Lam-*beau*!

▼ Punch Andrews, Craig Lambert, Rosalie Trombley, and Alto Reed, *Live Bullet* gold record presentation, CKLW (Windsor, Ontario), fall 1976.

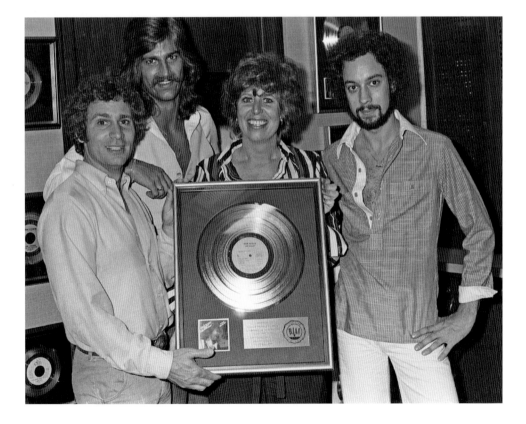

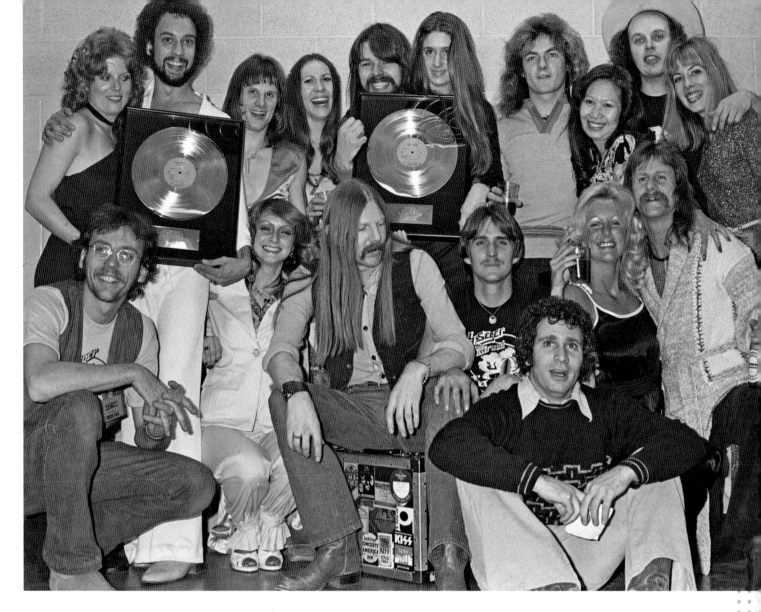

▲ Silver Bullet Band and crew,
Cobo Arena (Detroit), fall 1976.

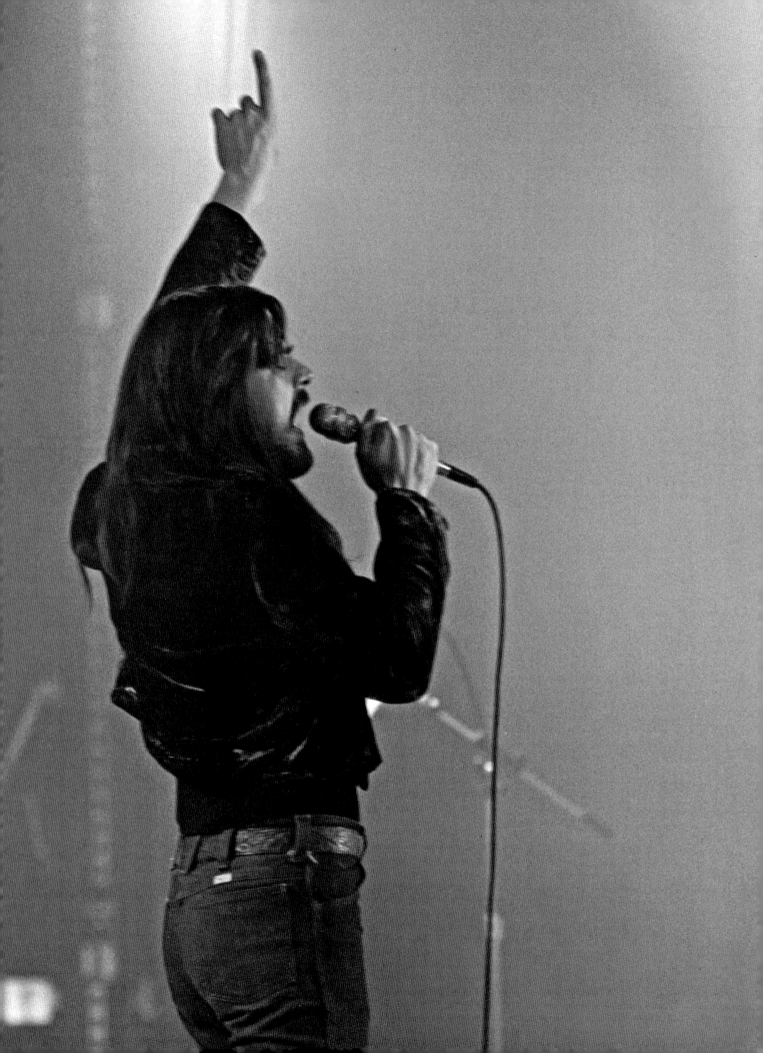

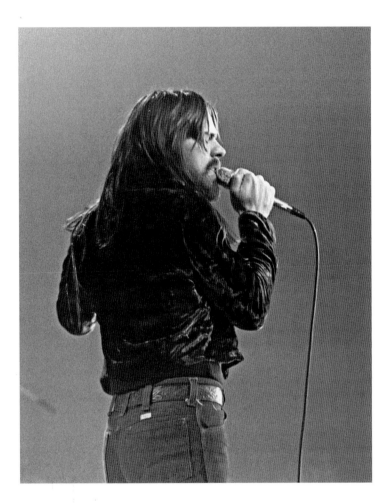

◄ ▲ Cobo Arena (Detroit), winter 1976.

▶ Michigan State University
(East Lansing), fall 1976.

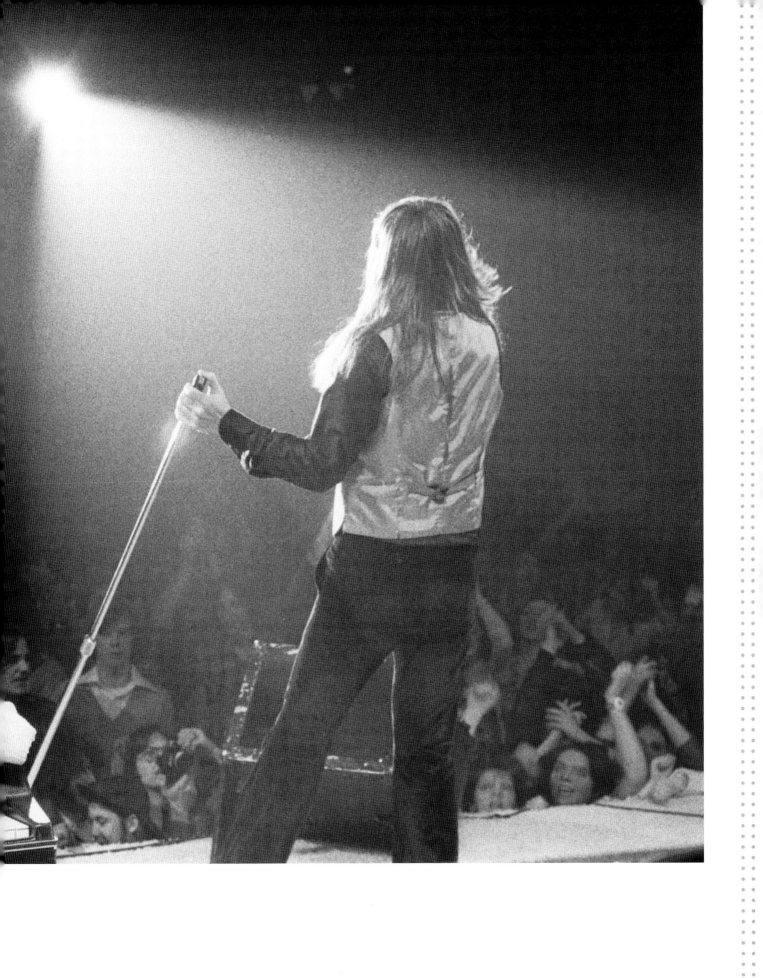

We're walking down the street to the Birmingham Camera Shop one day. Bob wants to buy a camera, when this guy, a businessman wearing a suit and tie, comes up to him and says, "Wow! You're Bob Seger!" and Seger replies, "Yep. I am." The guy asks, "Could you give me an autograph?" Seger answers, "Sure. Got a pen?" The guy pulls out a pen: "Shit, I don't have any paper." So he pulls a check out of his checkbook, and Seger says, "Wait a minute. You want my autograph on a check? I don't think so. Let's get a piece of paper from the store." He went out of his way to find the guy paper for an autograph.

◄ Press conference, Somerset Inn (Troy), June 26, 1976, with Max Kinkel (CKLW News).

Bob was being interviewed at the Somerset Inn by CKLW newsman Max Kinkel before the 1976 concert at the Pontiac Silverdome, which was called Pon-Met Stadium back then. I wasn't working for them directly at the time, but Bob told me he was going to do the interview and asked me to "Come and take some shots," so I did. The show itself was huge—a big deal. They sold out; it was a great show. Seger did an excellent job—but he wore this white suit, like Elvis. Some of the guys on the crew were like, "What the fuck is that suit about?" Although none of them would say anything to Bob about it—except maybe John Rapp, but, then, I guess he wouldn't either because he was too polite. After Pon-Met, though, I never saw that suit again.

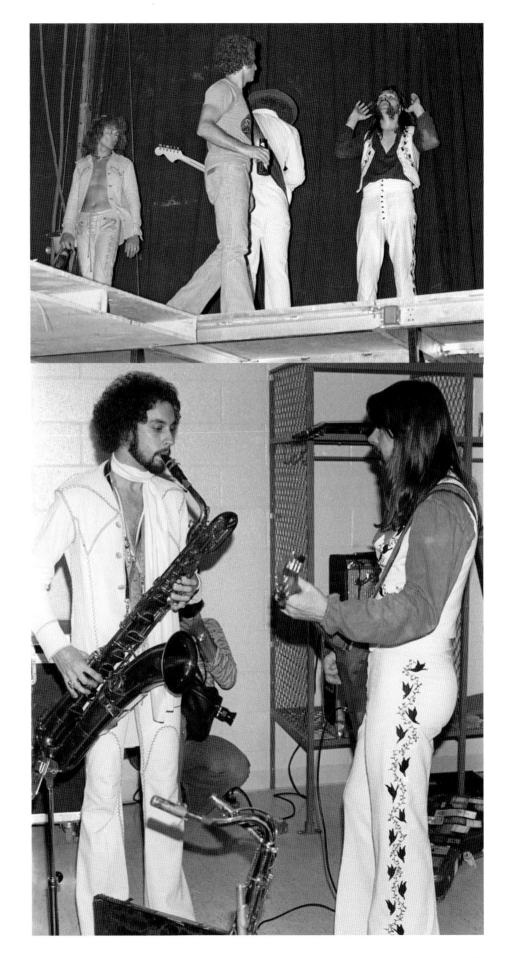

▶ Pontiac Metropolitan
Stadium (Pontiac), June
26, 1976.

▶ With Alto Reed, Pontiac
Metropolitan Stadium
(Pontiac), June 26, 1976.

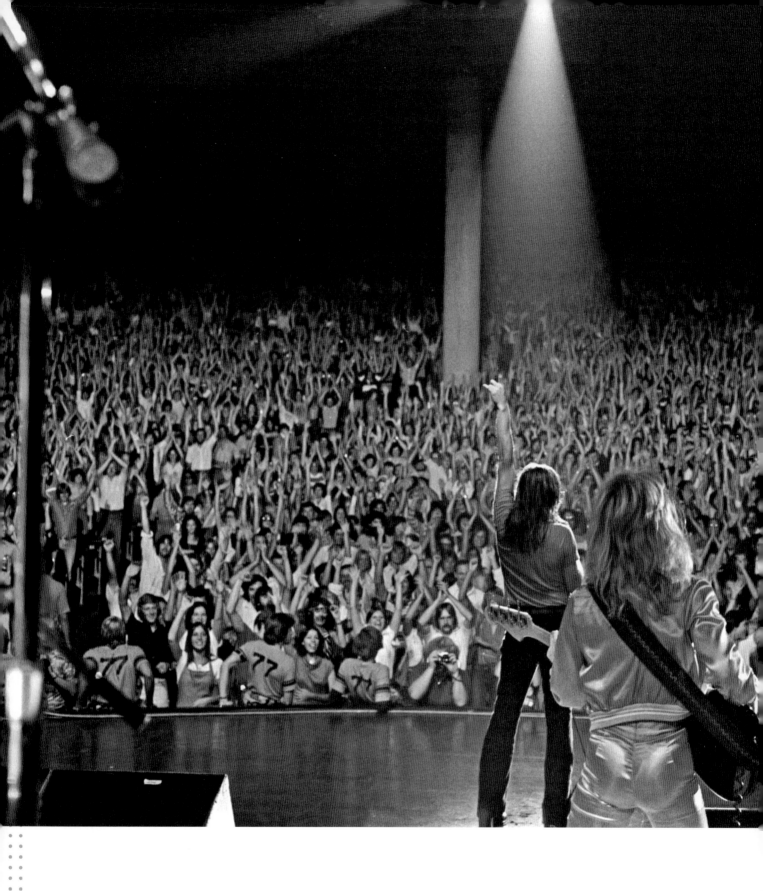

TRAVELIN' MAN

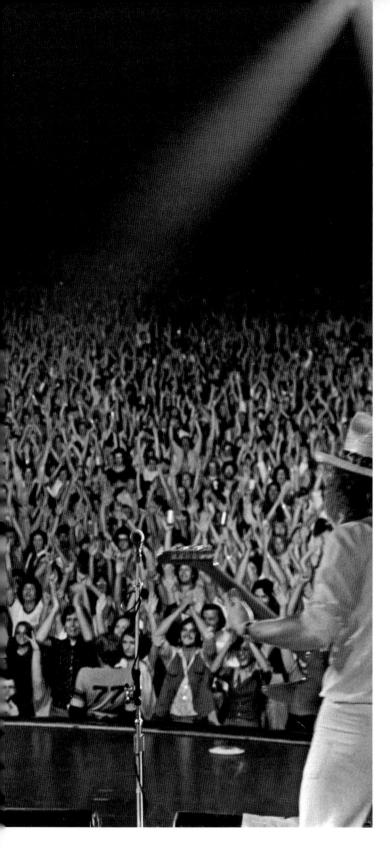

Pine Knob, the big amphitheater outside Detroit, became like Bob Seger's personal hometown club. He couldn't have played there when I was working for him; he didn't yet have that big of a following—big enough to fill 1,500 seats but not 15,000. But after he got big, he could play there and sell it out any time he wanted, and four nights in a row was not uncommon. He could have played there a whole week, every day, but Punch didn't want to oversaturate the market. I give Punch credit for that kind of stuff. His thing was to take Bob to other markets and make people want him to return and play Detroit. We went out on the road a lot more than we played in Detroit, and it worked. Lots of people came out to see him play whenever he came back.

◄ Bob Seger & the Silver Bullet Band at Pine Knob Music Theatre (Independence Township), summer 1977.

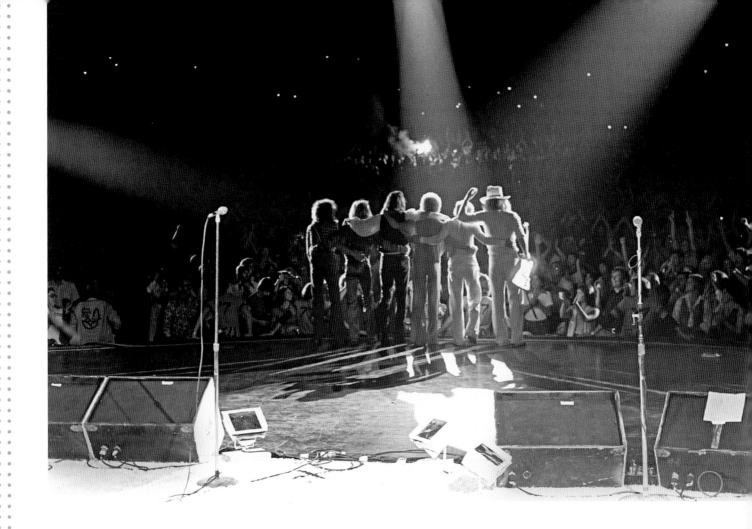

◄ ▼ Bob Seger & the Silver Bullet Band at Pine Knob
Music Theatre (Independence Township),
summer 1977.

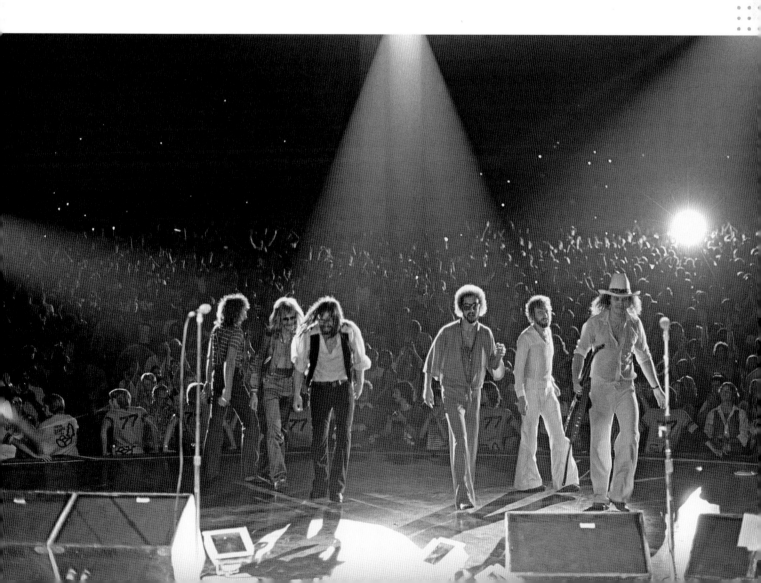

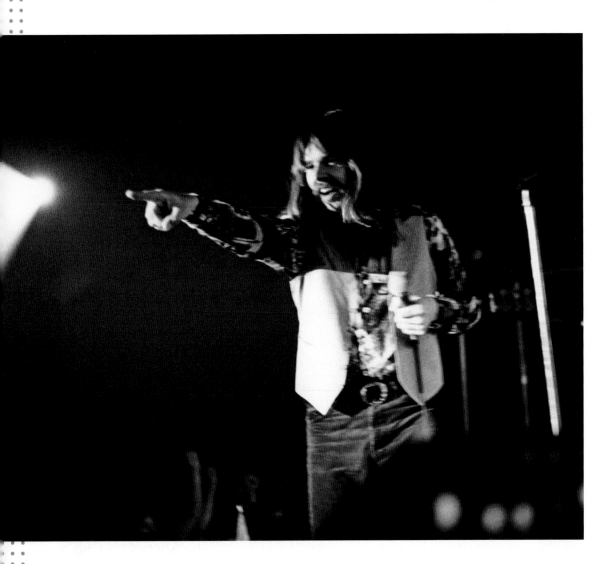

▲ Michigan State University
(East Lansing), fall 1976.

▶ Cobo Arena (Detroit), spring 1979.

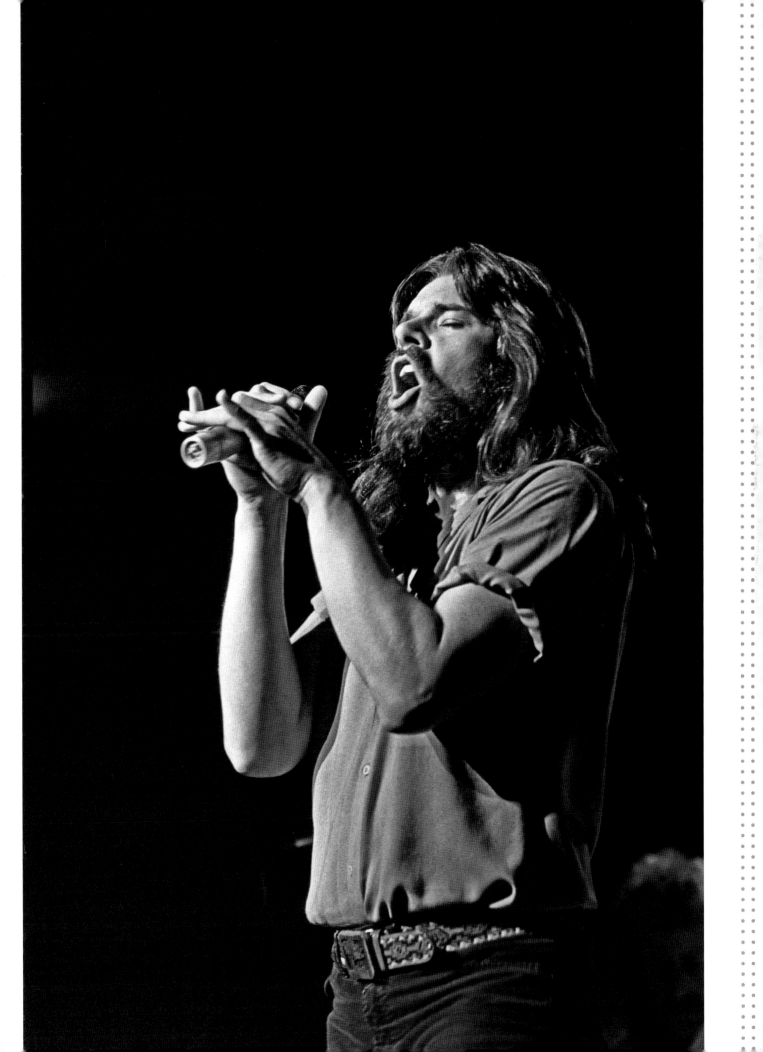

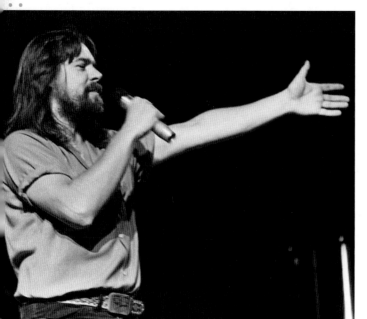

◄ Cobo Arena (Detroit), spring 1979.

▼ Cobo Arena (Detroit), 1980.

▶ Wendler Arena (Saginaw), winter 1977.

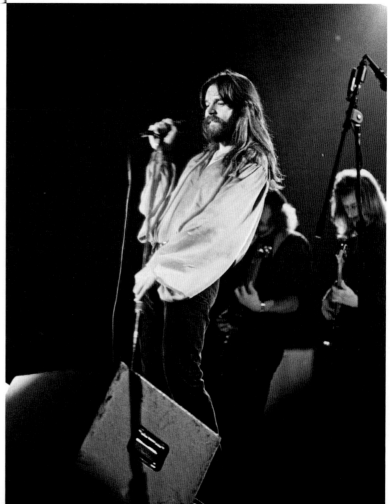

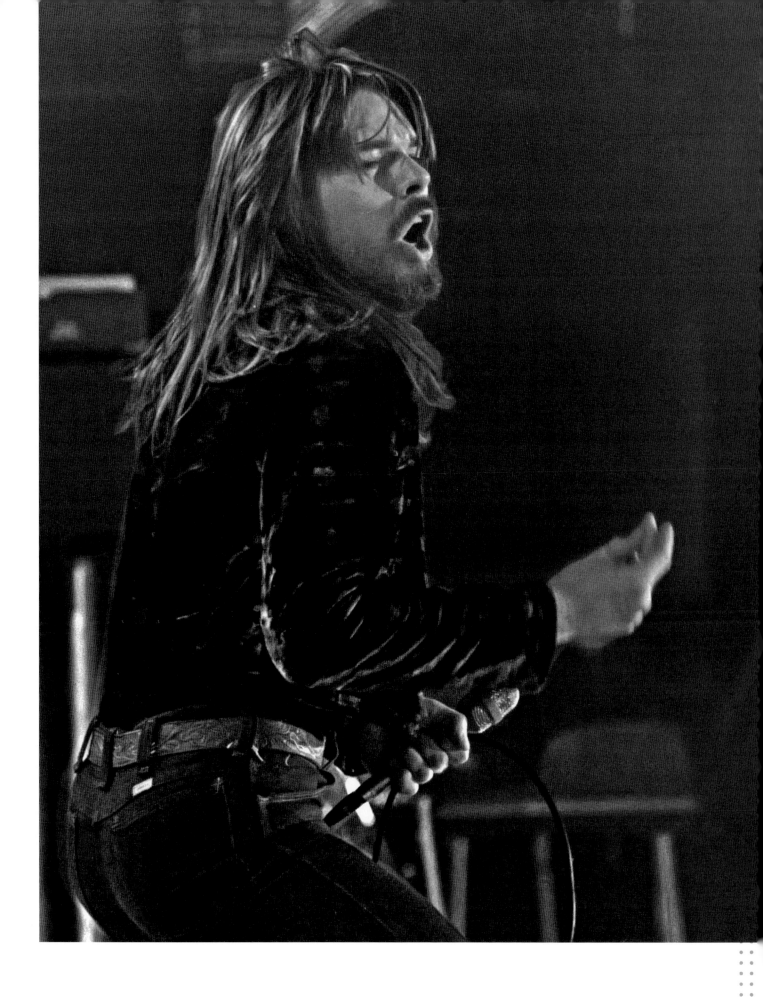

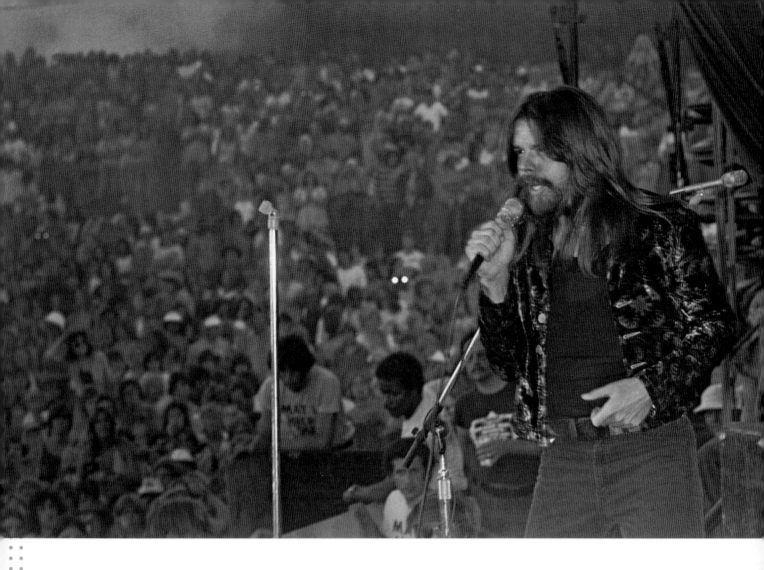

▲ ▶ Michigan Jam (Martin Speedway, Martin), July 2, 1977.

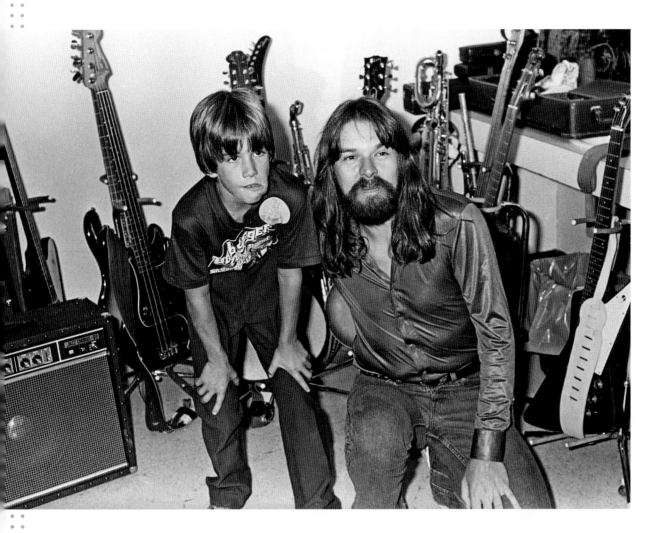

Seger was always such a nice guy, kinda shy. He'd talk to strangers who wanted autographs, but not for too long. That's why I think he endeared himself to a lot of people around here. He was like the guy next door. But, man, when he stepped on stage, look out! That boy became a fire-breathin' vocalist with a story to tell!

▲ With a fan at Pine Knob Music Theatre (Independence Township), summer 1977.

▶ Press conference, Northfield Hilton (Troy), 1977.

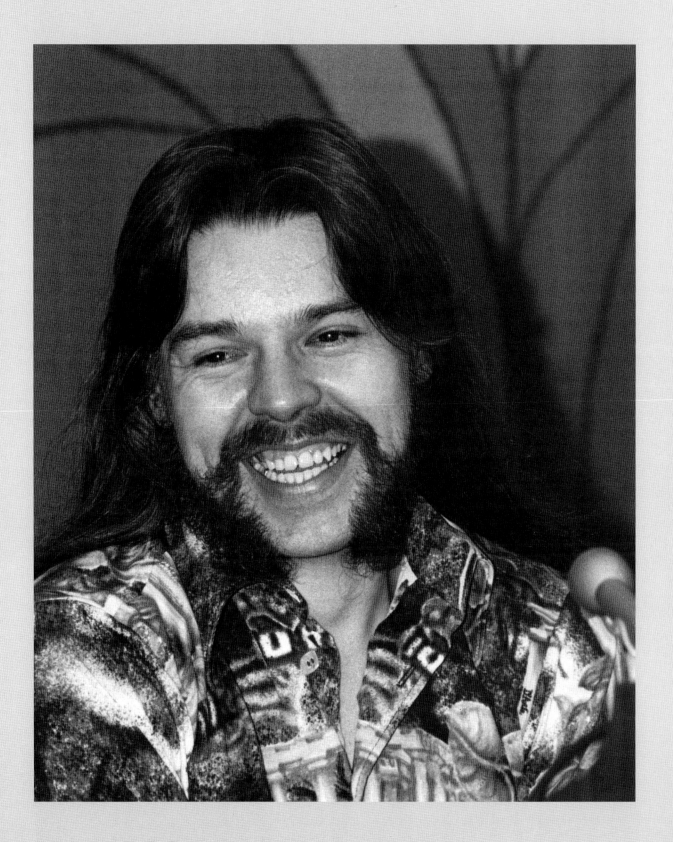

▲ From the left: With Mike Diamond, Les Garland, Rosalie Trombley, Tim Trombley, Dave Sholin, Craig Lambert, and Todd Trombley, Pine Knob Music Theatre (Independence Township), summer 1978.

◄ Michigan State University (East Lansing), fall 1975.

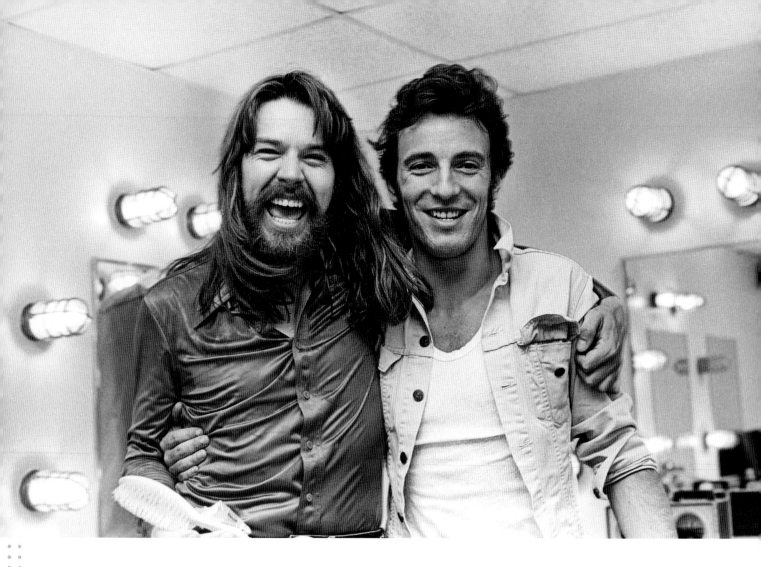

▲ With Bruce Springsteen, Pine Knob Music Theatre (Independence Township), September 2, 1978.

Bruce Springsteen was in town on September 1, 1978, playing the Masonic Auditorium, and Seger was doing four nights at Pine Knob. Ken Calvert, who was then a Columbia Records promotion guy, called me to say Bruce wanted to meet Bob, and he'd like to bring Bruce out to the September 2 show, maybe shoot some photos and all that. Bruce and Calvert came into the dressing room with Jon Landau, Bruce's manager, right after the show—hence the sweat on Bob in the photos. Rosalie Trombley from CKLW was there, too, with her son Tim and Herb McCord, also from CKLW. I asked John Rapp, Bob's bodyguard, to keep everyone else out so I could shoot some photos of this first meeting between two great artists. After we finished with the photographs, I signaled to John Rapp to let 'em in, and the place got packed with well-wishers and press people and everyone else who was invited to that very special night's activity.

▲ With Bruce Springsteen and Ken Calvert, Pine Knob Music Theatre (Independence Township), September 2, 1978.

◄ With Bruce Springsteen, Pine Knob Music Theatre (Independence Township), September 2, 1978.

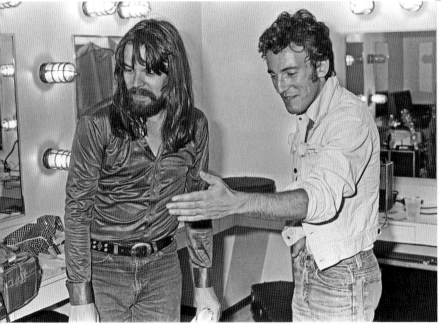

George Seger showed up often to see his brother perform. They were good friends, obviously really tight—emotionally and physically. The resemblance is striking: put the long hair on George, and he's Bob, a few years older.

▼ George and Bob Seger, Cobo Arena (Detroit), spring 1980.

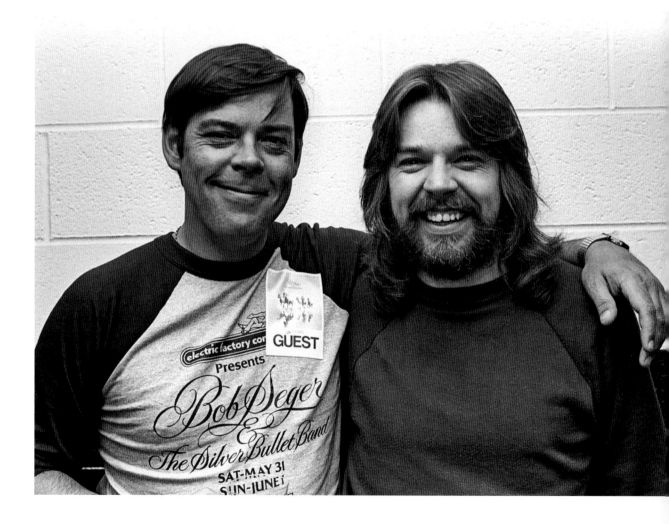

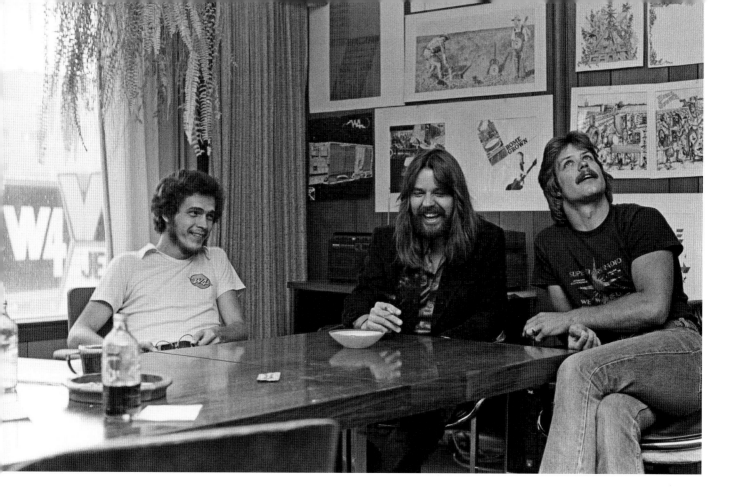

▲ With Joe Urbiel (left) and Jim Johnson
(right) at W4 Radio (Detroit), June 1979.

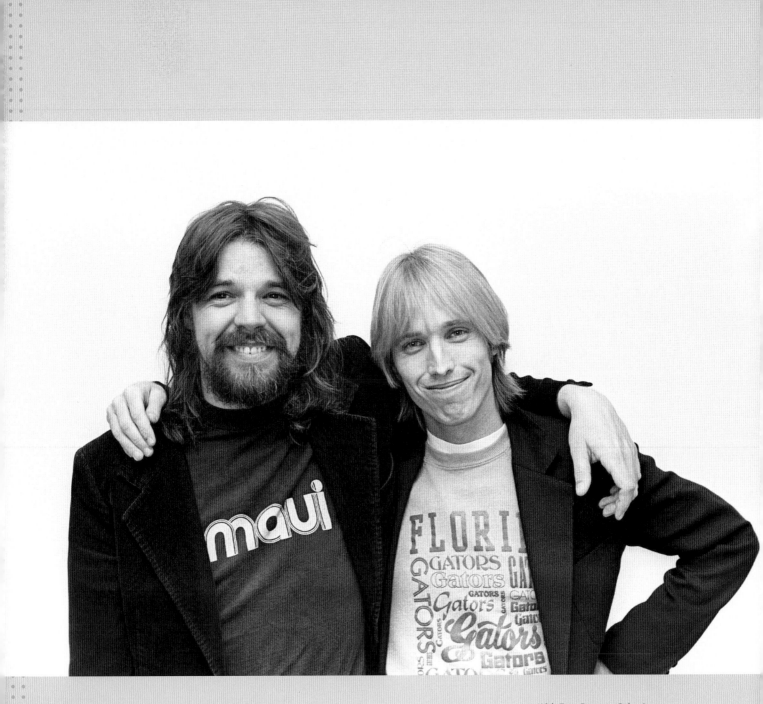

▲ With Tom Petty at Cobo Arena (Detroit), June 1979.

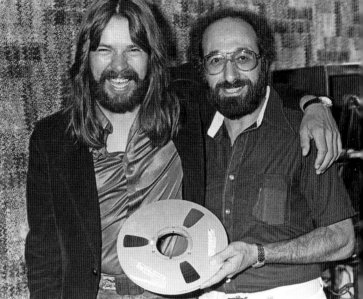

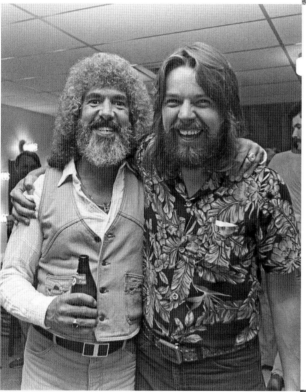

▲ With Paul Christy, WNIC (Dearborn), summer 1979.

◀ With Arthur Penhallow, Pine Knob Music Theatre (Independence Township), summer 1980.

▼ Sirius Trixon, Old Parthenon Restaurant (Detroit), fall 1984.

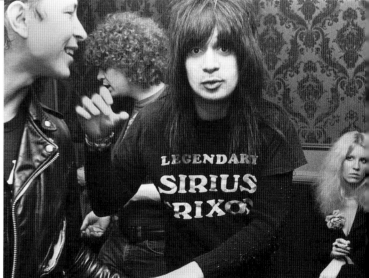

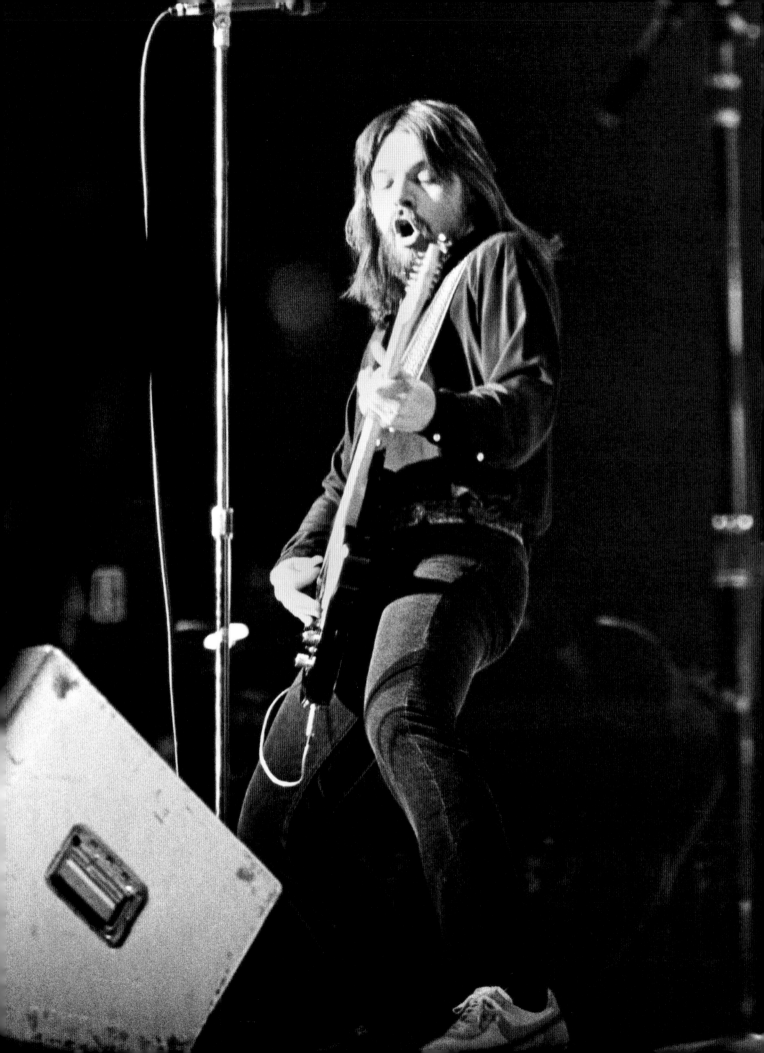

What counted most was that Bob dug what was going on. If he was happy, everybody was happy. If Seger wasn't happy, nobody was happy. He was the boss.

◄ Madison Square Garden, September 1980.

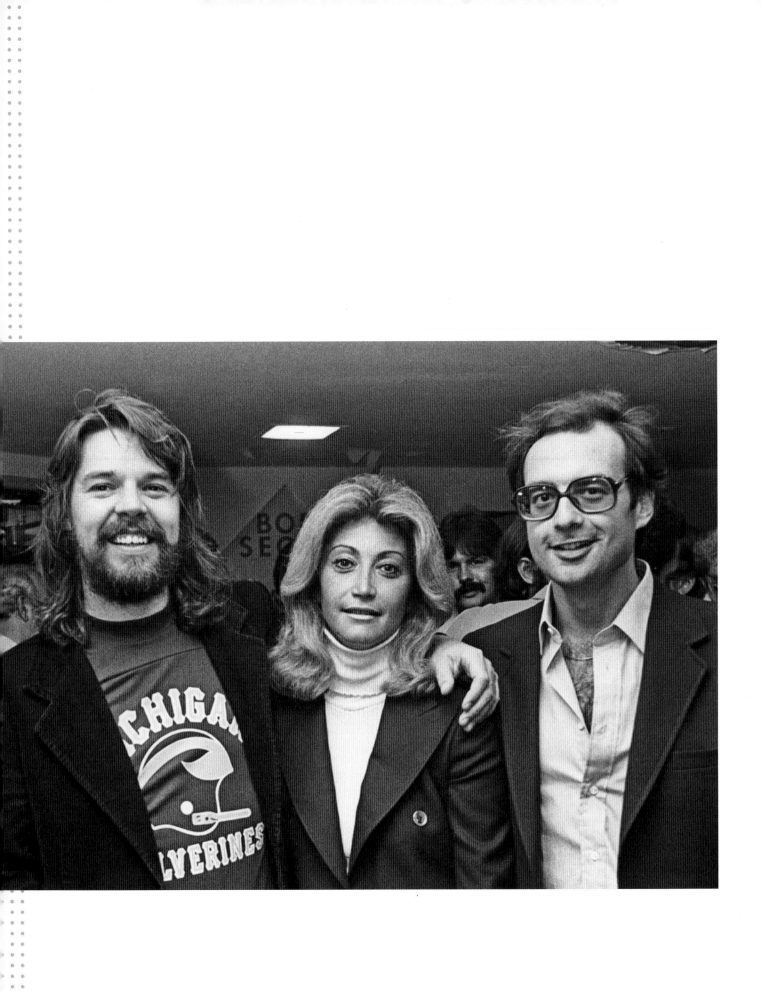

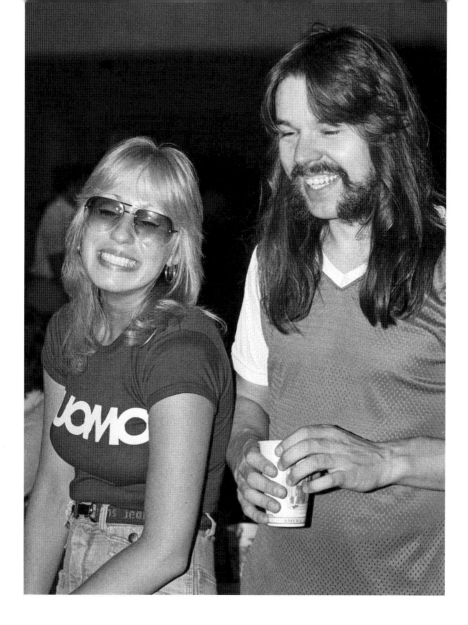

▲ With Karen Savelly, 1981.

◄ With Sylvia and, to her left,
 David Handleman (Troy), fall 1981.

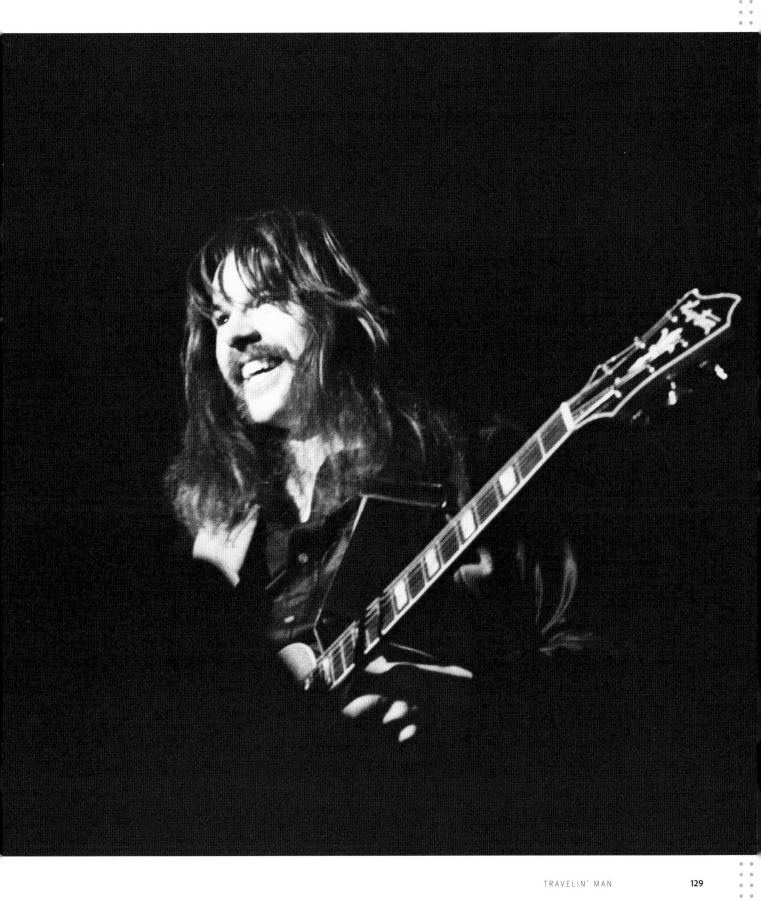

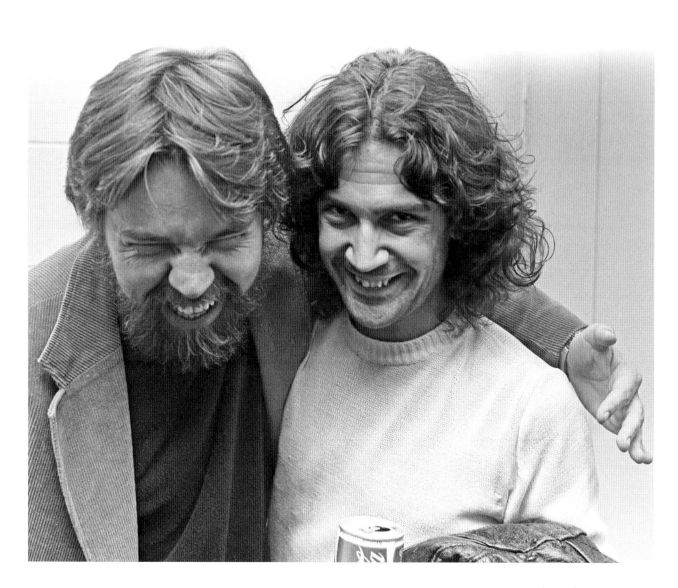

▲ With Billy Squier, Cobo Arena (Detroit), summer 1982.

After I stopped working for him and he grew more famous, Bob still wanted me to take the photographs of him getting gold records or doing interviews or most anything. He trusted me: he knew I wasn't going to send out bad pictures of him. So I was lucky in that respect. You'll see Seger in photos with DJs and other record business people, and he's usually looking right at me. I don't know if he was being obstinate with the other photographers or just treating me better, but it always made me feel good to know I could get the shot.

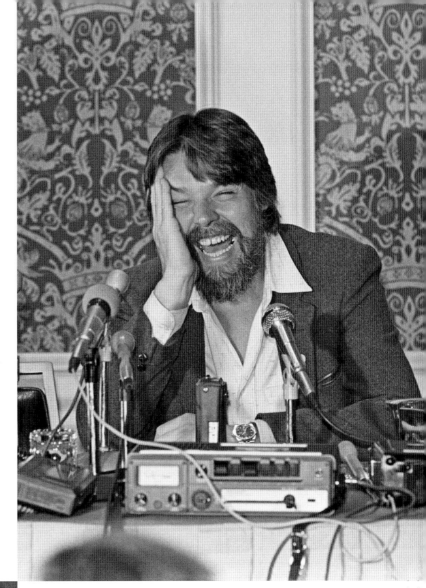

Convenient Ticket Co. (CTC) Award presentation, Northfield Hilton (Troy), February 25, 1983.

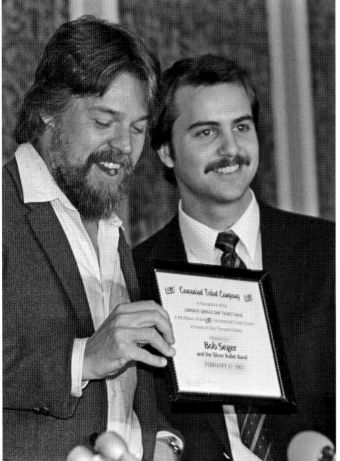

Seger wasn't really big on press conferences and big media events, but he agreed for certain special circumstances. This one was held on February 25, 1983, at the Northfield Hilton in Troy when CTC (Convenient Ticket Company)—the predecessor to Ticketmaster—presented Bob with a plaque to commemorate the fastest single-day ticket sale (more than 60,000, which was huge in the early computer days) in the company's history.

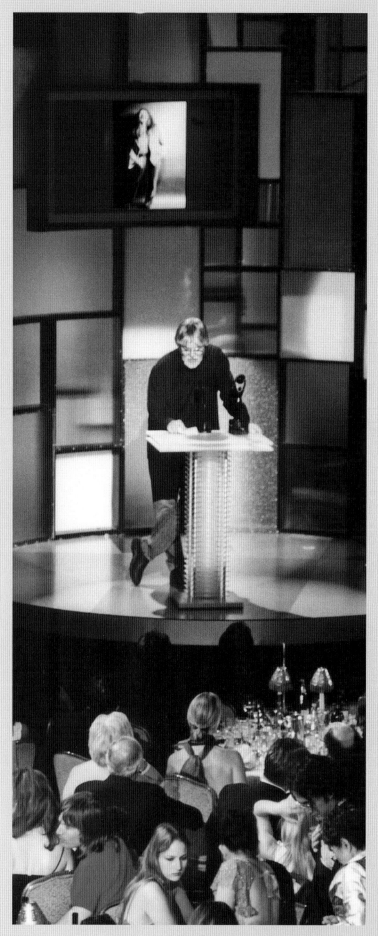

▲ Kid Rock, Rock and Roll Hall of Fame
induction ceremony, Waldorf–Astoria Hotel
(New York), March 15, 2004.

▶ Rock and Roll Hall of Fame induction
ceremony, Waldorf–Astoria Hotel (New
York), March 15, 2004.

Bob's induction into the Rock and Roll Hall of Fame in 2004 was special, like a victory for all of us—especially those of us who had been involved in the early days. On a media credential trip to shoot photos for *Hour Detroit*, I drove to New York with Jeanette Frost, a great model I was working with at the time. When we arrived at the Waldorf-Astoria Hotel, Punch was standing in the lobby talking with a bunch of people, Jeanette walked up to him and said, "Uncle Punchy, how you doin'?" (When Jeanette was younger, she would attend all of the gigs around Michigan with her uncle, the fabulous Craig Frost, former member of Grand Funk Railroad and the Silver Bullet Band's keyboard player since 1979.) Punch asked Jeanette, "What are you doin' here kiddo?" She answered, "I came with Tom" and pointed toward me. Punch yelled, "Weschler get over here!"

Nobody was allowed to go into the ballroom during the ceremony other than the Hall of Fame's official photographer, one of the best in the business—Bob Gruen—and me. The organizers allowed me in during Seger's induction only because they had licensed so many of my photographs of Seger to use for their presentation that they felt I was part of their "club." I had my own personal "escort," a security guy who took me everywhere. When I told him, "I don't want to go on the floor, man. I want to go to the balcony, where I can get the whole scene," he was like, "Really? That'll make my job easier." So we went up to the balcony, where I was able to shoot pictures of the whole band playing. Afterward, he took me into the press room.

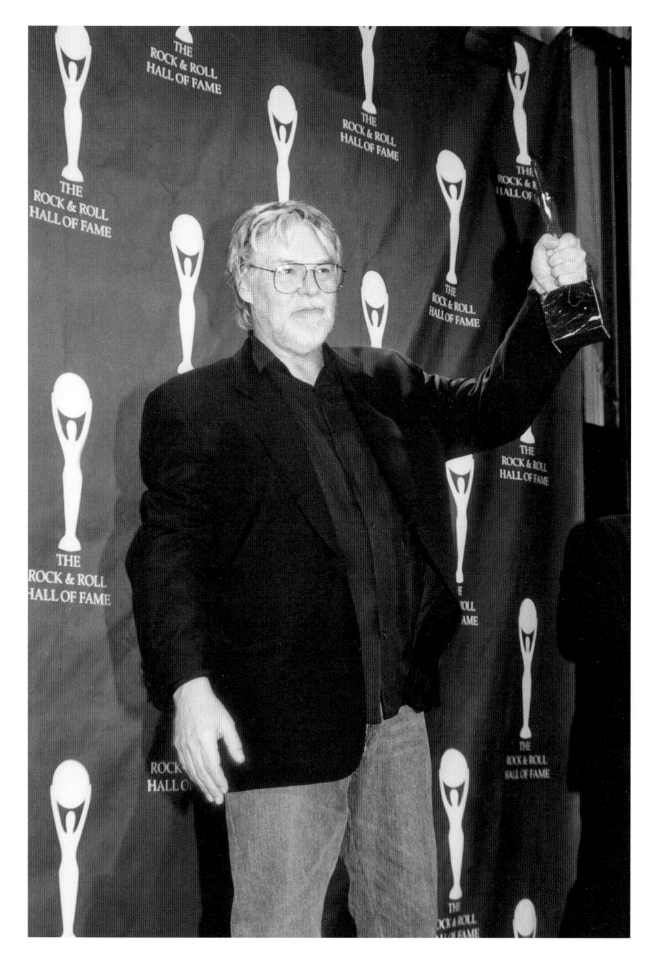

Bob was very excited. He was talking to the world press—Japan, Indonesia, England, Germany, France, everybody was there. I hadn't seen him in two years, but I wound up standing right next to him before he went in, and he turned around to say, "Hi. What's up, man?" And I answered, "Yeah, how you doin'? Congratulations." I don't think he realized that it was me standing next to him. But when I was down in front with the other photographers, in my element, he looked down from the staging area and said to the other band members, "Hey, there's Weschler!" and held the trophy up for me to get a nice shot of it. After that, I went backstage and we said hello and talked for a few minutes before he split back up to his room with his family.

▲ With Nita Seger, Rock and Roll Hall of Fame induction ceremony, Waldorf–Astoria Hotel (New York), March 15, 2004.

MONGREL

We were at GM Studios on Nine Mile Road near Gratiot Avenue in East Detroit while working on *Mongrel*, and on a corner near the studio was a small, family-owned restaurant with good home-made cooking. We'd go there for lunch. In a frame on the wall they had a colored etching of a little girl feeding her dog. Seger took to that picture and told me, "That could be an album cover." The image was owned by a printing company. Punch called them for permission to use it, and they told him to go ahead, no big deal. I was a bit disappointed because I thought I'd get to do the album cover.

They did need some photos for the album's back and the inside foldout, though, so at least I got to shoot those. On the back of the album was a photograph I took of Bob in Cincinnati at a festival in summer 1970. Dave Leone, one of our booking agents and Punch's business partner in the Hideout clubs, loved that picture so much he asked to buy the negative from me. I told him, "I can't sell it to you; it belongs to Capitol." He replied, "Fuck Capitol . . ." and had it blown up to wall size, to a 6-by-12-foot mural on his wall at Diversified Management Associates in Southfield, Michigan.

Since *Mongrel* was going to be a foldout cover, Punch asked me, "What are you gonna do in the middle?" I said, "I get to do the inside, too?" He's like, "Yeah, Weschler, you get to do the inside, too." They were probably laughing when I left. They

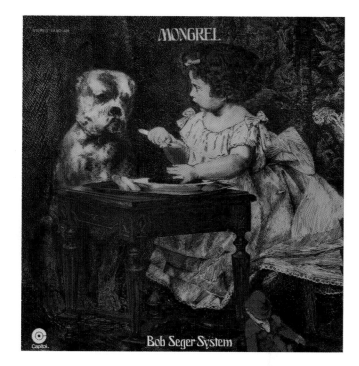

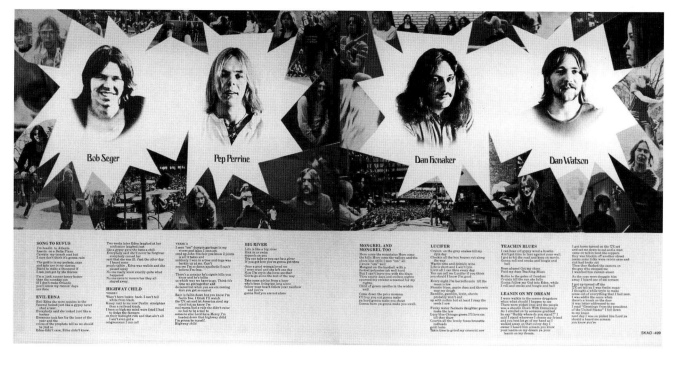

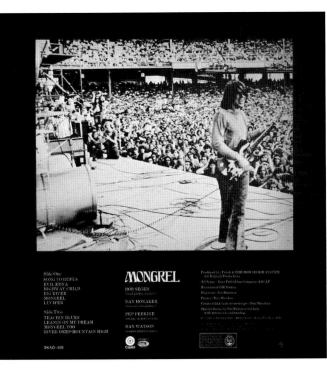

Side One
SONG TO RUFUS
EVIL EDNA
HIGHWAY CHILD
BIG RIVER
MONGREL
LUCIFER

Side Two
TEACHIN BLUES
LEANIN ON MY DREAM
MONGREL TOO
RIVER DEEP-MOUNTAIN HIGH

SKAO-499

MONGREL

BOB SEGER

DAN HONAKER

PEP PERRINE

DAN WATSON

thought it was a pain in the ass to do stuff like that. I guess they knew I loved doing album covers.

There was a big baseball game that weekend in Ann Arbor—the MC5, the Rationals, Ted Nugent, Seger, the Up, many people in the music community of Detroit and Ann Arbor would be there. I shot as many photographs as I could, selected the ones I wanted, and cut out each one to look like a shard of broken glass. The four baseballs coming through the glass are the band—Seger, Pep, Dan, and Watson. Punch saw that and said, "Let's take the baseball seam lines off their faces." I asked him, "Then what's breaking the glass?" He answered, "Stars!" "Oh."

Working on that cover was the first time I got stroked by anybody. It wasn't a DJ or anybody like that—it was guys in the band! "I get to pick my picture, man, right? . . . etc." Dan Honaker took me out to dinner; he wanted to make sure the picture we used was the one he wanted. He said, "Punch listens to you, so push for this one. My girlfriend likes it." "Yeah," I said, "and your groupies, too." It was the first time I realized I had any power.

▼ Crosley Field (Cincinnati), June 27, 1970.

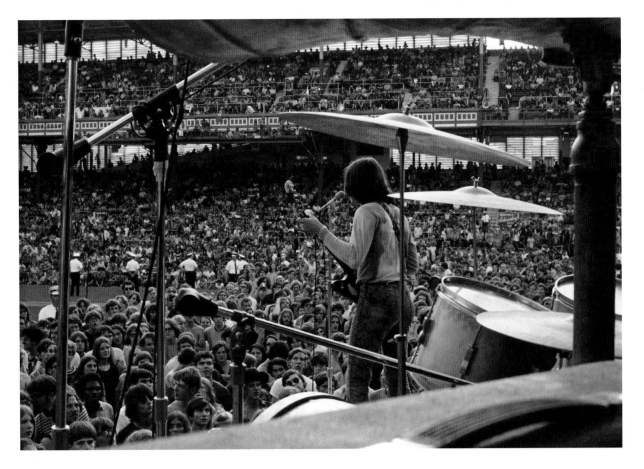

Punch had just made a deal with Capitol for Bob to put out a solo album. I went on a vacation to Europe: Krinkle (Richard Kruezkamp), who was working for the James Gang at the time, called me to say, "We're going to Europe, you want to go with me?" They were going on a European tour with The Who. Needless to say, I went along, took photographs, met new music people, and went out to dinner with Pete Townshend. But all that was sort of a secondary thing for me. I wanted to travel around Europe and photograph it like so many others had done. So I said, "Thanks for letting me hang out, fellas. I'm going on my own now." I got to Paris and then the south of France, San Rafael, Nice, Monte Carlo. When I was ready to come home, I boarded a plane in Nice. The airplanes at that airport take off parallel to the water, and as the plane was going up I was shooting out a north-facing window, which had a view of the lower French Alps.

 When I returned to the office a week later, Bob called me and said, "Come out to the house on Bogey Lake. I need some photos for the album cover, and I want a photo of me rowing a boat by myself on the lake. And I want stop signs on it." I asked, "What do you mean?" He replied, "Those glaring things that come from a lens being pushed toward the sun"—he meant the octagons coming through in direct sunlight.

 We went out on the boat, shot a few different angles, and got some good photographs. The next day, I brought the slides to the office, put them all in a slide tray, and started showing them. One of my slides from the French Alps got sandwiched in with one of Bob. Punch and Bob reacted with a positive, "Wow, that's kind of cool. What's that?" I said, "It's a mistake, just one of my slides from Europe." "Leave it there. That's fuckin' great! We can just put a title over the top." "Okay . . ." So I had a double image made, and that's how that cover got done.

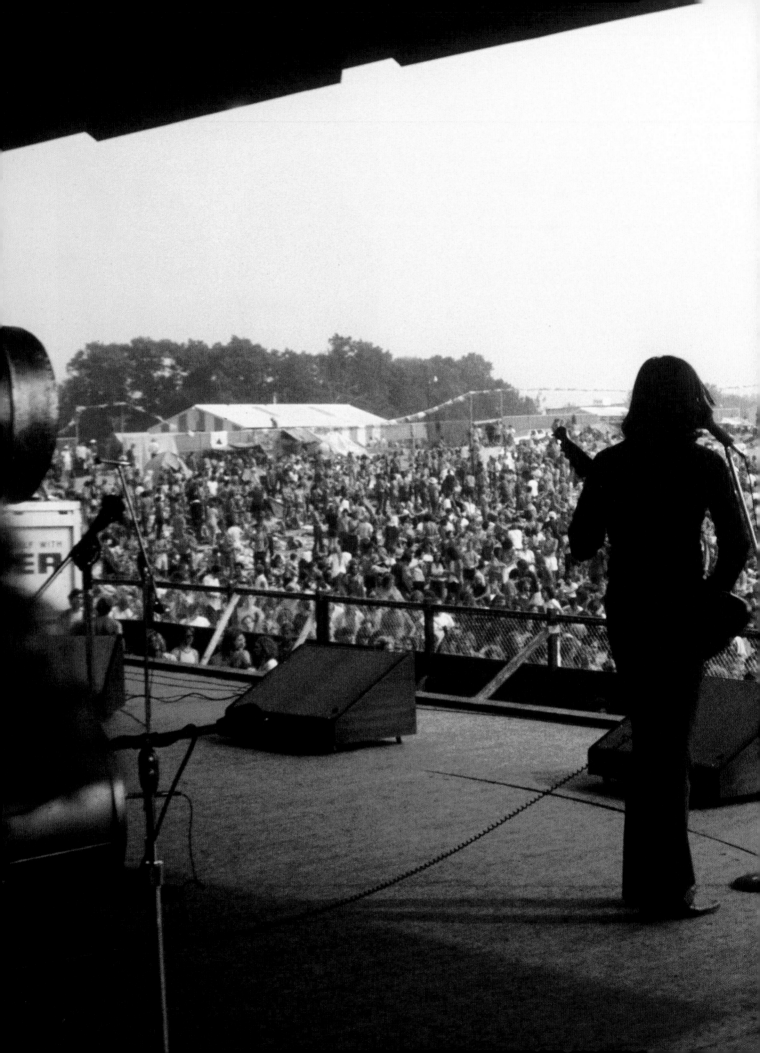

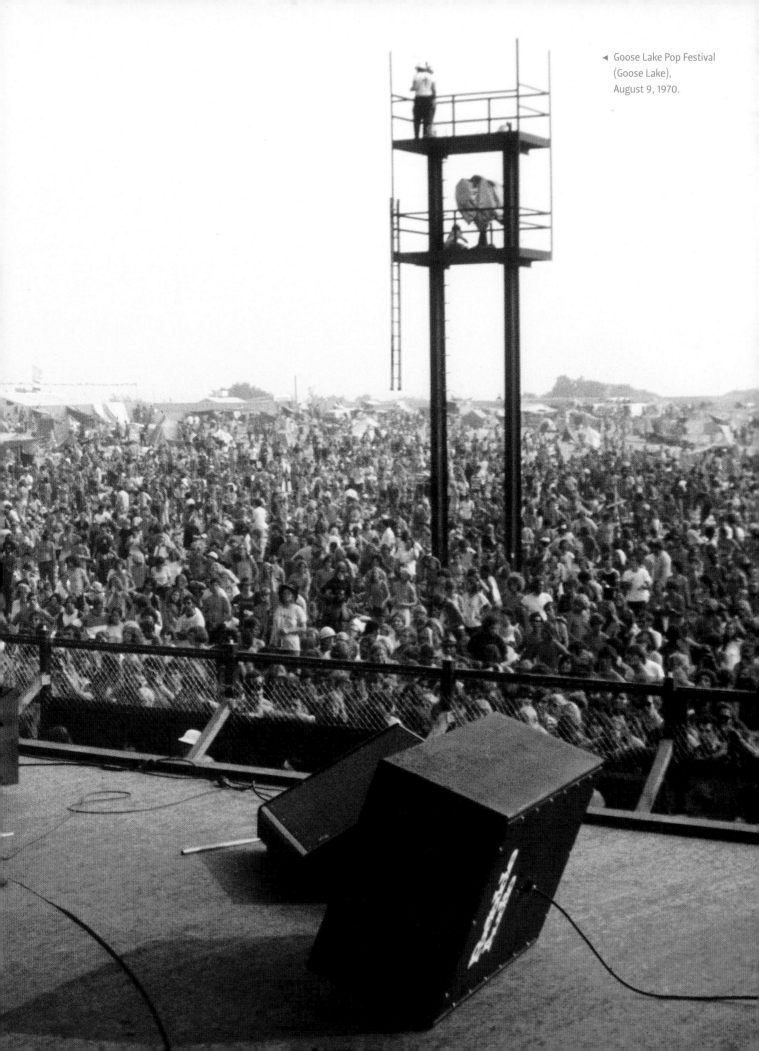

◄ Goose Lake Pop Festival
(Goose Lake),
August 9, 1970.

"Rock and Roll Never Forgets" never became an album title; it turned into *Night Moves*. But, before that, I had a great idea for a cover, explaining to Punch, "How about if we get a hot-looking girl with a great ass, put some super-short 'Daisy Duke'-style Levis on her, and just shoot the picture of her from behind." Punch asked, "How does that relate to 'Rock and Roll Never Forgets'?" "Well, you're never gonna forget that ass . . ." "Okay, but girls are gonna buy the album, too." So I thought, "Why don't we tie a pink ribbon around her finger like your mother used to do when she was trying to get you to remember something?" That was my rationale.

I knew just the right girl. When I called her and asked if she wanted to participate in this shoot, her answer was a reluctant yes. So we went to this house under construction in Bloomfield Hills, white walls everywhere, no lighting. We went on a weekend when there weren't any construction workers there and shot the photograph.

I took it to Punch, and he liked it so much that we had a cover, or so we thought. Seger saw it and said, "Yep. Go ahead and use it." Then one of the girls in the office said, "Ya know, you guys will be labeled as chauvinist pigs if you put that out." All three of us caved, and we didn't use it.

Bob tells me he's gonna call the next album *Smokin' O.P.'s*. He had been recording other people's material, and in those days some people would bum a cigarette by saying, "Give me an OP," and "OP" meant "other people's." The title made sense—"smokin'," because he was literally blowin' the other people's versions away. Bob was smokin' them on their own tunes. He came up with the title and told me, "Come up with a cover."

I didn't have any ideas at first. I went out that night to see some bands playing around town and stopped at our local grocer/party store Kakos just a block from our office to pick up some smokes—back then I smoked Camels. I took one look at a Lucky Strike cigarette pack and said to myself, "That's it!" I jumped back in the car and sped back to the office. Now, back in those days, there was no Photoshop or Adobe Illustrator, so I used a Frisbee to cut out the big red circle from Cello-Tak in the middle and added some burnished type on an overlay to create the album cover design. Quite simple. I called Seger at two in the morning to tell him, "I got the album cover. You're gonna love it." He asked, "What is it?" After I described it, he said, "Sounds great! Show it to Punch."

So I zipped over to Punch's the next morning. His reaction was quick and to the point: "That's the cover. Done! Don't even think about another cover." Seger came in to see it and was impressed.

It's featured, along with *Mongrel*, in Michael Ochs's *1000 Record Covers* (Taschen Books, 2005).

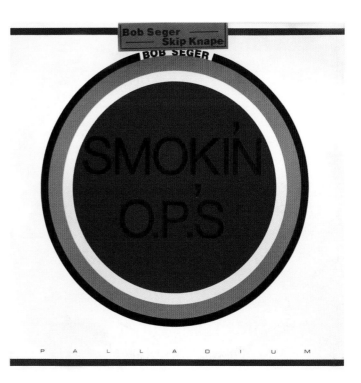

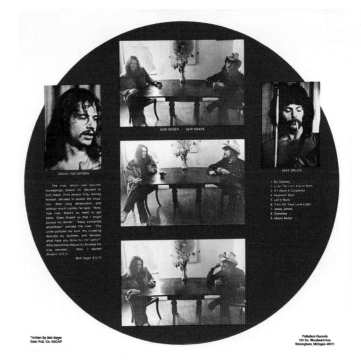

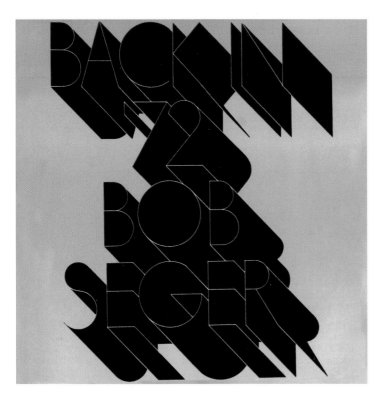

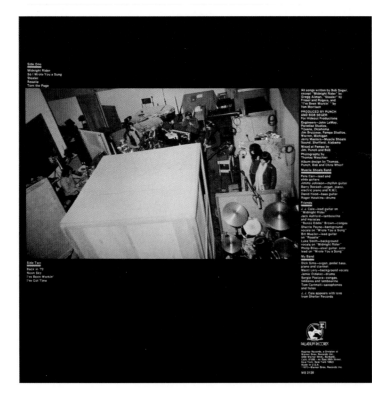

The presidential election came to mind first: we were going to do stars and stripes, but Punch thought that would be a drag because of politics, and Bob didn't really like the idea, so we nixed it. Carol Bokonowicz, who did a lot of artwork, designing posters and logos, for us and for Palladium, came up with a line drawing of *Back in '72* with Nixon on it. It was better than the one we actually did use (in my opinion). This guy named Chris Whorf came up with that taxi–cab yellow and black color scheme. Bob liked it, and Warner Bros. needed it right away, so it was all a bit of a rush. I sent it, with instructions, to Warner Bros.' art department.

The photograph I shot for the back was done at Leon Russell's Paradise Studios near Tulsa. We intended to put song titles and other copy from the album cover verso on the big wooden box in the middle of the photograph, which would have worked well with many of the musicians around the outside edges. But, in the rush to finish it, no type was placed on the wooden box—a lesson learned.

This one is a story from album-cover hell. We had an absolutely dynamite painting by Robbie Fleischer. It was Bob's seventh album, so we wanted someone to paint a picture of a Seagram's 7 bottle, except it was gonna be titled "Seger's 7." Robbie did a great job emulating the bottle of whiskey and the logo change. We called the Seagram's office in New York and told them what we had planned. They asked to see it, since their initial thought was it would be free promotion for them. They said it was fine and that they didn't have a problem as long as we didn't use the word "Seagram's," so we thought everything was cool.

We sent the album artwork to California two days before it was scheduled to go to press, but then Warner Bros. called us in a panic: "We can't use this cover, man. Our lawyers are afraid Seagram's will sue us." I said, "Fellas, we got permission to use it." They answered, "We don't care. We're not doing it. That cover's dead. You want your album to come out, think of something else."

So in two days I had to come up with an album cover. I went upstairs to my little art room/office and sat there playing with ideas. To me, "seven" is dice, so I put dice rolling with seven different colors dropping into the little black dots, and that was it. I wasn't that happy with it at the time, but Bob seemed to like it. Punch liked it, but he wanted to put a word in there: "contrasts." Why? He said, "Just put it on there." "Okay, boss, whatever you say." He was the chief, so we added "contrasts."

On the back, one of the photos I used of Bob playing piano was taken by Scott Sparling, who's gone on to create the great Bob Seger website segerfile.com. Scott had given the photograph to Bob in Ann Arbor at the Primo Show Bar one night. Bob then dropped the photo off at the office for me to use on the back cover. The other photos on the back are some I took of Bob and the band playing at the Birmingham Theater.

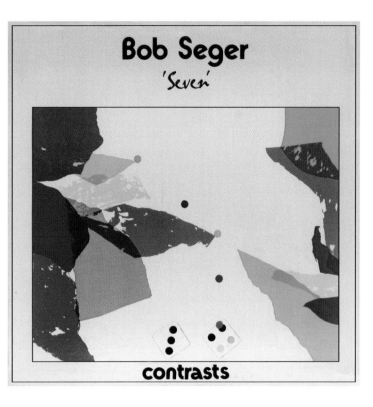

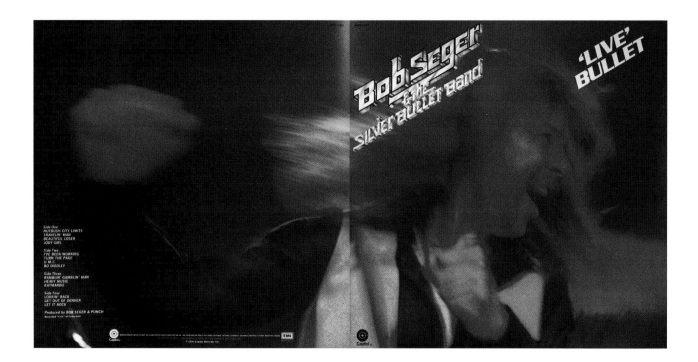

Side One
NUTBUSH CITY LIMITS
TRAVELIN' MAN
BEAUTIFUL LOSER
JODY GIRL

Side Two
I'VE BEEN WORKING
TURN THE PAGE
U.M.C.
BO DIDDLEY

Side Three
RAMBLIN' GAMBLIN' MAN
HEAVY MUSIC
KATMANDU

Side Four
LOOKIN' BACK
GET OUT OF DENVER
LET IT ROCK

Produced by BOB SEGER & PUNCH
Recorded "Live" At Cobo Hall

LIVE BULLET

Punch wanted nothing but great pictures all over the album. I contacted the many photographers I knew all over the country and had over two thousand slides sent to the office. At this big party we had at Punch's house with the band, all the roadies, and others, I showed the slides on Punch's refrigerator, just flashing through them, with Punch saying, "Okay, this one's good. Put it in the pile. Not that one . . ." and on and on well into the night.

We started at 8:00 at night, and by 3:30 the next morning Buzzy Van Houten and I were the only ones left standing. Most of the band had gone home. One or two stayed and were sleeping on couches. Punch was in bed, and me and Buzzy were still going at it, on our eighth beer, when all of a sudden, Robbie Marklowitz's slide of Bob's head swinging sideways in the bright red and yellow light came up. I said, "I can make an album cover out of that." Buzzy agreed: "That's the one, man. That's perfect. That's Seger!" So I drew with Magic Marker on Punch's refrigerator. I thought it would wash off, but it didn't, so there was a 12-by-12-inch image left on his refrigerator.

We picked out the other photos earlier in the night, but Robbie Marklowitz got the cover. I phoned him and said, "You got the cover, baby!" to which he answered, "Yes!!!!"

Capitol needed the artwork within two days, so I didn't get any sleep. At that time there was a process for slides called Cibachrome: you could put a slide in the enlarger and actually print a picture of it without going through the negative process. I had to make Cibachrome prints of every slide and lay out everything. Steve Noxon did the *Live Bullet* logo, I put that in place on an overlay, and we sent it out via Railway Express Agency. Capitol loved it, and everything worked out.

Roy Kohara, who was head of Capitol's art department, called and said, "Ya know, the placement of the logo has to change." I replied, "Okay, go ahead, put it wherever you want, as long as you don't put it over Bob's face." When the album came out, I opened the first box I could get my hands on. It looked very good, even great—but then I saw the credit: Art Direction: Roy Kohara, Thomas Weschler. Kohara didn't do anything except move the logo, and he took first credit! I was pissed. But when Capitol gave me my first gold record for art direction I got un-pissed.

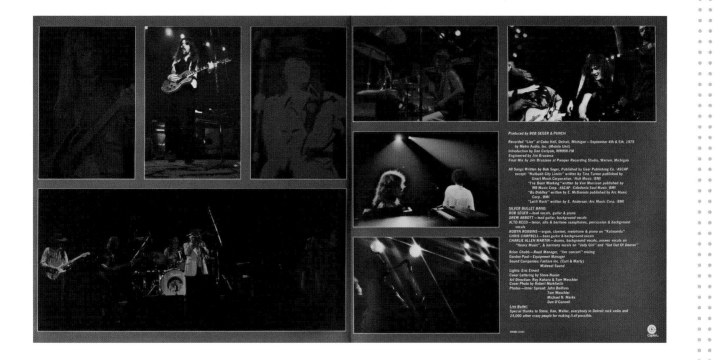

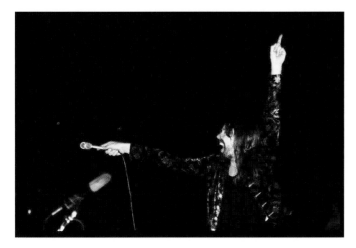

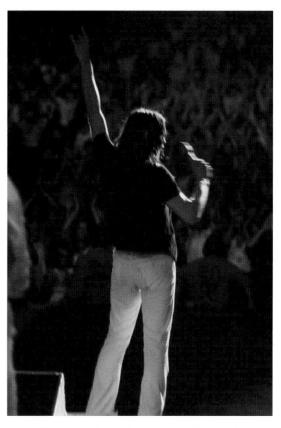

▲ Pine Knob Music Theatre (Independence Township), summer 1978.

▼ Cobo Arena (Detroit), winter 1977.

▲ Pine Knob Music Theatre (Independence Township), summer 1978.

When Seger came up with *Live Bullet* for the title of his first concert album, he asked me to try to come up with some ideas for the cover. My thought was to have a beautiful woman holding a bullet-shaped object with red lipstick around the nose—not overtly pornographic but something sly. I was on my way to Omar Newman's rented mansion in Bloomfield Hills, where he had a photo studio built in his giant living room with a fireplace and plenty of lights for those evenings you just want to photograph a beautiful girl. The setup was great, and a girl named Audrey was living there with Omar's housemate, Cal Barber. When I told her my idea, she said, "Hell yes, I'll do it!" So I found one of those egg-shaped packages that women's nylons come in and had her kiss it with red lipstick while wearing my tuxedo shirt and cufflinks with music notes on them. The shot turned out well, but Punch didn't think it would work for the cover. He decided to go with all live photographs of Bob and the band, which worked out just fine.

In 2002, Mike Boila from Punch's office called me and said, "We've got a proposition for you. We're going to come out with a second greatest hits album. Can I come over to your studio and look through everything you have on Seger?" For four days in a row he spent the whole morning at my studio looking through all of my Seger proofs and picking out photos he liked. It wound up not coming out that year but was scheduled for release the following year. They settled on two photographs—one from the back of *Brand New Morning* and one from East Lansing, Michigan, taken in '77, with Bob pointing at a kid in the audience who was holding his crutches in the air.

The day the album came out, there was a party in Royal Oak; it wasn't an official album-release party, just some people who were going to celebrate, including a few of my roadie friends and a couple of photographers I knew. I was driving through Berkley, Michigan, on the way there and got pulled over because my license plate had expired and there was an outstanding warrant even though I'd never received anything in the mail informing me. I told the officer where I was going and why. He believed me and was about to let me go with my promise to pay the fine from the ticket, but right then his lieutenant drove by (a very stern, by-the-book cop), so the officer had to play it by the book, too. I was in jail for an hour.

When I went to my first court date, the judge wanted to reschedule my appearance, so they postponed it to March 15—which was when I was supposed to be in New York for Seger's Rock and Roll Hall of Fame induction. I asked the court clerk if the date could be later and I told her why. The clerk replied, "Uh, you know Bob Seger? Wait a minute," and went to get an album of photographs of herself wearing Bob Seger T-shirts. The judge came out, overheard us, and asked, "Do you think you could get a Bob Seger autograph for my wife? She really loves him." So I asked, "Can I get this date changed?" He replied, "Sure, you can come in June." So it worked out great—I went to the Hall of Fame. When I returned for my court date in June, I delivered an 8 by 10 of Bob with his autograph for the judge's wife and I was free!

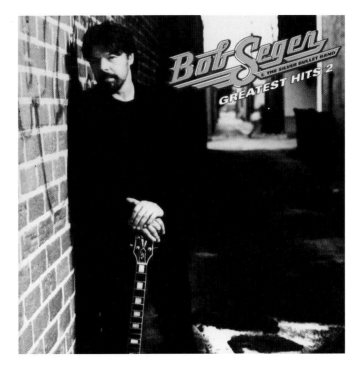

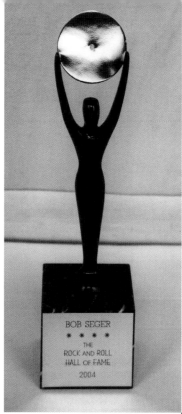

Rock and Roll Hall of Fame induction
ceremony, Waldorf–Astoria Hotel
(New York), March 15, 2004.

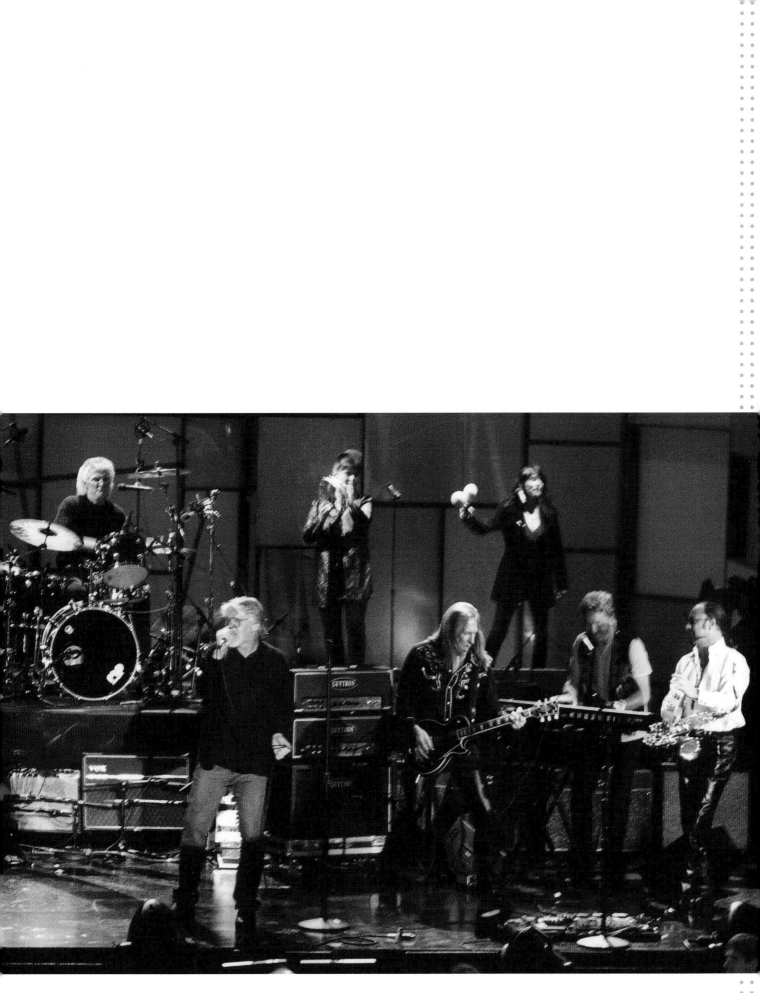

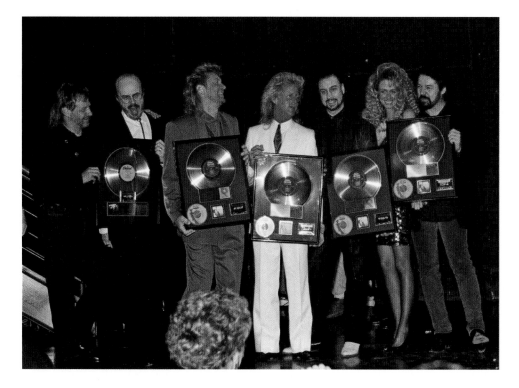

▲ Platinum Record Presentation, Royal Oak
Theater, October 1995. (left to right): David
Teegarden, Drew Abbott, Craig Frost, Chris
Campbell, Alto Reed, Nita Seger, Bob Seger.

▼ With Loretta and Mike Novak and
Tom Gulick, Industry (Pontiac), 1996.

Afterword

KID ROCK

I've been spoon-fed Bob Seger from the time I was born. My parents had barn parties on the weekends; they'd get some old tubs and fill them with beer, and they had a stereo out there in the barn and a dirt floor and they'd just throw down—and Bob Seger was always the soundtrack. I used to go to bed with Bob Seger blaring out there. So when I was a kid I always loved listening to those records. It became part of my DNA.

With no disrespect to the other guys, I do think Seger's the best in terms of the heartland rock 'n' rollers. It all comes down to the songwriting ability, the singing ability, the songs—just the overall feel of the music. I don't think anything compares to it. It's on its own level, and it seems like it just gets better. It's not something I've outgrown; I can turn to it at any point, and it reminds me of greatness.

I know people, myself included, sometimes wonder if Bob could have gotten even bigger if he had done some of the high-profile, media-type things other people have done. But he's going to go down in the books as one of the best—he already has, really—and I think that's going to keep growing because there's always been a little mystery there, which I think is something that's missing nowa-

I miss that mystery aspect, that thing that makes you want to dig deeper and discover what somebody's all about, and Seger still has that when almost nobody else does.

days in rock 'n' roll. Everything's out there for the taking. Everybody knows everything. I miss that mystery aspect, that thing that makes you want to dig deeper and discover what somebody's all about, and Seger still has that when almost nobody else does. And when you start to think about all the stuff he's done, whether it's *Risky Business* when Tom Cruise comes out in his underwear to "Old Time Rock & Roll" or when you hear his music in *Forrest Gump*, you realize Bob's completely in the consciousness, in the fabric of the culture, without having to do all that other stuff.

I've been fortunate enough to get to know him over the years. Having the same manager for a while, we started to hang out and share airplane rides, and our kids got to know each other, and we just formed a friendship between our families. Our kids are the same age, so we can actually share

TRAVELIN' MAN 153

stories and talk on the same level, and when you're talking about your family, everything goes out the window. You can really relate to each other as peers.

No matter how cool you try to play it, I'm blessed and lucky not only to be a fan of somebody like that but also to have become friends with him. The biggest moment for me, ever, on stage was when he joined me in Detroit to sing "Rock and Roll Never Forgets." I've sung with *everybody*, but that was the highlight. I was on cloud nine. And getting to do that a few more times and recording a song ("Real Mean Bottle") with him are highlights in my life.

I've been studying his career more than anybody's, and I've learned a lot by observing it and by talking to him about it. I think that, subliminally, I've patterned parts of my life after his—remaining in Detroit, staying grounded, and learning that you go through a lot of things, but in the end, if you do it right, you come out with your feet on the ground. He's a great artist and a great man who's made his mark on a lot of lives with his music.

Bob Seger Discography

All of the songs listed here are written by Bob Seger unless noted otherwise. All album chart positions are for the same chart, which has had different names over the years. All singles chart positions are for the *Billboard* Hot 100.

Albums

Ramblin' Gamblin' Man
Bob Seger System
Release date: April 1969
Label: Capitol
Producer: Punch Andrews
Songs: "Ramblin' Gamblin' Man," "Tales of Lucy Blue," "Ivory," "Gone" (Dan Honaker), "Down Home," "Train Man," "White Wall," "Black Eyed Girl," "2 + 2 = ?", "Doctor Fine," "The Last Song (Love Needs to Be Loved)"
Chart peak: No. 62, *Billboard* Top LP's
Singles: "2 + 2 = ?"; "Ivory," No. 97; "Ramblin' Gamblin' Man," No. 17

Noah
Bob Seger System
Release date: September 1969
Label: Capitol
Producer: Punch Andrews
Songs: "Noah," "Innervenus Eyes," "Lonely Man" (Tom Neme), "Loneliness Is a Feeling" (Neme), "Cat," "Jumpin' Humpin' Hip Hypocrite" (Neme), "Follow the Children" (Neme), "Lennie Johnson" (Dan Honaker), "Paint Them a Picture Jane" (Neme), "Death Row"
Singles: "Noah," "Innervenus Eyes"

Mongrel
Bob Seger System
Release date: August 1970
Label: Capitol
Producer: Punch Andrews
Songs: "Song to Rufus," "Evil Edna," "Highway Child," "Big River," "Mongrel," "Lucifer," "Teachin' Blues," "Leanin' on My Dream," "Mongrel Too," "River Deep, Mountain High" (Jeff Barry, Ellie Greenwich, Phil Spector)
Chart peak: No. 171, *Billboard* Top LP's
Single: "Lucifer," No. 84

Brand New Morning
Bob Seger
Release date: October 1971
Label: Capitol
Producer: Punch Andrews
Songs: "Brand New Morning," "Maybe Today," "Sometimes," "You Know Who You Are," "Railroad Days," "Louise," "Song for Him," "Something Like"

Smokin' O.P.'s
Bob Seger
Release date: August 1972
Labels: Palladium; November 1972 rerelease on Palladium/Reprise
Producer: Punch Andrews
Songs: "Bo Diddley"/"Who Do You Love?" (Bo Diddley), "Love the One You're With" (Stephen Stills), "If I Were a Carpenter" (Tim Hardin), "Hummin' Bird" (Leon Russell), "Let It Rock" (Chuck Berry), "Turn on Your Love Light" (Deadric Malone, Joseph Wade Scott), "Jesse James," "Someday," "Heavy Music"
Chart peak: No. 180, *Billboard* Top LP's & Tapes
Singles: "If I Were a Carpenter," No. 76; "Who Do You Love?"

Back in '72
Bob Seger
Release date: January 1973
Label: Palladium/Reprise
Producers: Punch Andrews, Bob Seger
Songs: "Midnight Rider" (Gregg Allman), "So I Wrote You a Song," "The Stealer" (Andy Fraser, Paul Rodgers), "Rosalie," "Turn the Page," "Back in '72," "Neon Sky," "I've Been Working" (Van Morrison), "I've Got Time"
Chart peak: No. 188, *Billboard* Top LP's & Tapes
Single: "Rosalie"

Seven
Bob Seger
Release date: March 1974
Label: Palladium/Reprise
Producers: Punch Andrews, Bob Seger
Songs: "Get Out of Denver," "Long Song Comin'," "Need Ya," "School Teacher," "Cross of Gold," "U.M.C. (Upper Middle Class)," "Seen a Lot of Floors," "20 Years from Now," "All Your Love"
Singles: "Need Ya"; "Get Out of Denver," No. 80; "U.M.C. (Upper Middle Class)"

Beautiful Loser
Bob Seger
Release date: April 1975
Label: Capitol
Producers: Punch Andrews, Bob Seger and the Muscle Shoals Rhythm Section
Songs: "Beautiful Loser," "Black Night," "Katmandu," "Jody Girl," "Travelin' Man," "Momma," "Nutbush City Limits" (Tina Turner), "Sailing Nights," "Fine Memory"
Chart peak: No. 131, *Billboard* Top LP's & Tapes
Singles: "Beautiful Loser"; "Katmandu," No. 43
Certified: Double platinum

Live Bullet
Bob Seger & the Silver Bullet Band
Release date: April 1976
Label: Capitol
Producers: Punch Andrews, Bob Seger
Songs: "Nutbush City Limits" (Tina Turner), "Travelin' Man"/"Beautiful Loser," "Jody Girl," "I've Been Working" (Van Morrison), "Turn the Page," "U.M.C. (Upper Middle Class)," "Bo Diddley" (Bo Diddley), "Ramblin' Gamblin' Man," "Heavy Music," "Katmandu," "Lookin' Back," "Get Out of Denver," "Let It Rock" (Chuck Berry)
Chart peak: No. 34, *Billboard* Top LP's & Tapes
Single: "Nutbush City Limits," No. 69
Certified: Five-times platinum

Night Moves
Bob Seger & the Silver Bullet Band
Release date: October 1976
Label: Capitol
Producers: Punch Andrews, Bob Seger, Jack Richardson, the Muscle Shoals Rhythm Section
Songs: "Rock and Roll Never Forgets," "Night Moves," "The Fire Down Below," "Sunburst," "Sunspot Baby," "Mainstreet," "Come to Poppa" (Earl Randle, Willie Mitchell), "Ship of Fools," "Mary Lou" (Young Jessie, Sam Ling)
Chart peak: No. 8, *Billboard* Top LP's & Tapes
Singles: "Night Moves," No. 4; "Mainstreet," No. 24; "Rock and Roll Never Forgets," No. 41
Certified: Six-times platinum

Stranger in Town
Bob Seger & the Silver Bullet Band
Release date: May 5, 1978
Label: Capitol
Producers: Punch Andrews, Bob Seger, the Muscle Shoals Rhythm Section
Songs: "Hollywood Nights," "Still the Same," "Old Time Rock & Roll" (George Jackson, Thomas Jones, Bob Seger [uncredited]), "Till It Shines," "Feel Like a Number," "Ain't Got No Money" (Frankie Miller), "We've Got Tonight," "Brave Strangers," "The Famous Final Scene"
Chart peak: No. 4, *Billboard* Top LP's & Tapes
Singles: "Still the Same," No. 4; "Hollywood Nights," No. 12; "We've Got Tonight;" "Old Time Rock & Roll," No. 28
Certified: Six-times platinum

Against the Wind
Bob Seger & the Silver Bullet Band
Release date: February 25, 1980
Label: Capitol
Producers: Punch Andrews, Bob Seger,
Bill Szymczyk, Muscle Shoals Rhythm Section
Songs: "The Horizontal Bop," "You'll Accomp'ny Me,"
"Her Strut," "No Man's Land," "Long Twin Silver Line,"
"Against the Wind," "Good for Me," "Betty Lou's Gettin'
Out Tonight," "Fire Lake," "Shinin' Brightly"
Chart peak: No. 1, *Billboard* Top LP's & Tapes
Singles: "Fire Lake," No. 6; "Against the Wind," No. 5;
"You'll Accomp'ny Me," No. 14; "The Horizontal Bop," No. 42
Grammy Awards: Best Rock Performance by a Duo or Group
with Vocal; Best Recording Package
Certified: Five-times platinum

Nine Tonight
Bob Seger & the Silver Bullet Band
Release date: September 1981
Label: Capitol
Producers: Punch Andrews, Bob Seger
Songs: "Nine Tonight," "Tryin' to Live My Life Without You,"
(Eugene Williams), "You'll Accomp'ny Me," "Hollywood
Nights," "Old Time Rock & Roll" (George Jackson, Thomas
Earl Jones III, Bob Seger [uncredited]), "Mainstreet,"
"Against the Wind," "The Fire Down Below," "Her Strut,"
"Feel Like a Number," "Fire Lake," "Betty Lou's Gettin' Out
Tonight," "We've Got Tonight," "Night Moves," "Rock and
Roll Never Forgets," "Let It Rock" (Chuck Berry)
Chart peak: No. 3, *Billboard* Top LP's & Tapes
Singles: "Tryin' to Live My Life Without You," No. 5;
"Feel Like a Number," No. 48
Certified: Five-times platinum

The Distance
Bob Seger & the Silver Bullet Band
Release date: December 13, 1982
Label: Capitol
Producer: Jimmy Iovine
Songs: "Even Now," "Makin' Thunderbirds,"
"Boomtown Blues," "Shame on the Moon" (Rodney
Crowell), "Love's the Last to Know," "Roll Me Away,"
"House Behind a House," "Comin' Home," "Little Victories"
Chart peak: No. 5, *Billboard* Top LP's & Tapes
Singles: "Shame on the Moon," No. 2; "Even Now," No. 12;
"Roll Me Away," No. 27; "Shame on the Moon"
Certified: Platinum

Like a Rock
Bob Seger & the Silver Bullet Band
Release date: March 28, 1986
Label: Capitol
Producers: Punch Andrews, Bob Seger, David Cole
Songs: "American Storm," "Like a Rock," "Miami,"
"The Ring," "Tightrope" (Craig Frost, Seger),
"The Aftermath" (Frost, Seger), "Sometimes,"
"It's You," "Somewhere Tonight," "Fortunate Son"
(live—CD bonus track) (John Fogerty)
Chart peak: No. 3, *Billboard* Top 200 Albums
Singles: "American Storm," No. 13; "It's You," No. 52;
"Like a Rock," No. 12; "Miami," No. 70
Certified: Platinum

The Fire Inside
Bob Seger & the Silver Bullet Band
Release date: August 27, 1991
Label: Capitol
Producers: Punch Andrews, Bob Seger,
Don Was, Barry Beckett
Songs: "Take a Chance," "The Real Love," "Sightseeing,"
"Real at the Time," "Always in My Heart," "The Fire Inside,"
"New Coat of Paint" (Tom Waits), "Which Way," "The
Mountain," "The Long Way Home," "Blind Love" (Tom
Waits), "She Can't Do Anything Wrong" (Bill Davis, Walt
Richmond)
Chart peak: No. 7, *Billboard* Top Pop Albums
Singles: "The Real Love," No. 24; "The Fire Inside" (edit)
Certified: Platinum

Greatest Hits

Bob Seger & the Silver Bullet Band
Release date: October 25, 1994
Label: Capitol
Songs: "Roll Me Away," "Night Moves," "Turn the Page," "You'll Accomp'ny Me," "Hollywood Nights," "Still the Same," "Old Time Rock & Roll" (George Jackson, Thomas Earl Jones III, Bob Seger [uncredited]), "We've Got Tonight," "Against the Wind," "Mainstreet," "The Fire Inside," "Like a Rock," "C'est La Vie" (Chuck Berry), "In Your Time"
Chart peak: No. 8, *Billboard* 200
Certified: Nine-times platinum

It's a Mystery

Bob Seger & the Silver Bullet Band
Release date: October 24, 1995
Producer: Bob Seger
Songs: "Rite of Passage," "Lock and Load" (Craig Frost, Tim Mitchell, Seger), "By the River," "Manhattan," "I Wonder," "It's a Mystery," "Revisionism Street" (Frost, Mitchell, Seger), "Golden Boy," "I Can't Save You Angelene," "16 Shells from a Thirty-Ought Six" (Tom Waits), "West of the Moon," "Hands in the Air" (Frost, Mitchell, Seger)
Chart peak: No. 27, *Billboard* 200
Singles: "Lock and Load," "I Wonder," "Hands in the Air"
Certified: Gold

Greatest Hits 2

Bob Seger & the Silver Bullet Band
Release date: November 4, 2003
Label: Capitol
Songs: "Understanding" (from the film *Teachers*), "The Fire Down Below," "Her Strut," "Beautiful Loser," "Sunspot Baby," "Katmandu," "Shame on the Moon" (Rodney Crowell), "Fire Lake," "Tryin' to Live My Life Without You" (live) (Eugene Williams), "Shakedown" (from the film *Beverly Hills Cop II*) (Seger, Harold Faltermeyer, Keith Forsey), "Manhattan," "New Coat of Paint" (Tom Waits), "Chances Are" (with Martina McBride, from the film *Hope Floats*), "Rock and Roll Never Forgets," "Satisfied," "Tomorrow," "Turn the Page" (bonus video)
Chart peak: No. 23, *Billboard* 200
Certified: Gold

Face the Promise

Bob Seger
Release date: September 12, 2006
Label: Capitol
Producer: Bob Seger
Songs: "Wreck This Heart," "Wait For Me," "Face the Promise," "No Matter Who You Are," "Are You," "Simplicity," "No More," "Real Mean Bottle" (with Kid Rock) (Vince Gill), "Won't Stop," "Between," "The Answer's in the Question" (with Patty Loveless), "The Long Goodbye"
Chart peak: No. 4, *Billboard* 200
Singles: "Wait For Me," "Wreck This Heart"
Certified: Platinum

Singles

b/w, "backed with"
(e.g., A–side b/w B–side)

1965

"T.G.I.F." b/w "The First" with
Doug Brown & the Omens (Punch)

1966

"Ballad of the Yellow Beret" b/w
"Florida Time" with the Beach Bums
(aka Doug Brown & the Omens)
(Are You Kidding Me?)

"East Side Story" b/w "East Side
Sound" (Cameo–Parkway and Hideout)

"Persecution Smith" b/w "Chain
Smokin'" with Bob Seger & the Last
Heard (Cameo–Parkway and Hideout)

"East Side Story" b/w "East Side
Sound" with Bob Seger & the Last
Heard (Cameo–Parkway and Hideout)

"Sock It to Me Santa" b/w "Florida
Time" with Bob Seger & the Last Heard
(Cameo–Parkway)

1967

"Vagrant Winter" b/w "Very Few"
with Bob Seger & the Last Heard
(Cameo–Parkway and Hideout)

"Heavy Music (Pt. 1)" b/w "Heavy
Music (Pt. 2)" with Bob Seger &
the Last Heard (Cameo–Parkway
and Hideout)

1968

"2 + 2 = ?" b/w "Death Row" with
the Bob Seger System (Capitol)

"Ramblin' Gamblin' Man" b/w "Tales
of Lucy Blue" with the Bob Seger
System, No. 17 (Capitol)

1969

"Ivory" b/w "The Last Song (Love
Needs to Be Loved)" with the Bob
Seger System, No. 97 (Capitol)

"Noah" b/w "Lennie Johnson"
with the Bob Seger System (Capitol)

"Innervenus Eyes" b/w "Lonely Man"
with the Bob Seger System (Capitol)

"Ramblin' Gamblin' Man" b/w
"2 + 2 = ?" with the Bob Seger
System (Capitol Starline rerelease)

1970

"Lucifer" b/w "Big River" with the
Bob Seger System, No. 84 (Capitol)

1971

"Looking Back" b/w "Highway Child,"
No. 96 (Capitol)

1972

"If I Were a Carpenter" b/w
"Jesse James," No. 76 (Palladium)

"Who Do You Love?" b/w "Turn On
Your Love Light" (Reprise)

1973

"Rosalie" b/w "Neon Sky" (Palladium)

1974

"Need Ya" b/w "Seen a Lot of Floors"
(Palladium)

"Get Out of Denver" b/w "Long Song
Comin'," No. 80 (Palladium)

"U.M.C. (Upper Middle Class)" b/w
"This Old House" (Palladium)

1975

"Beautiful Loser" b/w "Fine Memory"
(Capitol)

"Katmandu" b/w "Black Night,"
No. 43 (Capitol)

1976

"Nutbush City Limits" (live) b/w
"Nutbush City Limits" (live mono) with
the Silver Bullet Band, No. 69 (Capitol)

"Night Moves" b/w "Ship of Fools,"
No. 4 (Capitol)

1977

"Mainstreet" b/w "Jody Girl" with the
Silver Bullet Band, No. 24 (Capitol)

"Rock and Roll Never Forgets" b/w
"The Fire Down Below" with the Silver
Bullet Band, No. 41 (Capitol)

1978

"Still the Same" b/w "Feel Like a
Number" with the Silver Bullet Band,
No. 4 (Capitol)

"Hollywood Nights" b/w "Brave
Strangers" with the Silver Bullet Band,
No. 12 (Capitol)

"We've Got Tonight" b/w "Ain't Got No
Money" with the Silver Bullet Band,
No. 13 (Capitol)

1979

"Old Time Rock & Roll" b/w "Sunspot Baby" with the Silver Bullet Band, No. 28 (Capitol)

1980

"Fire Lake" b/w "Long Twin Silver Line" with the Silver Bullet Band, No. 6 (Capitol)

"Against the Wind" b/w "No Man's Land" with the Silver Bullet Band, No. 5 (Capitol)

"You'll Accomp'ny Me" b/w "Betty Lou's Gettin' Out Tonight" with the Silver Bullet Band, No. 14 (Capitol)

"The Horizontal Bop" b/w "Her Strut" with the Silver Bullet Band, No. 42 (Capitol)

1981

"Tryin' to Live My Life Without You" (live) b/w "Brave Strangers" (live) with the Silver Bullet Band, No. 5 (Capitol)

"Feel Like a Number" (live) b/w "Hollywood Nights" (live) with the Silver Bullet Band, No. 48 (Capitol)

1982

"Shame on the Moon" b/w "House Behind a House" with the Silver Bullet Band, No. 2 (Capitol)

1983

"Even Now" b/w "Little Victories" with the Silver Bullet Band, No. 12 (Capitol)

"Roll Me Away" b/w "Boomtown Blues" with the Silver Bullet Band, No. 27 (Capitol)

"Old Time Rock & Roll" b/w "Till It Shines" with the Silver Bullet Band, No. 58 (Capitol)

1984

"Understanding" b/w "East L.A.," No. 17 (Capitol)

1986

"American Storm" b/w "Fortunate Son" (live) with the Silver Bullet Band, No. 13 (Capitol)

"Like a Rock" b/w "Livin' Inside My Heart" with the Silver Bullet Band, No. 12 (Capitol)

"It's You" b/w "The Aftermath (12<AP' Remix)" with the Silver Bullet Band, No. 52 (Capitol)

"Miami" b/w "Somewhere Tonight" with the Silver Bullet Band, No. 70 (Capitol)

"Shakedown" b/w "The Aftermath" (from the soundtrack to the film *Beverly Hills Cop II*), No. 1 (MCA)

1989

"Blue Monday" (from the soundtrack to the film *Road House*) (Arista)

1991

"The Real Love" b/w "Roll Me Away" with the Silver Bullet Band, No. 24 (Capitol)

"The Fire Inside" (edit) b/w "New Coat of Paint" with the Silver Bullet Band (Capitol)

1995

"Lock and Load" (rock mix) b/w "Lock and Load" (single edit) with the Silver Bullet Band (Capitol)

"I Wonder" (Capitol)

1996

"Hands in the Air" with the Silver Bullet Band (Capitol)

1998

"Chances Are" with Martina McBride (from the soundtrack to the film *Hope Floats*) (Capitol)

2006

"Wait For Me" (Capitol)

"Wreck This Heart" (Capitol)

Songs Also Appear on . . .

1977: "Ramblin' Gamblin' Man," *Michigan Rocks* album (Seeds & Stems)

1978: "Night Moves," from the soundtrack to the film *FM* (MCA)

1980: "Nine Tonight," from the soundtrack to the film *Urban Cowboy* (Asylum)

1983: "Old Time Rock & Roll," from the soundtrack to the film *Risky Business* (Virgin)

1984: "Understanding," from the soundtrack to the film *Teachers* (Capitol)

1986: "Living Inside My Heart," from the soundtrack to the film *About Last Night* (EMI America); "Star Tonight" for Don Johnson's album *Heartbeat* (Razor & Tie)

1987: "Shakedown," from the soundtrack to the film *Beverly Hills Cop II* (MCA); "The Little Drummer Boy," *A Very Special Christmas* (A&M)

1989: "Blue Monday," from the soundtrack to the film *Road House* (Arista)

1994: "Against the Wind," from the soundtrack to the film *Forrest Gump* (Epic); "Against the Wind," *Harley Davidson Road Songs* (Capitol)

1995: "Against the Wind," *World of Noise* (Q); "Sock It to Me Santa," *A Rock 'n' Roll Christmas* (Excelsior)

1998: "Chances Are" with Martina McBride, from the soundtrack to the film *Hope Floats* (Capitol)

1998: "Roll Me Away," from the soundtrack to the film *Armageddon* (Sony)

1999: "Till It Shines," from the soundtrack to the film *Mumford* (Hollywood)

2000: "Fire Lake," *Legendary Harley-Davidson Road Songs* (Capitol)

2002: "Against the Wind," *Capitol Records 1942–2002* (Capitol)

2005: "East Side Story," "Heavy Music (Pt. 1)," and "Sock It to Me Santa," from the album *Cameo-Parkway 1957–1967* (ABKCO)

2008: "Sock It to Me Santa," *Christmas a Go-Go* (Wicked Cool)

Video Game Appearances

2008: "Her Strut," from *Grand Theft Auto IV*; "Hollywood Nights," from *Guitar Hero: World Tour*

2009: "Old Time Rock & Roll," "Her Strut," and "Get Out of Denver," from *Guitar Hero: World Tour* download pack; "Turn the Page," from *Guitar Hero: Metallica*

Guest Appearances

1971: The MC5, *High Time* (Atlantic); Brownsville Station, "Tell Me All About It" (vocals)

1978: "Radioactive" and "Living in Sin" on Gene Simmons's *Gene Simmons* (Casablanca)

1983: "Christmas in Cape Town" and "Take Me Back" on Randy Newman's *Trouble in Paradise* (Reprise)

1986: Blues Busters, *Accept No Substitutes* (Landslide)

1988: Little Feat, *Let It Roll* (Warner Bros.)

1991: Aaron Neville, *Warm Your Heart* (A&M)

2005: "Landing in London" on 3 Doors Down's *Seventeen Days* (Universal Republic)

2008: "Something in the Water" on Little Feat's *Join the Band* (429 Records)

TRAVELIN' MAN

Acknowledgments

We have both had the privilege of some special years with Bob Seger, either working for and photographing him (Tom) or interviewing and writing about him (Gary). We've been able to share good times and many special occasions—sold-out arena concerts, weddings, sailboat victories, his induction into the Rock and Roll Hall of Fame—and haven't pissed him off, too much, over the years. It's been a pleasure to delve deeply into what has become an almost mythic period of his career and to bring his fans a unique and largely untapped perspective into it.

We'd like to thank the folks at Wayne State University Press, especially Jane Hoehner and Kathryn Wildfong, for helping to take this project from our heads and hearts and turn it into a book. Also thanks to Brecque Keith in the Walter P. Reuther Library; Scott Sparling, who runs the wonderful segerfile.com website; Ken Settle, another photographer and Seger enthusiast extraordinaire; and Patti Montemurri—all of whom looked over our shoulders and helped us track down and clear up elusive and sometimes contradictory facts. Stephen Scapelliti was irreplaceable for his legal assistance. And, for helping organize mountains of photographs, proof sheets, negatives, digital files and notes, thanks to Jenny Coates; Yvonne McCune; Lisa Parks; Chelsea Jackson; Carl Lacey; Will, Bill, and Race at Backstage Gallery; and Rich Castillo and John Isaia at Commercial Imaging and Design (CID). And more thanks to John Mogos for technical support.

We also enjoyed the enthusiastic support and encouragement from the office of Punch Enterprises, including the always acerbic Mr. Andrews himself, as well as Mike Boila, Bill Blackwell, Frank Copeland, and Anne Sullivan. They were both wary and engaged throughout the process of putting together *Travelin' Man*; we hope they enjoy the final product. Ditto to Kid Rock and John Mellencamp, whose words, fore and after, truly enrich our book.

Tom thanks, in no particular order, some of the people who helped make this book a reality: Friends whose encouragement over the years has been indispensable to my photographic career, including Amber Karkauskas, Michele Lucassian, Mike Novak, Beth Fisher, Loretta Syler, Ken Zapczynski, Jack Ashton, RG Dempster, John and Jim Carlson, Tausha McQuisten, Omar Newman, Stanley Livingston, Sheryll Johnson, Dick and Mike Keskey, Steve Hanson, Charlie Auringer; my former colleagues and students from the Academy of the Sacred Heart; Dick Rosemont at the FBC (Flat, Black and Circular) record store; the late Barry Kramer and the late Douglas Severson (aka Moonman); Russ Klatt (Frame Art Gallery); James Grogan; Leni Sinclair; Larry Rubin; my sister-in-law "Aunt" Rose and my brother-in-law Bill Hines, both of whom went to Southwestern High School in Detroit; my brother Edward and my sister Marge for helping raise a little rock 'n' roll boy in the 1950s; and, of course, my parents Edith and Al Weschler, who I wish were still alive to see this.

Gary offers great thanks to those he works for regularly, who gave him the leeway and latitude to work on this book—even when they didn't know they were doing it: Jacquelyn Gutc, Megan Frye, Valerie West, Julie Jacobson, Nicole Robertson, Steve Frye, and Glenn Gilbert at the Oakland Press; David J. Prince, Jonathan Cohen, Jessica Letkemann, Bill Werde, and Robert Levine at *Billboard*; Judy Rosen and the gang at the Pulse of Radio; Gayden Wren at the New York Times Syndicate; Brandon Geist, Kory Grow, and Tom Beaujour at *Revolver*; United Press International (UPI); Bob Kernen and Tom Sharrard at Grokmusic.com; Doug Podell, Jon Ray, and all at WCSX Detroit; Bob Madden, Brian Nelson, Eric Jensen, and Keith Hastings at WHQG (The Hog!) in Milwaukee; Laura Lee at Radio 106.7 in Columbus, Ohio; and a partridge in a pear tree. My gratitude also to the too many friends and relatives to name without missing somebody important, but especially to my beloved Hannah; my dear Shari; Liebe and Annie the wonder dogs; and housemate Rick, all of whom never tired of that old time rock 'n' roll—or at least pretended they didn't.

Index